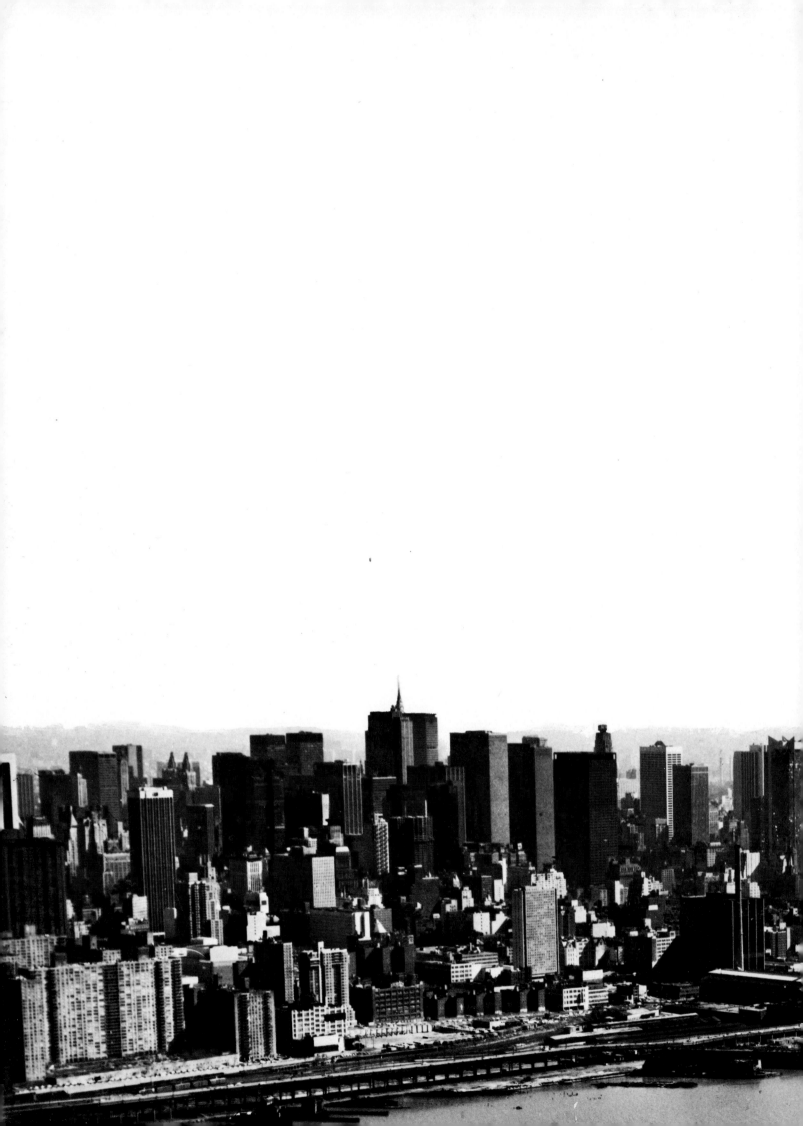

NEW YORK IN
AERIAL VIEWS

68 Photographs by
WILLIAM FRIED

With Identifications by
Edward B. Watson

DOVER PUBLICATIONS, INC.
NEW YORK

Published in Canada by General Publishing Company, Ltd., 30 Lesmill Road, Don Mills, Toronto, Ontario.
Published in the United Kingdom by Constable and Company, Ltd., 10 Orange Street, London WC2H 7EG.

New York in Aerial Views: 68 Photographs is a new work, first published by Dover Publications, Inc., in 1980.

International Standard Book Number: 0-486-24018-5
Library of Congress Catalog Card Number: 80-68748

Manufactured in the United States of America
Dover Publications, Inc.
180 Varick Street
New York, N.Y. 10014

INTRODUCTION

Since prehistory, man has put his mark on the planet with great projects. Now 2000 years old, the Great Wall of China remains the largest construction project ever undertaken. But its builders could only imagine it in its entirety; an all-encompassing view was beyond their abilities.

Not until the first hot-air balloon flights in the eighteenth century did man actually see from above the landscape he had created. The pioneers who went aloft would later write vivid descriptions of how the world looked from above. A thought that runs through all these early accounts is that the real scene was startlingly different from what the balloonist had anticipated.

In the middle of the last century the invention of photography made it possible to bring the actual images home. Light sensitizing of glass plates had developed to the point where exposure times became short enough for images to be made from an airborne platform. The first usable aerial photograph, a picture of downtown Boston, was made from a balloon by James Wallace Black in 1860.

Since that time, aerial photographs have been made with cameras carried aloft by balloons, kites, birds, powered aircraft, rockets and satellites. Not only has every part of our planet been photographed; we are photographing the surfaces of other planets, such as Mars and Jupiter.

I organized Skyviews shortly after World War II, using one camera and a rented airplane. At that time my clients, all in real estate, used the photographs in making property sales. Skyviews has since photographed almost every type of subject visible from the air.

Flying assignments range from Canada to Florida, with the major part of our work in the Greater New York area. As they come in, assignments are plotted on a large wall map and a detailed flight plan is worked up. What may eventually be dozens of separate pieces of information relating to the identification of subjects and the desired objectives of the photography are put into a form that can be used in sequence during the course of a typical three- or four-hour flight. The grouping of assignments increases efficiency by lowering the average flight time between locations.

Although the company charters helicopters on occasion, most of the work is done from a company-owned Piper PA22. This aircraft has unique door openings and hatches in its sides and bottom permitting both oblique and vertical aerial photography. Special wing tips make possible very slow flight and maximum stability, particularly important at low altitudes.

In recent years, operations over the New York City area have become increasingly difficult. The growth of air traffic, along with new and complex air-traffic control procedures, has required advanced coordination of most flights and special electronic equipment to identify our aircraft to the radar. This plus the vagaries of the weather make a day's work anything but routine.

Specialized aerial cameras provide a large variety of formats, including 35mm, 6 x 7 cm, 4 x 5 inches, 5 x 7 inches and 9 x 9 inches, the last being used primarily for mapping. Most of the work is done with black-and-white film developed by Eastman Kodak especially for aerial photography and cut in quantity to a special size for our company.

One of the questions we are asked most often is: "Who uses aerial photographs?" The greatest number of flying hours is spent photographing market areas before site-location decisions are made for supermarkets, retail stores, banks, service stations and restaurants. The photographs also have application in residential, commercial and industrial development, legal documenta-

tion, real-estate appraisal, engineering projects such as highway, bridge and railroad planning, and documentation for governmental and private usage.

Although many of the photographs that comprise this book were taken for these purposes, when they are brought together between covers a new picture emerges: that of the growth and organization of one of the most vital, rapidly changing and complex cities in the world. A close study of the photographs, taken between the 1940s and 1970s, reveals the social and economic changes in the city. The radical alteration of the Manhattan skyline reflects the building boom of the sixties. The inroads made by public housing on the Lower East Side is also obvious. Aerial views dramatize the skewed street plan of Greenwich Village—the result of the historic development of the area. The very shape of the island is changing: the Battery City landfill continues a pattern of expansion that began hundreds of years ago (Greenwich Avenue marks the original shoreline of Lower Manhattan).

Of the lifework of the thousands of generations that have preceded us, our evidence exists only in faded papers and sketches. This generation will leave behind clear documentation for future historians. Aerial photography, such as that presented on these pages, will provide an important part of the picture.

W.F.

NEW YORK IN
AERIAL VIEWS

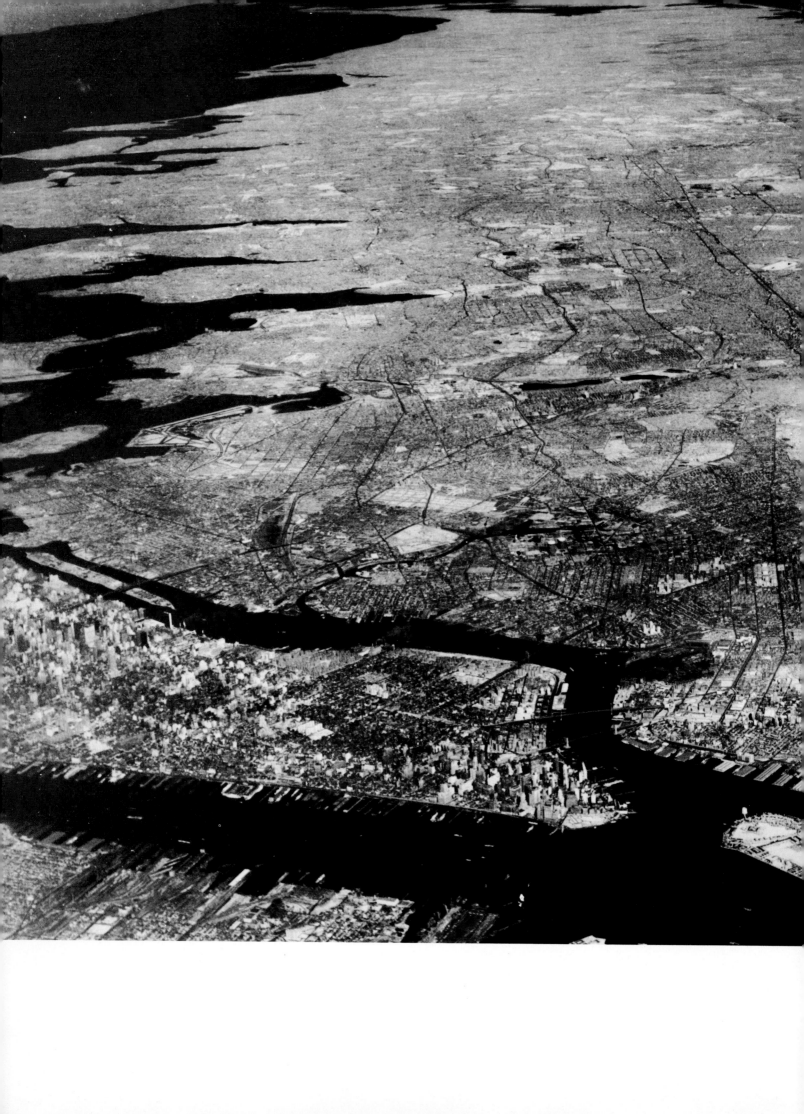

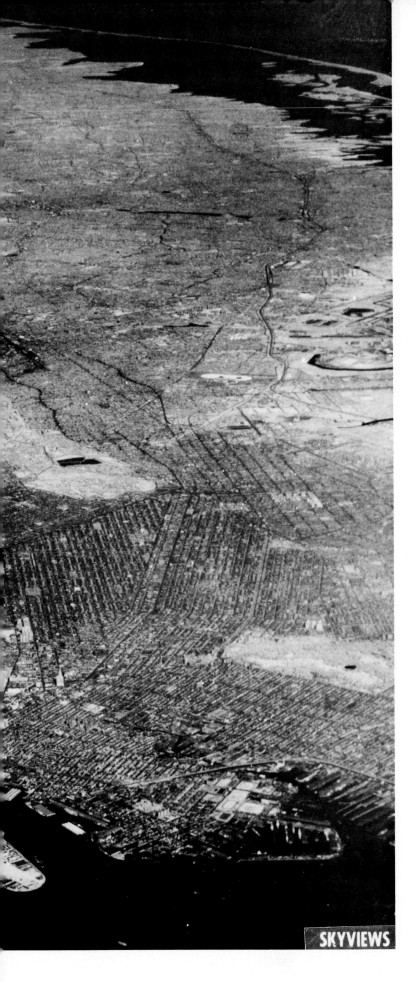

1

East across Long Island, from New Jersey, 1964

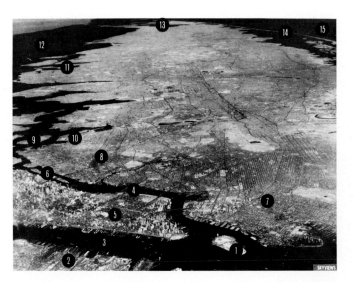

1 Governors Island.
2 Jersey City, New Jersey.
3 Hudson River.
4 East River.
5 Manhattan.
6 Roosevelt Island.
7 Brooklyn.
8 Queens.
9 Rikers Island.
10 La Guardia Airport.
11 Oyster Bay.
12 Long Island Sound.
13 Montauk Point.
14 Fire Island.
15 Atlantic Ocean.

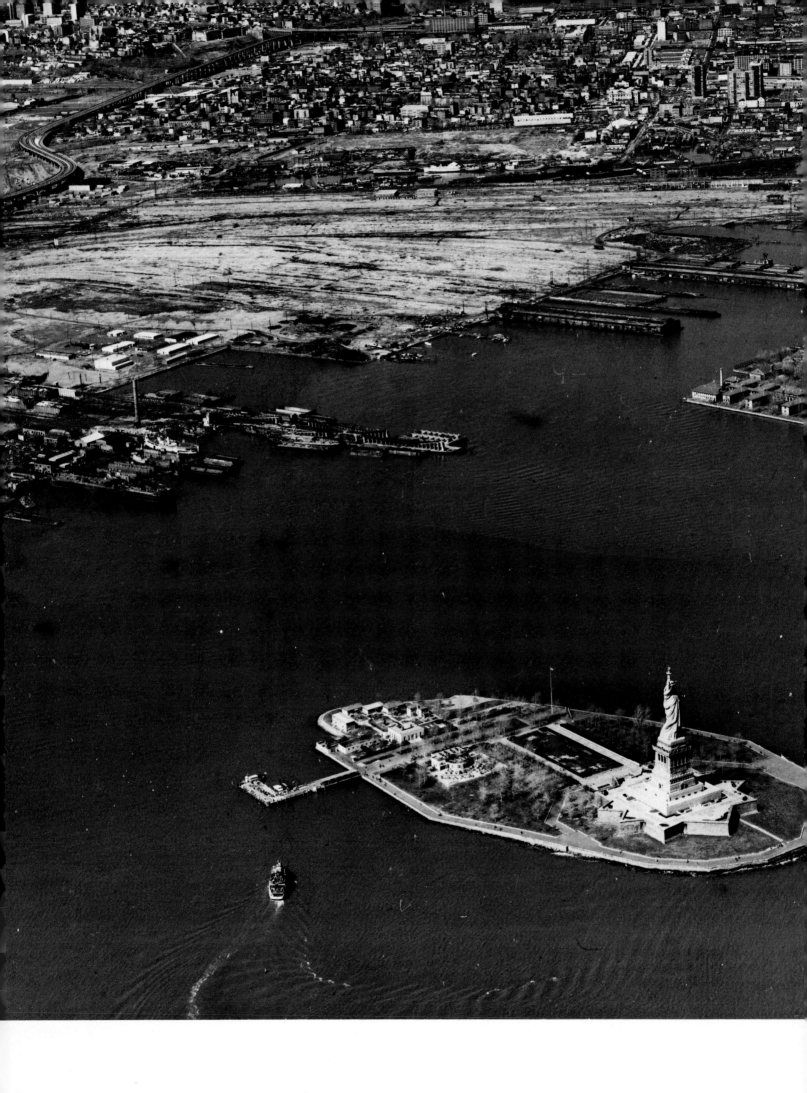

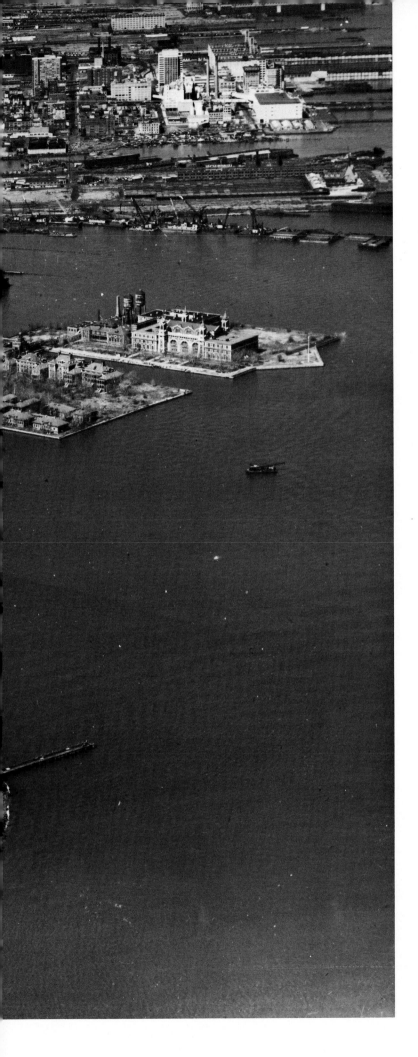

2
Northwest across Upper New York Bay, April 9, 1977

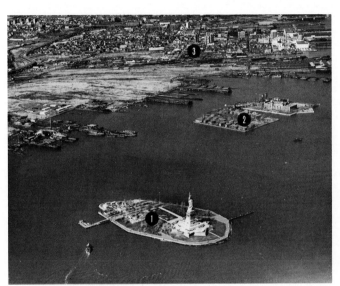

1 Liberty Island, with the Statue of Liberty.
2 Ellis Island.
3 Jersey City, New Jersey.

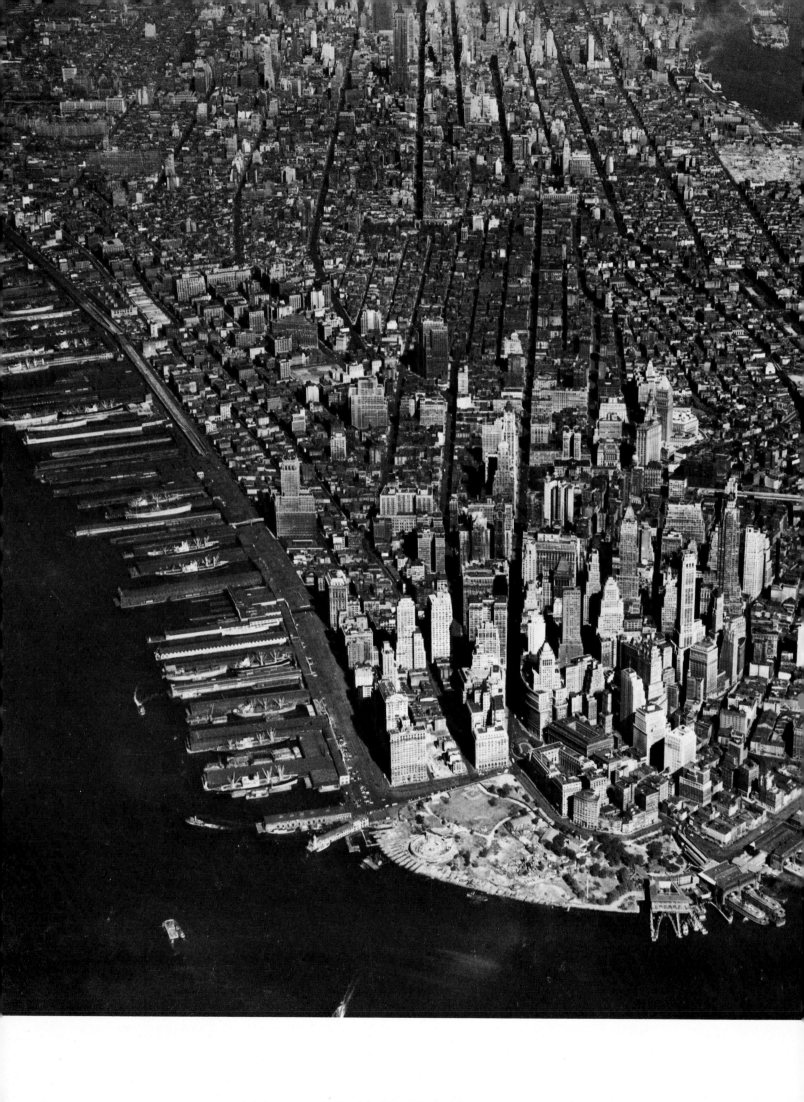

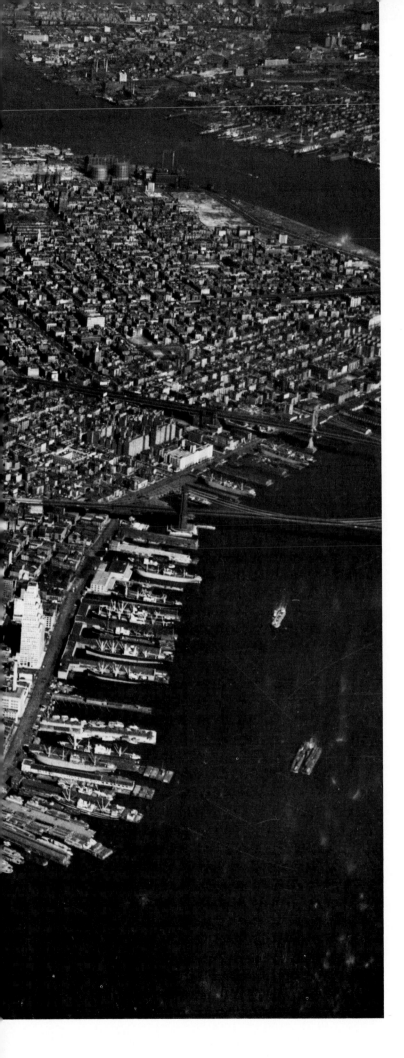

3
The southern half of Manhattan, north from
Upper New York Bay, October 13, 1946

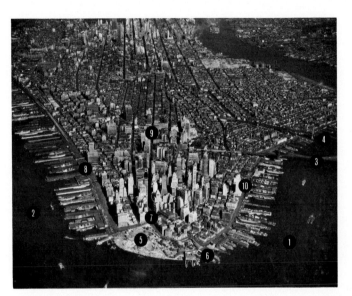

1 East River.
2 Hudson River.
3 Brooklyn Bridge.
4 Manhattan Bridge.
5 Battery Park.
6 Staten Island Ferry Terminal.
7 Bowling Green.
8 West Side Highway.
9 Broadway.
10 South Street.

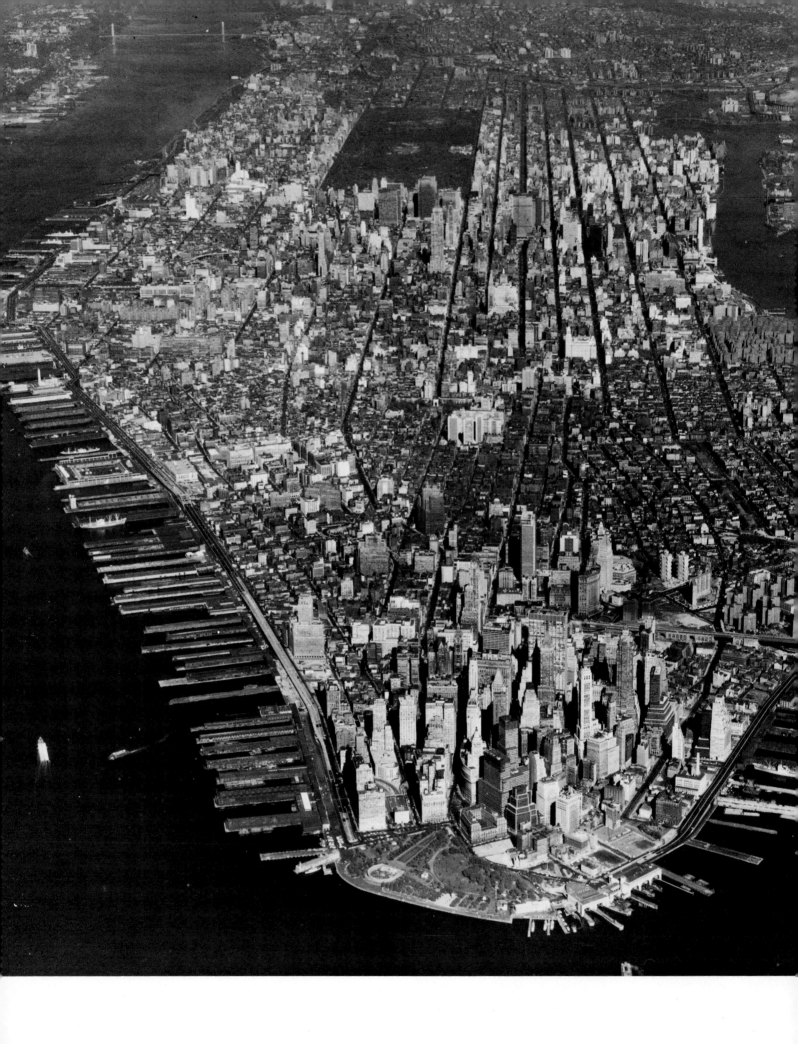

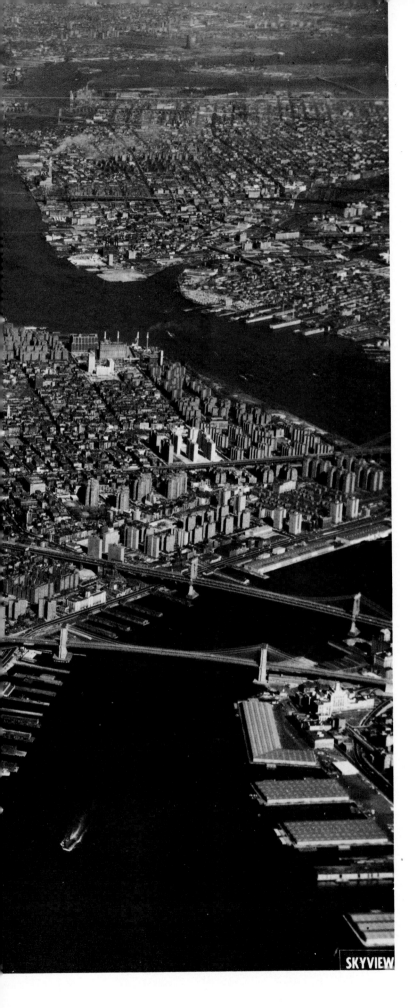

4
Manhattan, north from Upper New York Bay, October 30, 1966

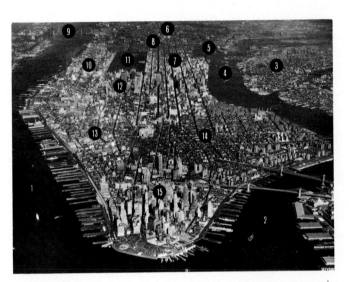

1 Hudson River.
2 East River.
3 Queens.
4 Roosevelt Island.
5 Ward's Island.
6 The Bronx.
7 Upper East Side.
8 Harlem.
9 George Washington Bridge.
10 Upper West Side.
11 Central Park.
12 Midtown.
13 Greenwich Village.
14 Lower East Side.
15 Financial District.

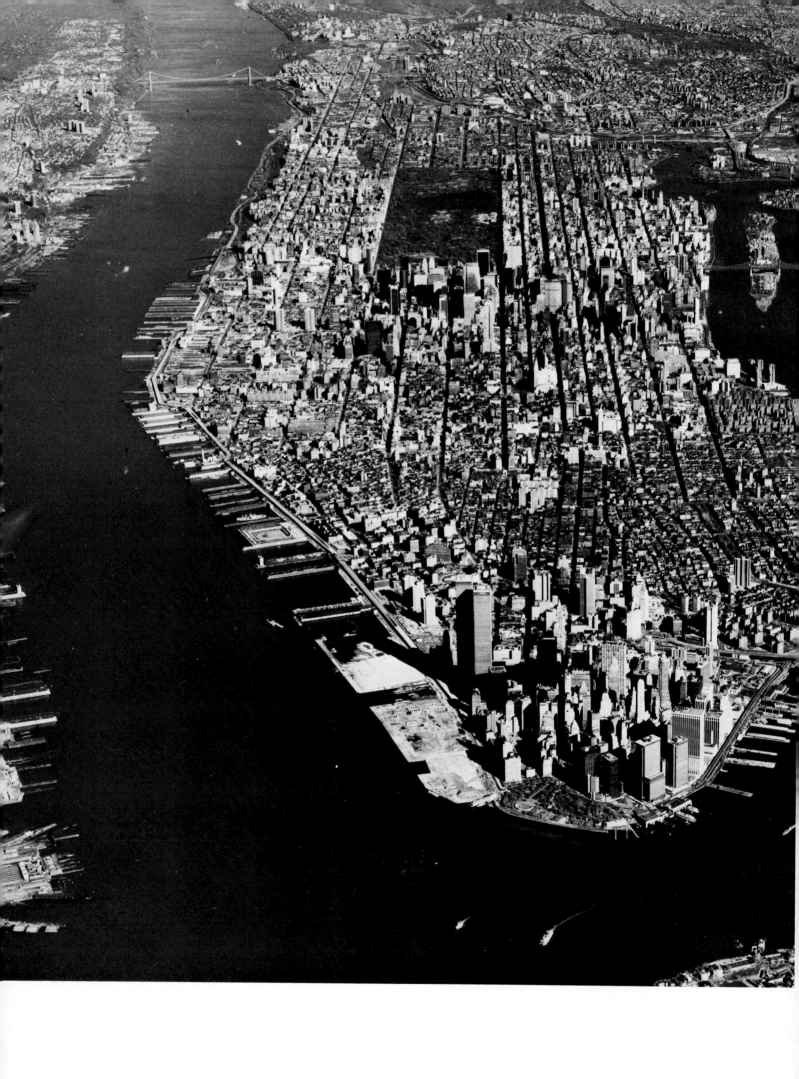

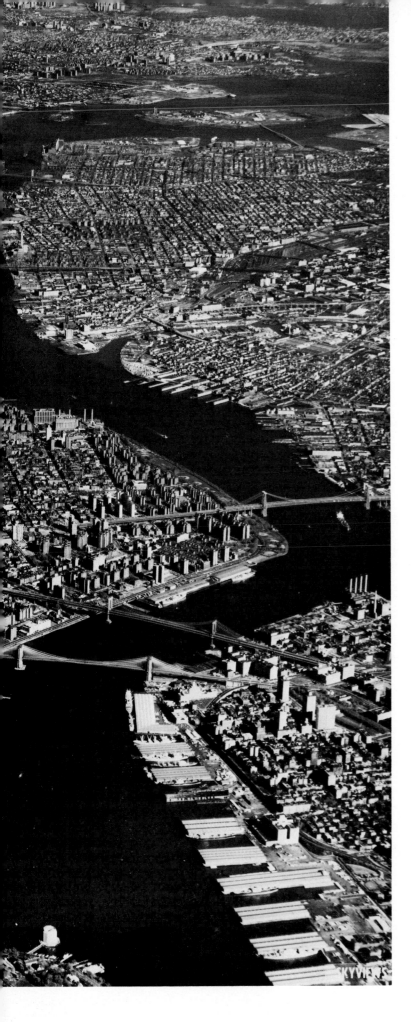

5

Manhattan, north from Upper New York Bay,
November 11, 1976

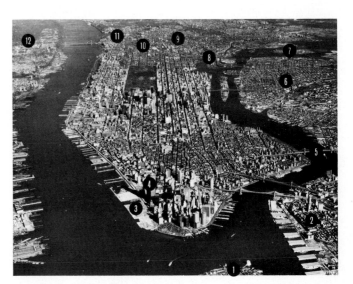

1 Governors Island.
2 Brooklyn Heights.
3 Battery Park City landfill.
4 World Trade Center.
5 Williamsburg Bridge.
6 Queens.
7 Rikers Island.
8 Triborough Bridge.
9 The Bronx.
10 Harlem River.
11 Washington Heights.
12 Ft. Lee, New Jersey.

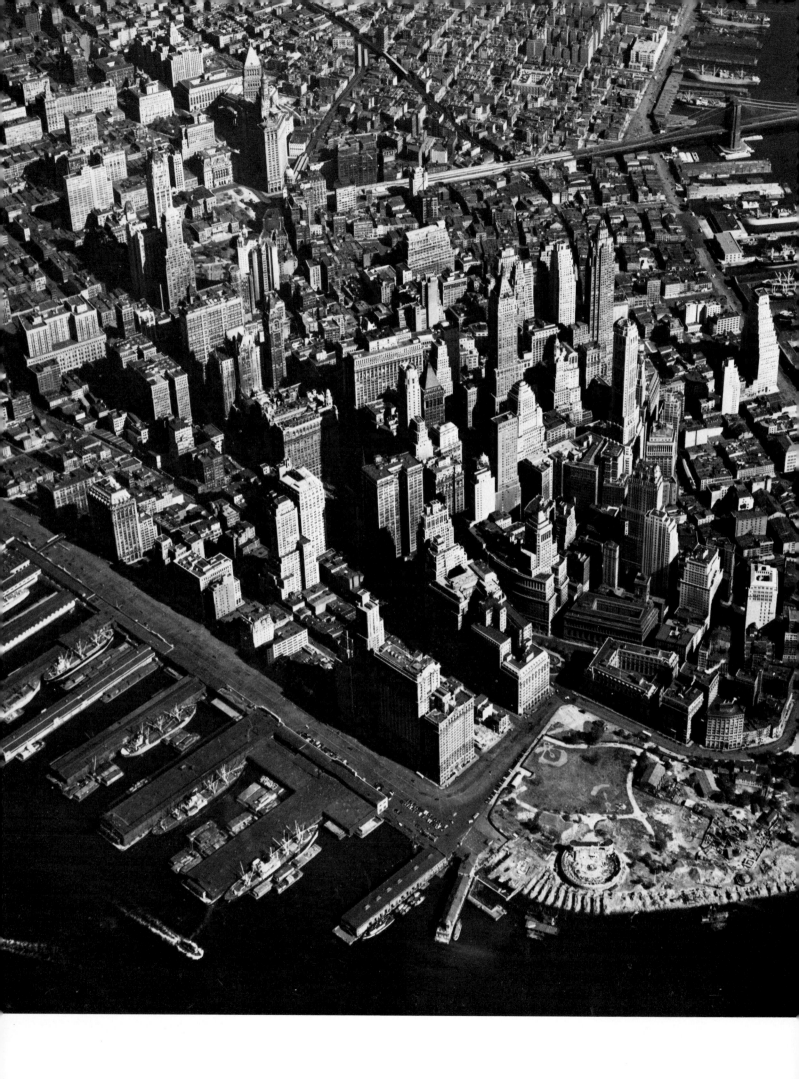

6
The southern tip of Manhattan, northeast toward the Brooklyn Bridge, October 13, 1946

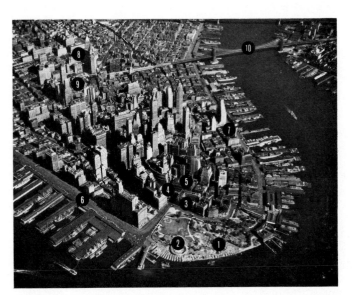

1 Battery Park.
2 Castle Clinton.
3 U.S. Custom House.
4 Bowling Green.
5 Produce Exchange.
6 West Side Highway.
7 South Street.
8 Civic Center.
9 City Hall.
10 Brooklyn Bridge.

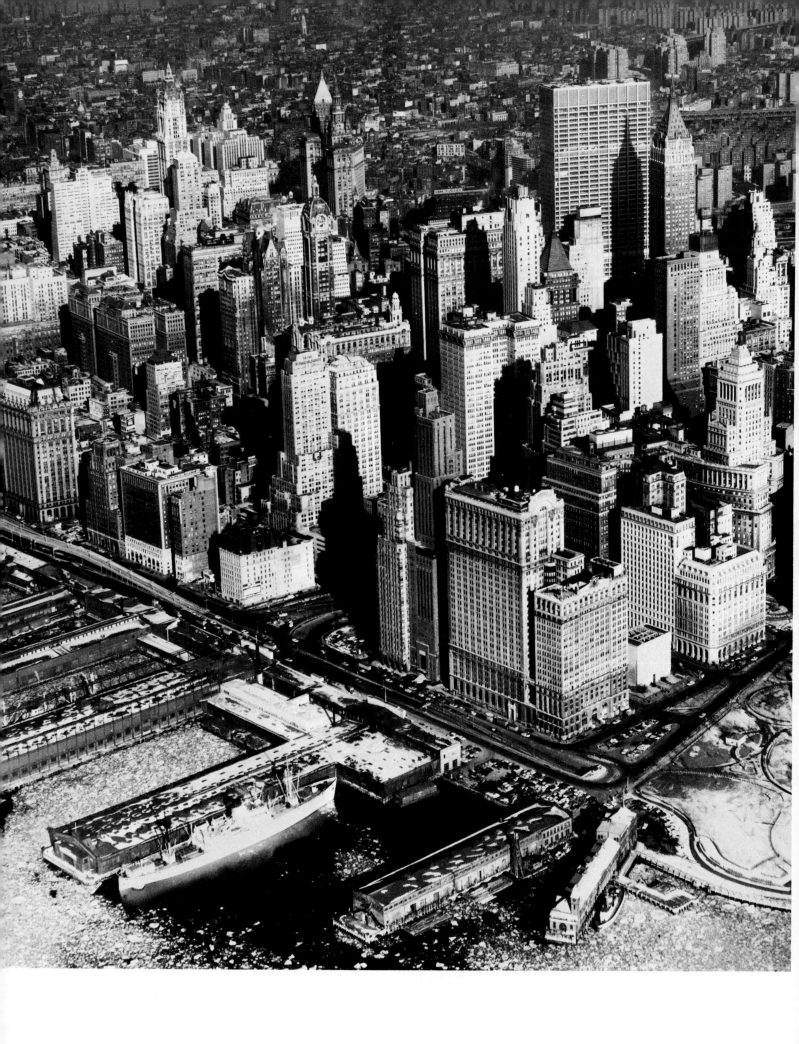

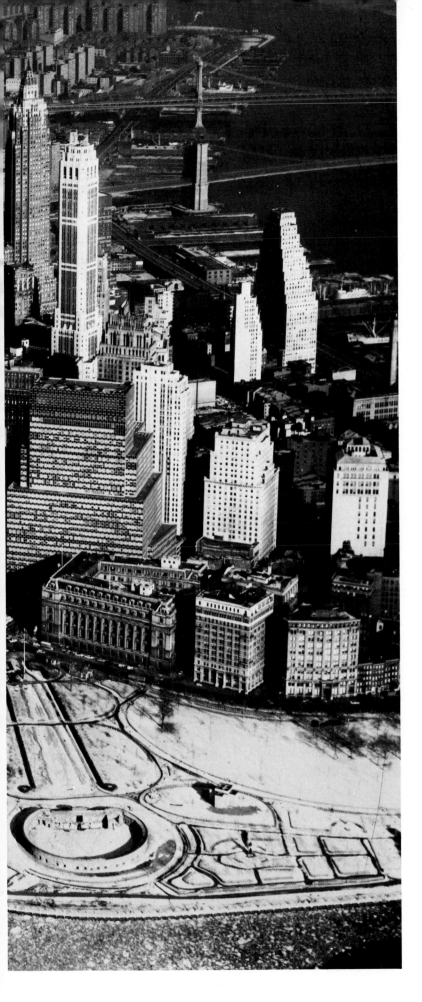

7
Southern Manhattan, east from Battery Park
and the West Side Highway, February 2, 1961

1 U.S. Custom House.
2 2 Broadway.
3 26 Broadway.
4 1 Broadway.
5 17 Battery Place.
6 Downtown Athletic Club.
7 21 West Street.
8 Citibank Tower.
9 60 Wall Tower.
10 Bank of New York Building.
11 Chase Manhattan Bank Building.
12 Woolworth Building.
13 Singer Building.
14 Pier A.

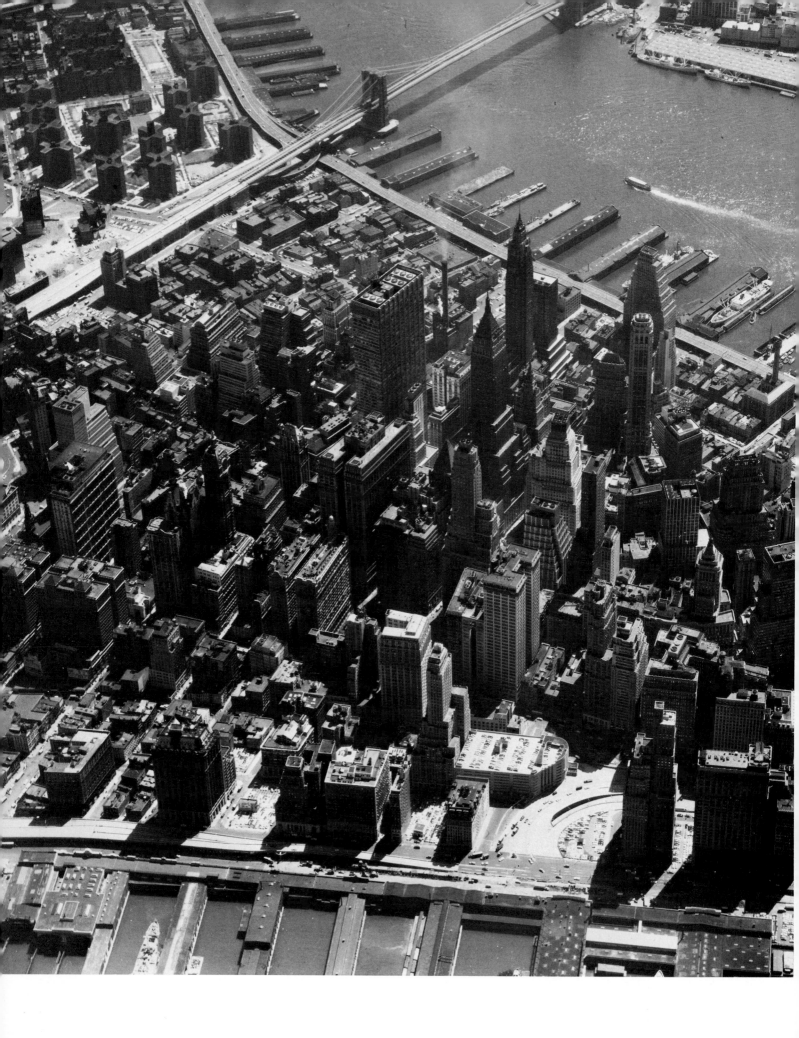

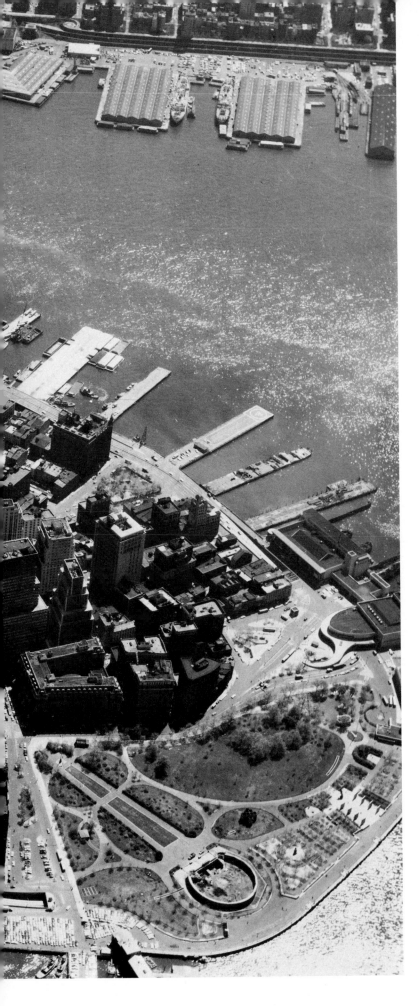

8
The Financial District, east from the Hudson River, May 3, 1963

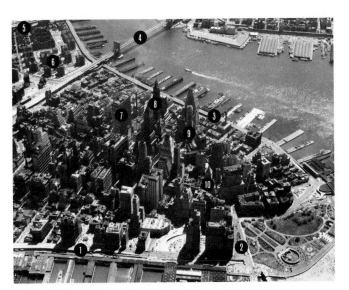

1 West Side Highway.
2 Battery Place.
3 South Street Viaduct.
4 Brooklyn Bridge.
5 Williamsburg Bridge.
6 Gov. Alfred E. Smith Houses.
7 Chase Manhattan Bank Building.
8 60 Wall Tower.
9 Citibank Tower.
10 26 Broadway.

9
Directly over the heart of the Financial District,
May 23, 1972

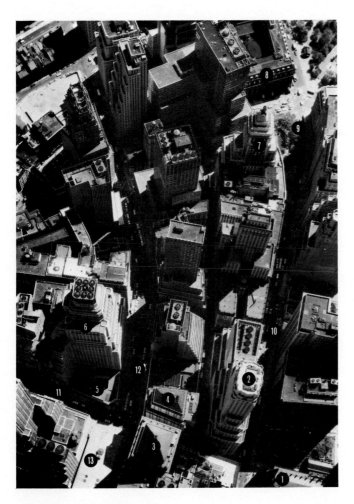

1 Trinity Church.
2 Irving Trust Company.
3 Bankers Trust Tower.
4 New York Stock Exchange.
5 Morgan Guaranty Trust Company.
6 15 Broad Street Building.
7 27 Broadway Building.
8 U.S. Custom House.
9 Bowling Green.
10 Broadway.
11 Wall Street.
12 Broad Street.
13 Federal Hall National Memorial.

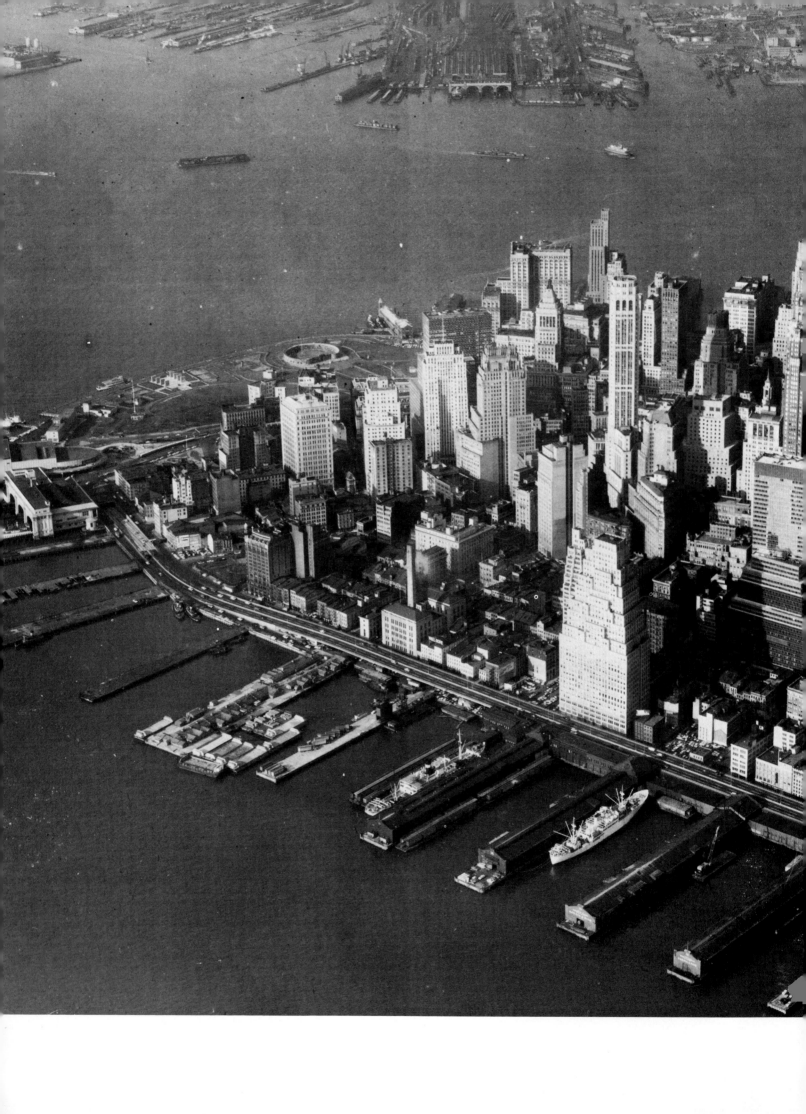

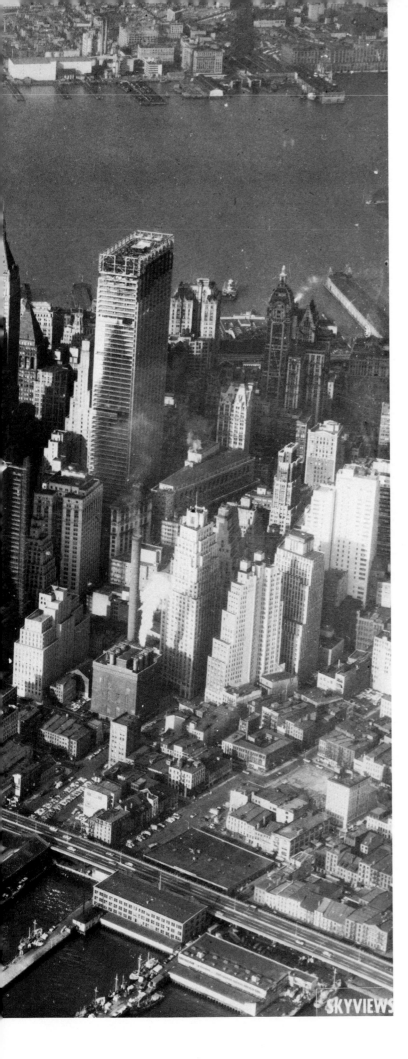

10
West across the southern tip of Manhattan,
January 25, 1960

1 120 Wall Street.
2 Citibank Tower.
3 Ferry slips.
4 Chase Manhattan Bank Building.
5 Franklin D. Roosevelt (East River) Drive.
6 Hudson River.
7 East River.
8 Battery Park.
9 60 Broad Street Building.
10 Fulton Fish Market.
11 Beekman Street.
12 Jersey City, New Jersey.

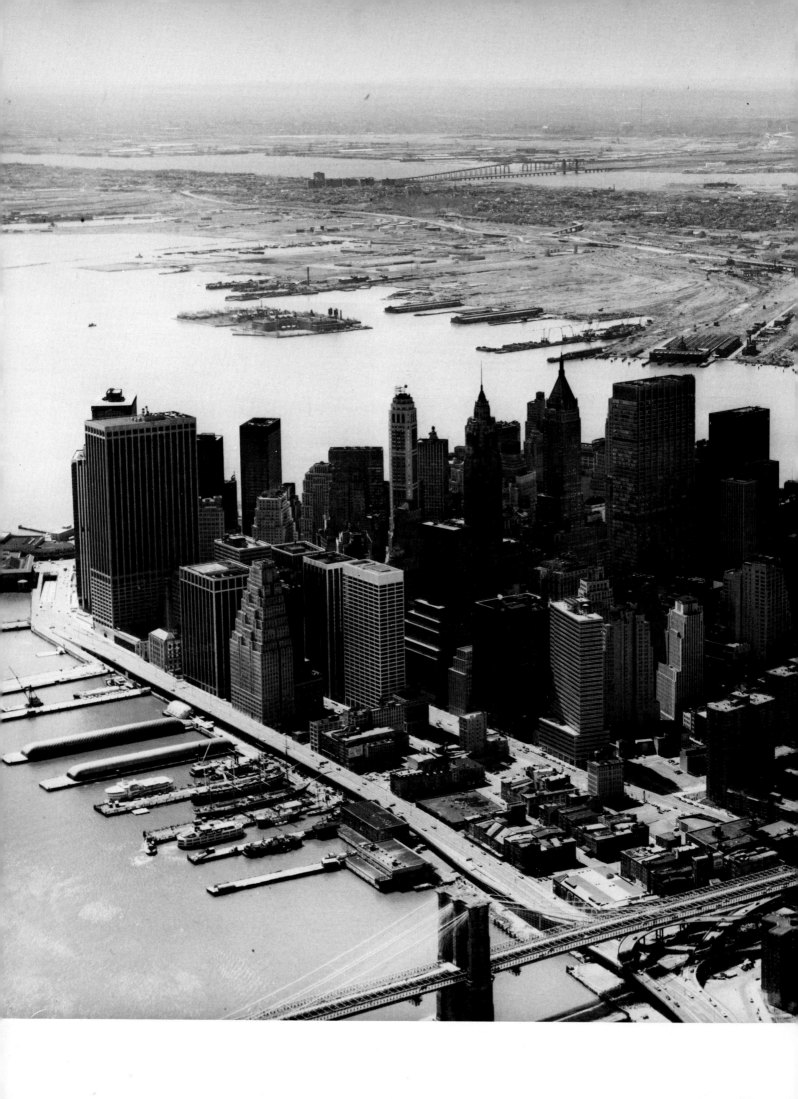

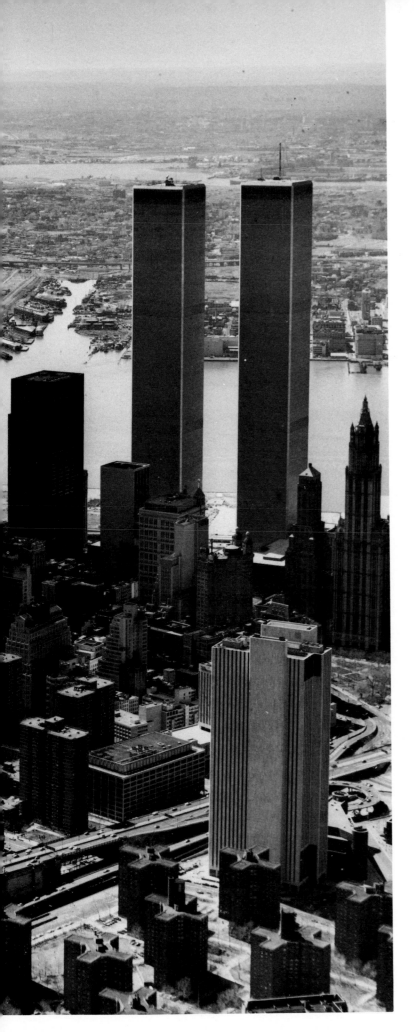

11
West over southern Manhattan, April 9, 1977

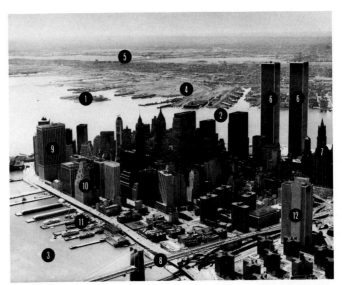

1 Ellis Island.
2 Hudson River.
3 East River.
4 Jersey City, New Jersey.
5 Newark Bay.
6 World Trade Center.
7 Woolworth Building.
8 Brooklyn Bridge.
9 55 Water Street.
10 120 Wall Street.
11 South Street Seaport.
12 New York Telephone Building.

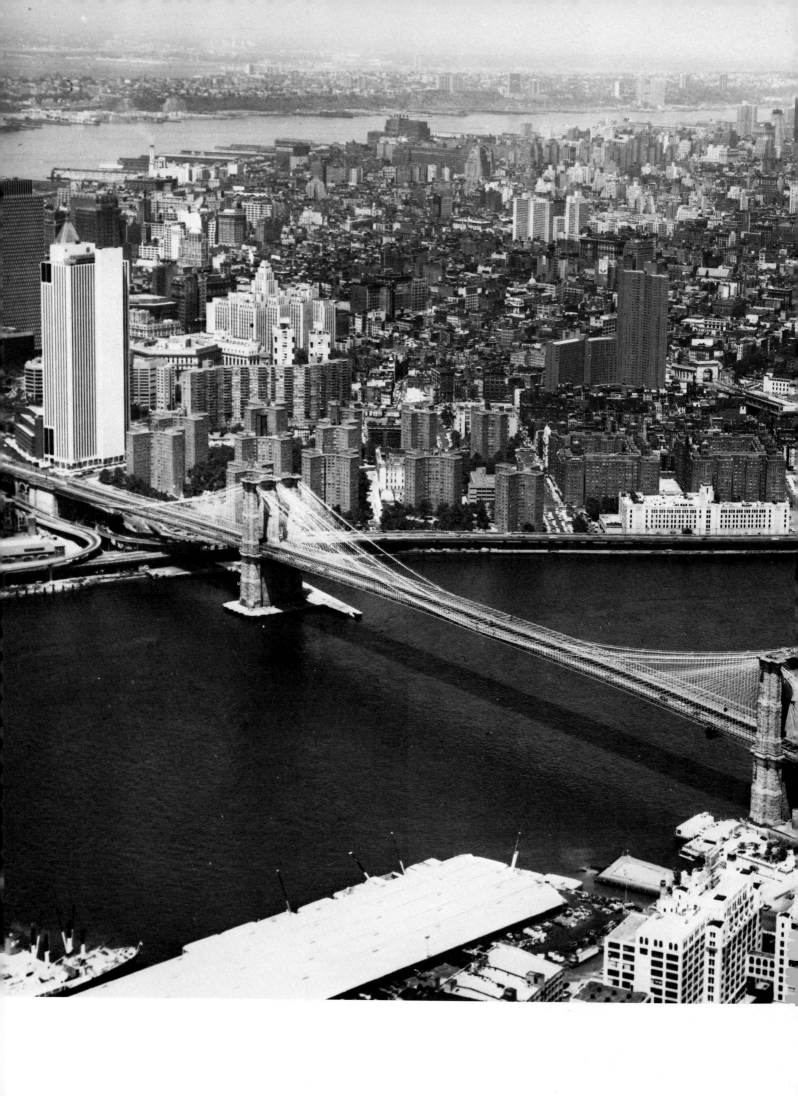

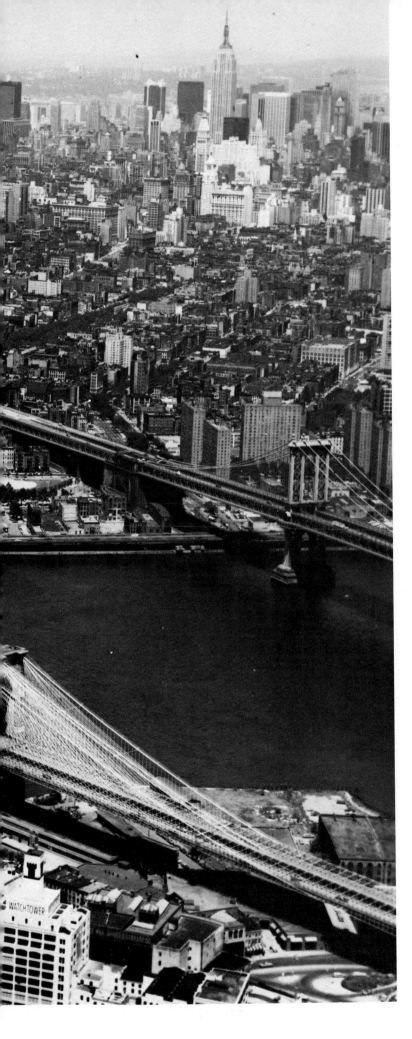

12
Northwest across Manhattan from the East River, July 15, 1977

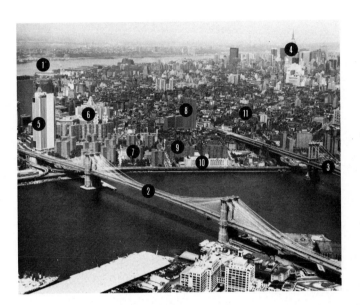

1 Hudson River.
2 Brooklyn Bridge.
3 Manhattan Bridge.
4 Empire State Building.
5 New York Telephone Building.
6 Criminal Court Building.
7 Gov. Alfred E. Smith Houses.
8 10–20 Confucius Plaza Apartments.
9 Knickerbocker Village.
10 New York Post Building.
11 Sara D. Roosevelt Parkway.

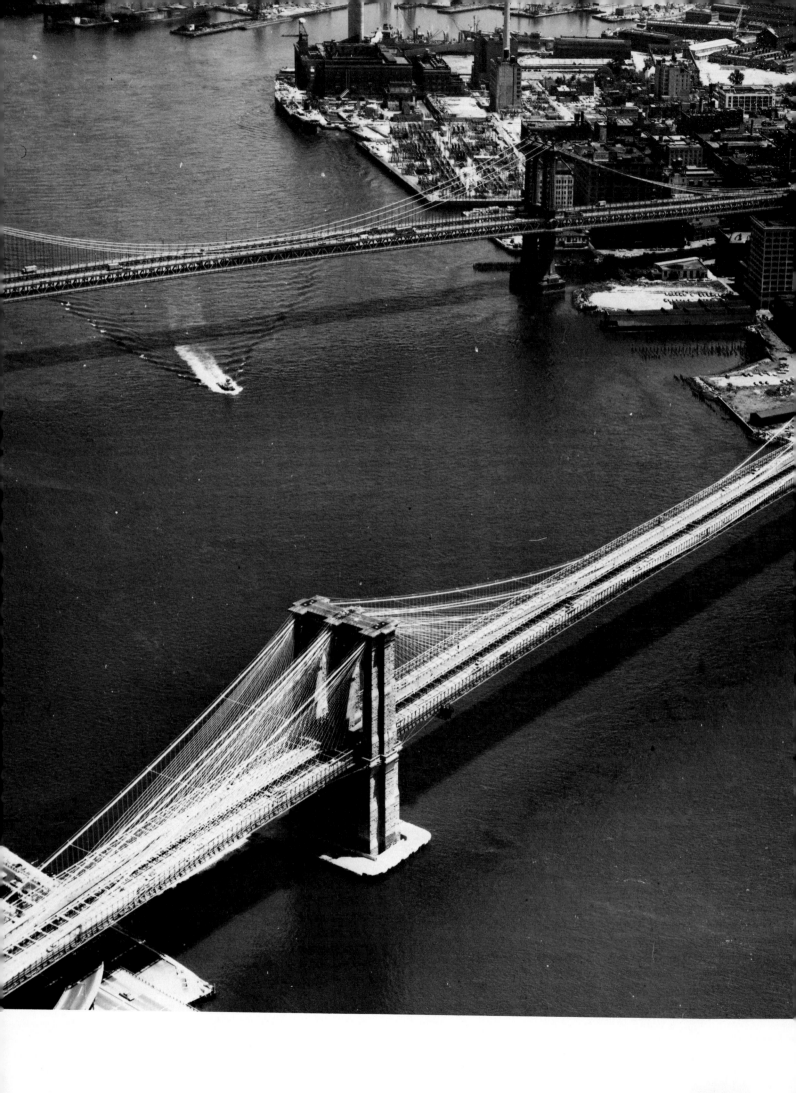

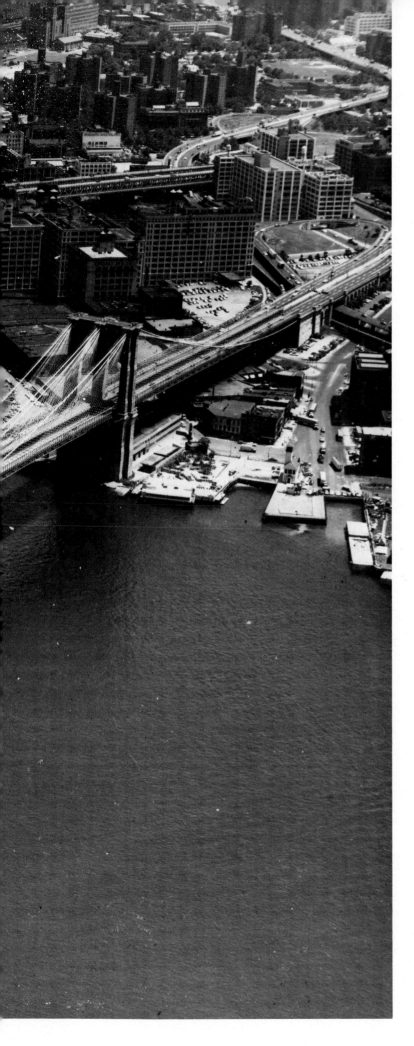

13
Above the East River, July 15, 1977

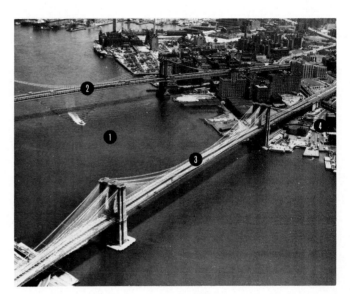

1 East River.
2 Manhattan Bridge.
3 Brooklyn Bridge.
4 Brooklyn Heights.

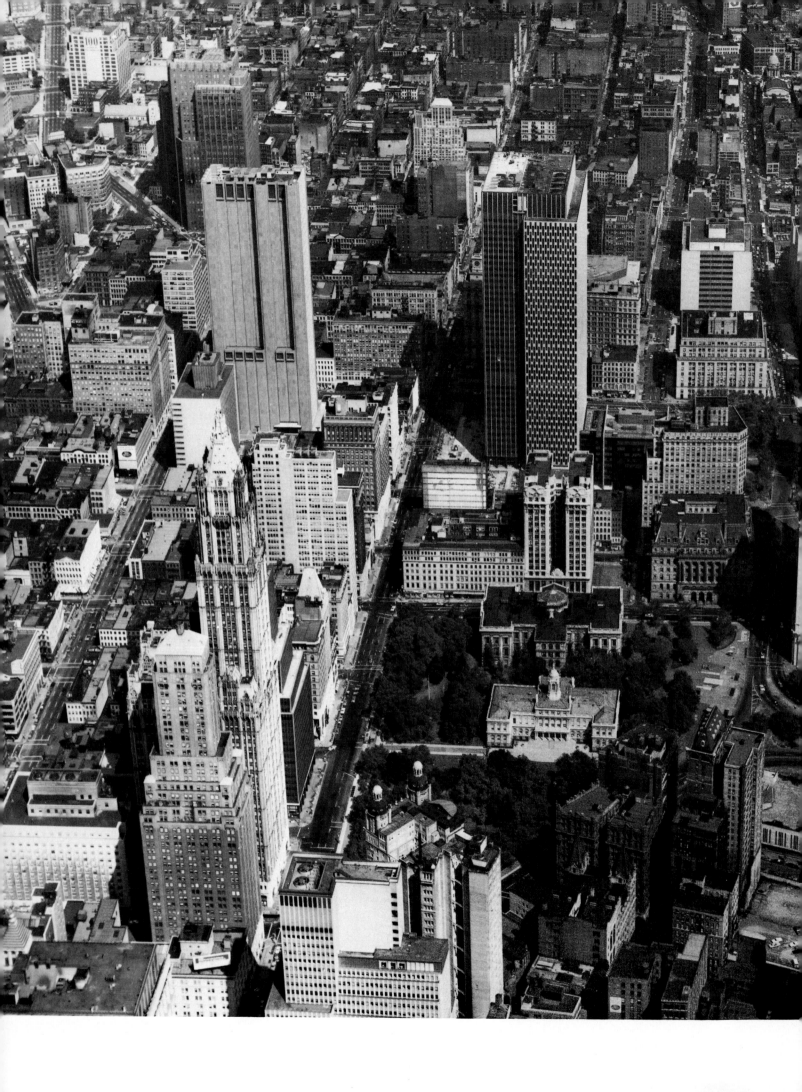

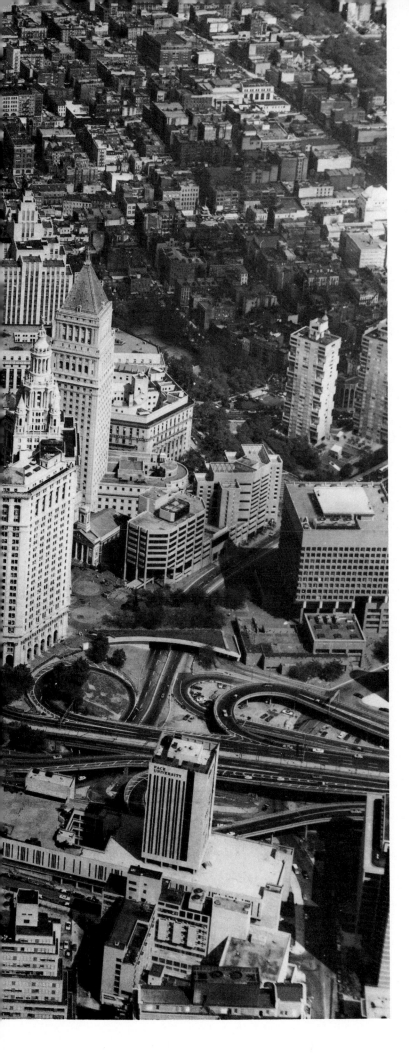

14
The Civic Center, north from City Hall,
September 19, 1976

1 Varick Street.
2 Canal Street.
3 Church Street.
4 Broadway.
5 New York Telephone Building.
6 Woolworth Building.
7 Transportation Building.
8 Pace University.
9 Municipal Building.
10 City Hall.
11 Tweed Courthouse.
12 United States Courthouse.
13 Criminal Court Building.
14 Federal Office Building.
15 Hall of Records.
16 Police Headquarters.

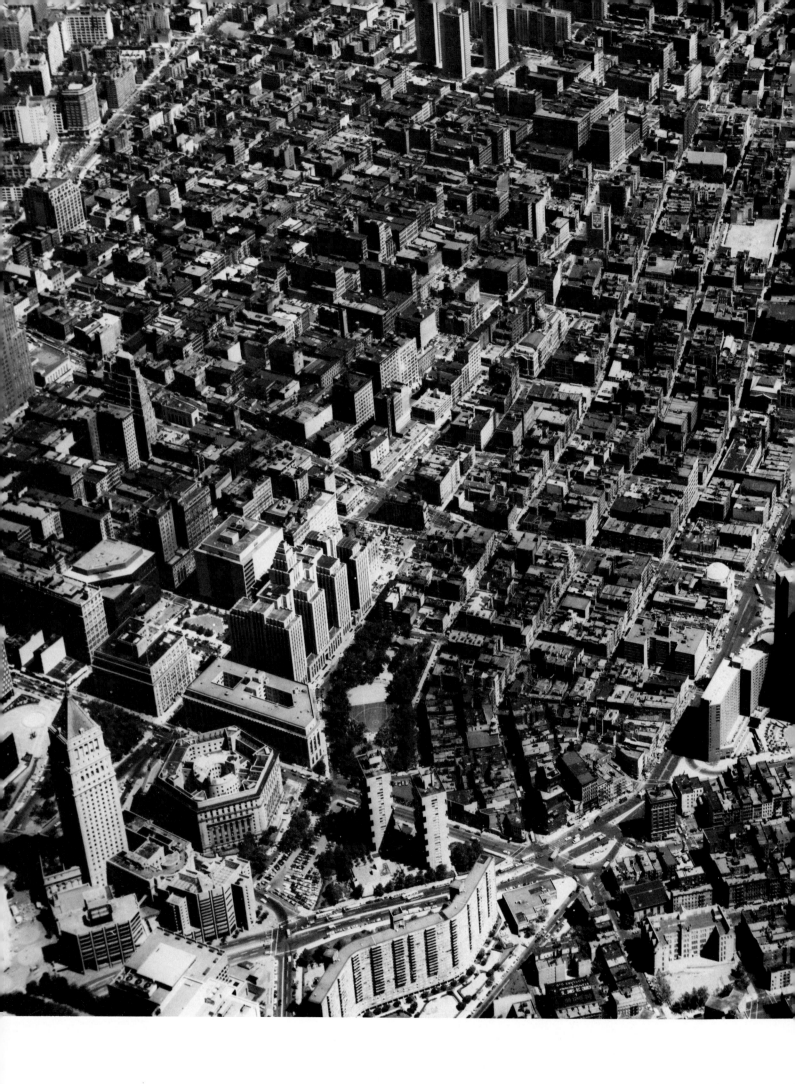

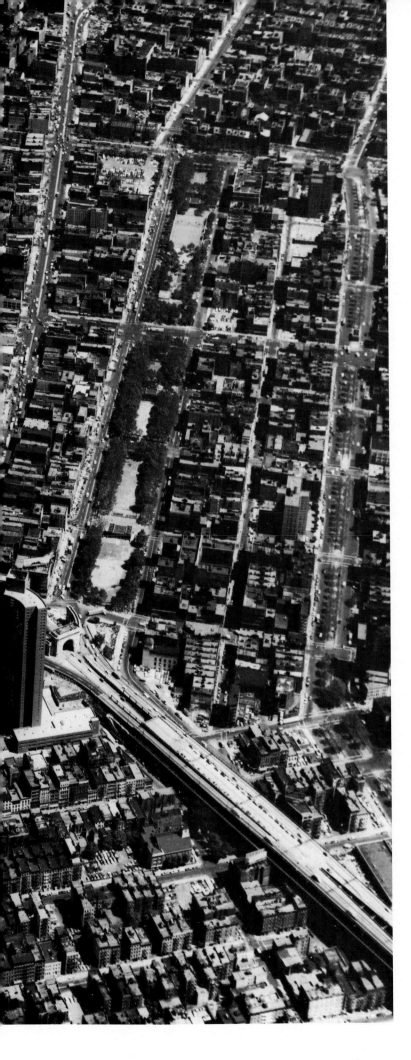

15
The center of lower Manhattan, north from the
Civic Center, June 15, 1978

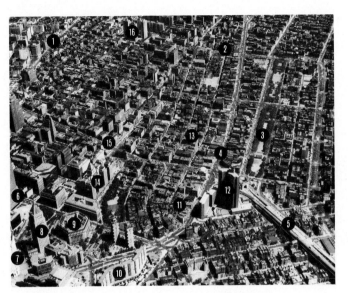

1 Avenue of the Americas (Sixth Avenue).
2 East Houston Street.
3 Sara D. Roosevelt Parkway.
4 The Bowery.
5 Manhattan Bridge.
6 U.S. Customs Court, Federal Office Building.
7 Municipal Building.
8 U.S. Courthouse.
9 New York County Courthouse.
10 Chatham Green Houses.
11 Chinatown.
12 Confucius Plaza Apartments.
13 Little Italy.
14 Criminal Court Building.
15 Canal Street.
16 University Village.

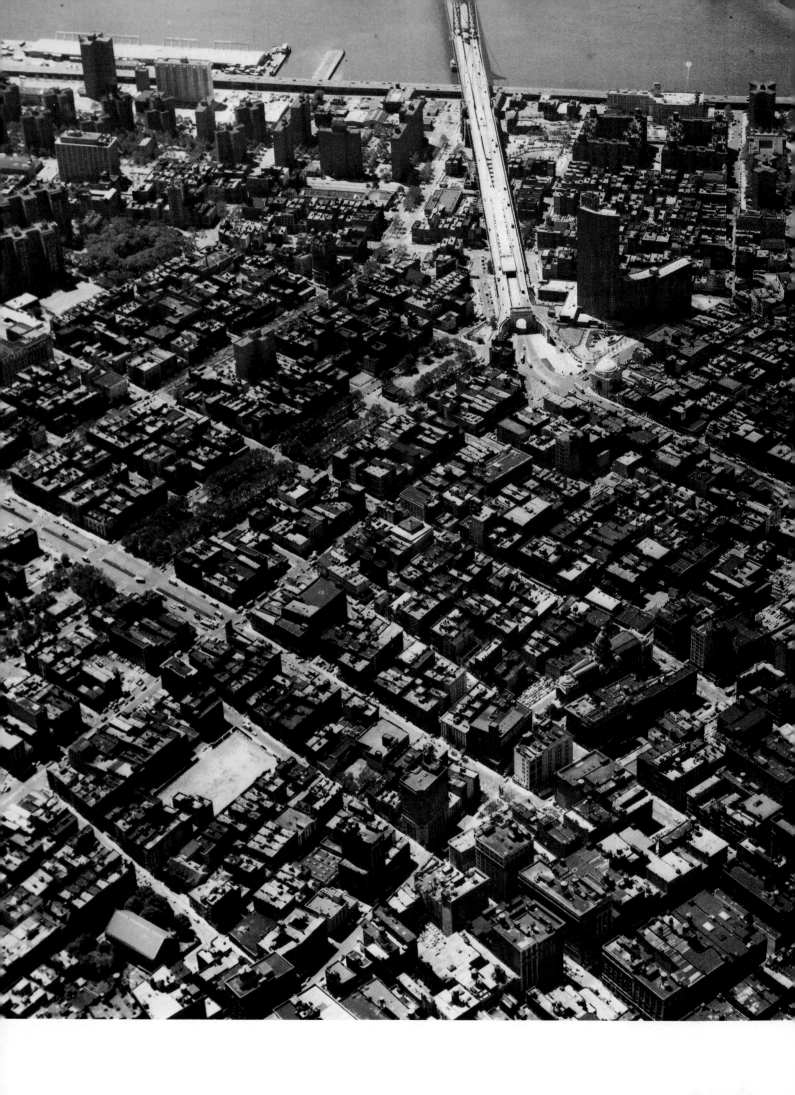

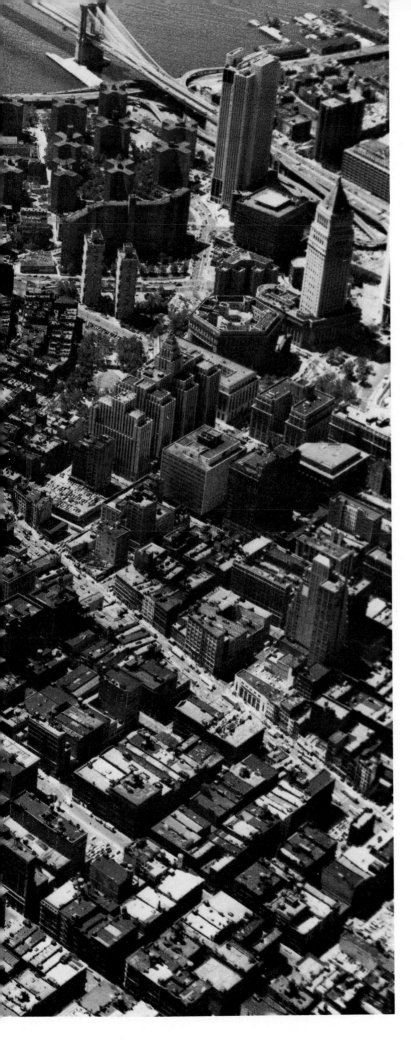

16
Southeast over the Lower East Side from Prince Street, June 15, 1978

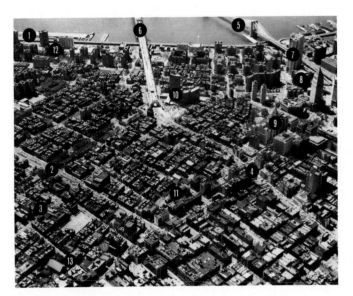

1 South Street Viaduct.
2 Delancey Street.
3 The Bowery.
4 Canal Street.
5 Brooklyn Bridge.
6 Manhattan Bridge.
7 New York Telephone Building.
8 Police Headquarters.
9 Criminal Court Building.
10 Confucius Plaza Apartments.
11 Former Police Headquarters.
12 La Guardia Houses.
13 Prince Street.

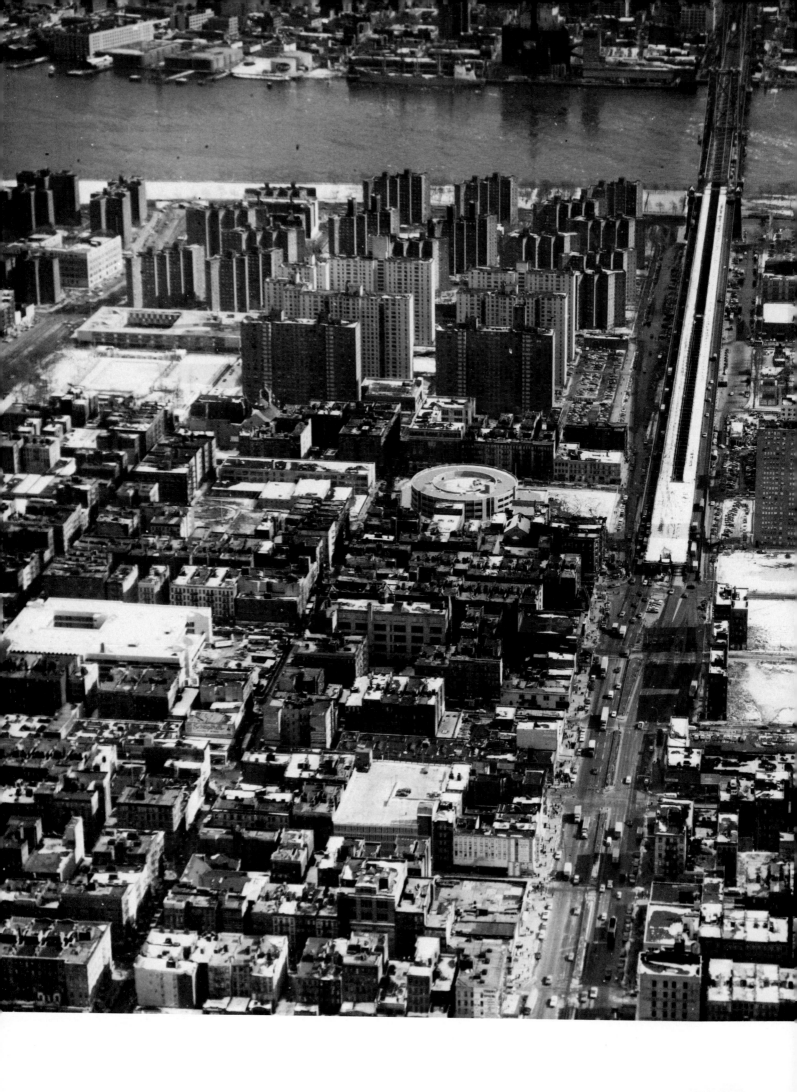

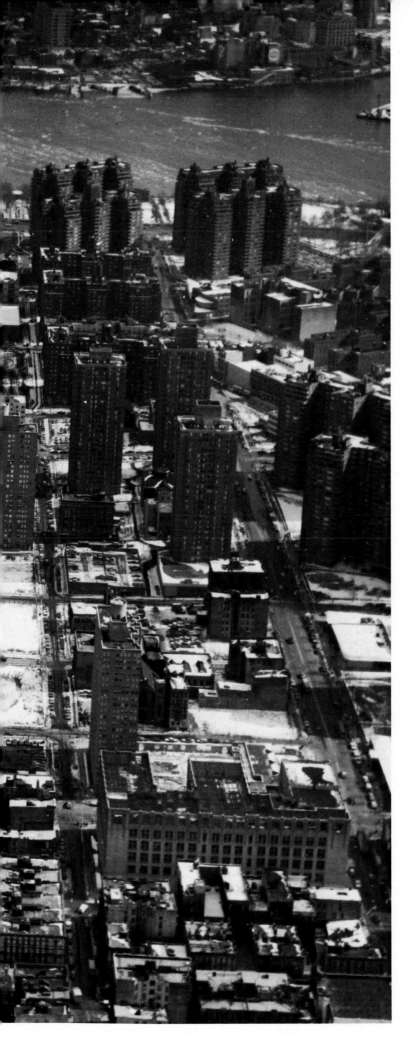

17
The Lower East Side, east to Brooklyn,
February 10, 1976

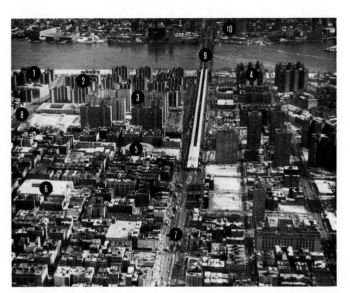

1 Lillian Wald Houses.
2 Baruch Houses.
3 Masaryk Towers.
4 Corlears Hook Apartments.
5 Primary School No. 142.
6 Intermediate School No. 25.
7 Delancey Street.
8 East Houston Street.
9 Williamsburg Bridge.
10 Williamsburg, Brooklyn.

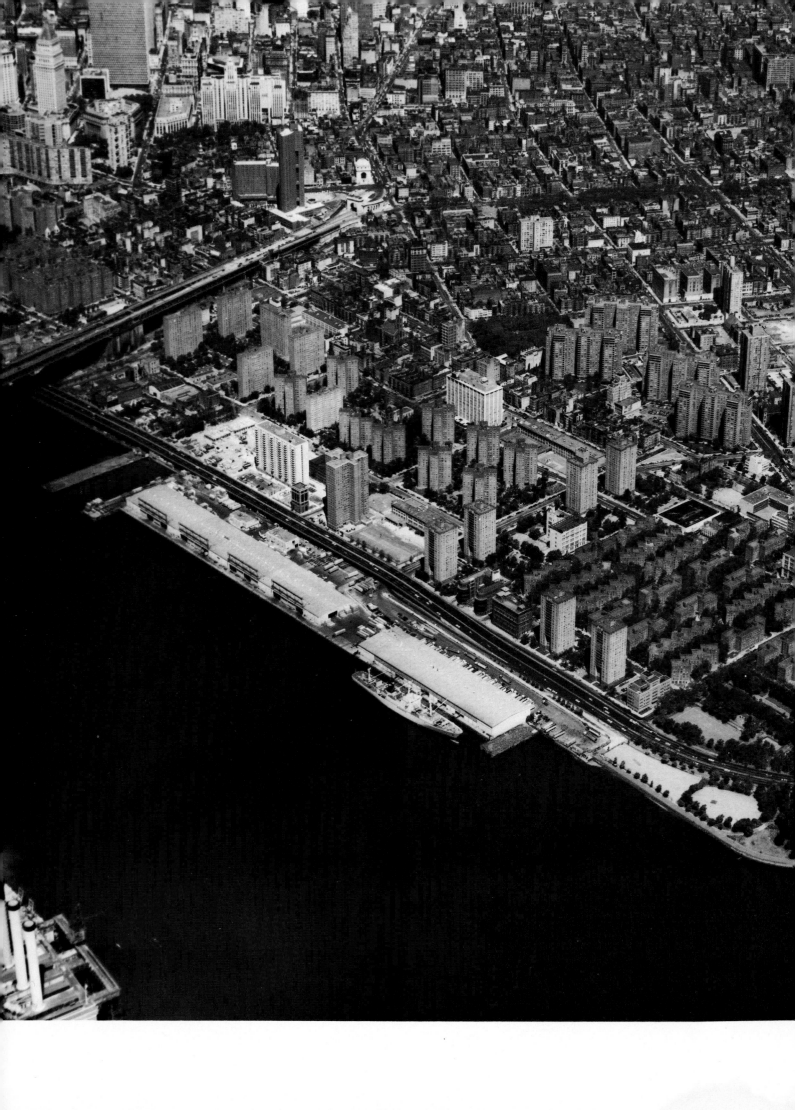

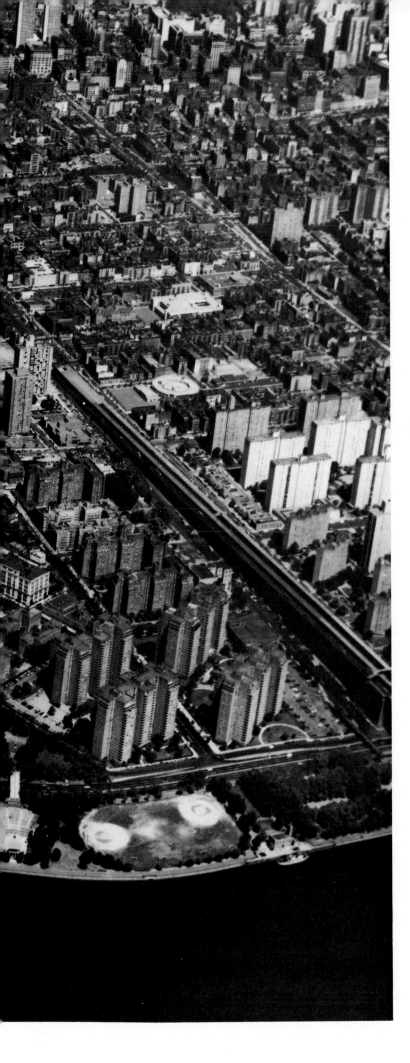

18

The Lower East Side, southwest from the East River, June 15, 1978

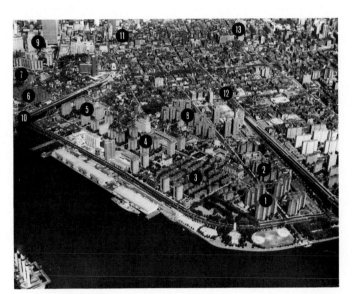

1 Corlears Hook Apartments.
2 Hillman Houses.
3 Vladeck Houses.
4 La Guardia Houses.
5 Rutgers Houses.
6 Knickerbocker Village.
7 Gov. Alfred E. Smith Houses.
8 Seward Park Houses.
9 Civic Center.
10 Manhattan Bridge.
11 Canal Street.
12 Delancey Street.
13 University Village.

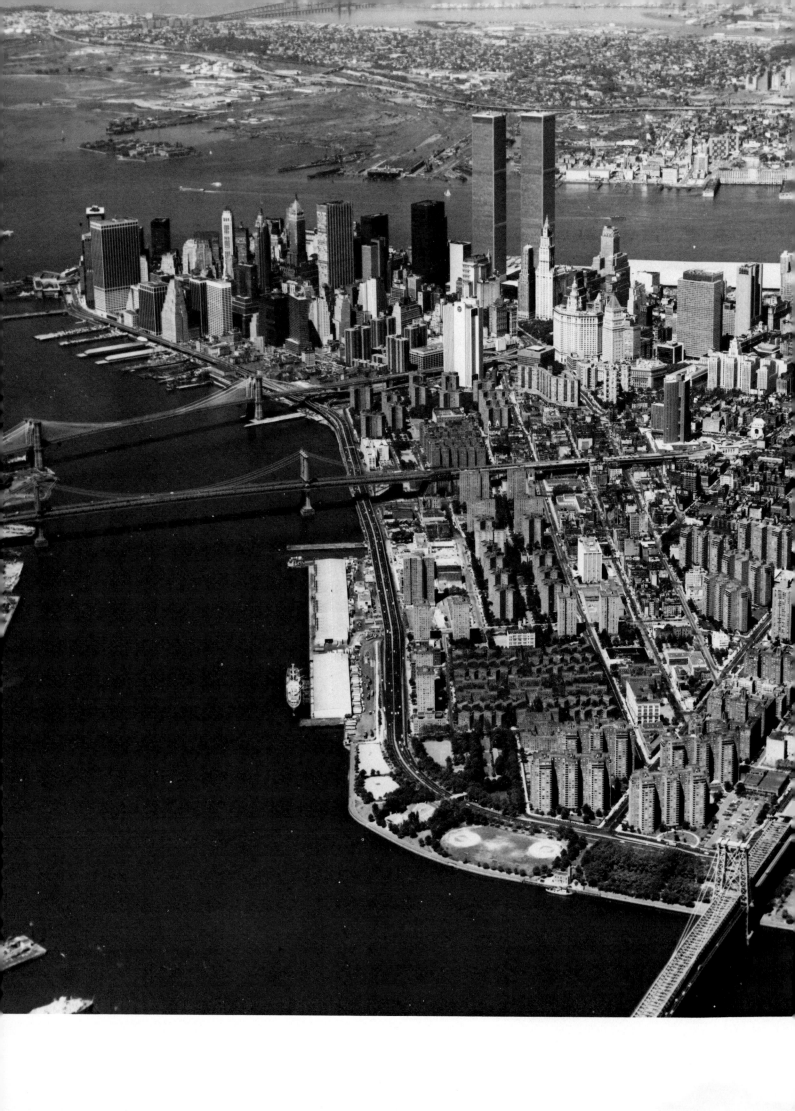

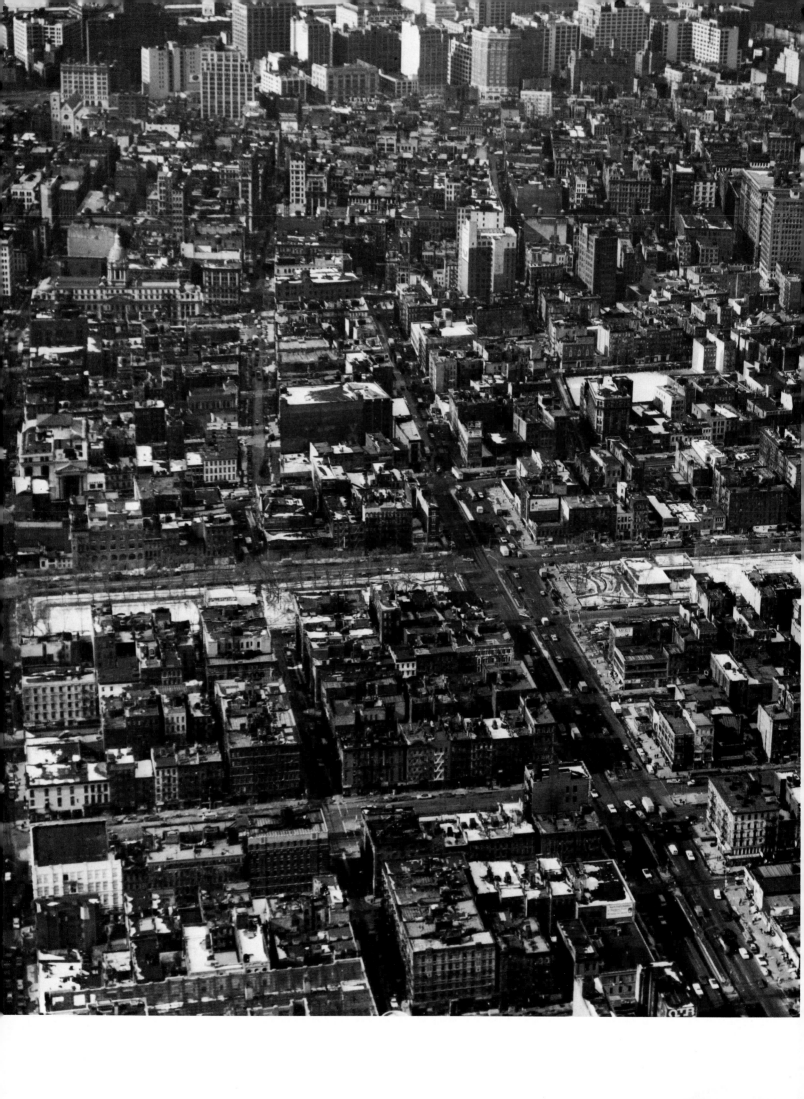

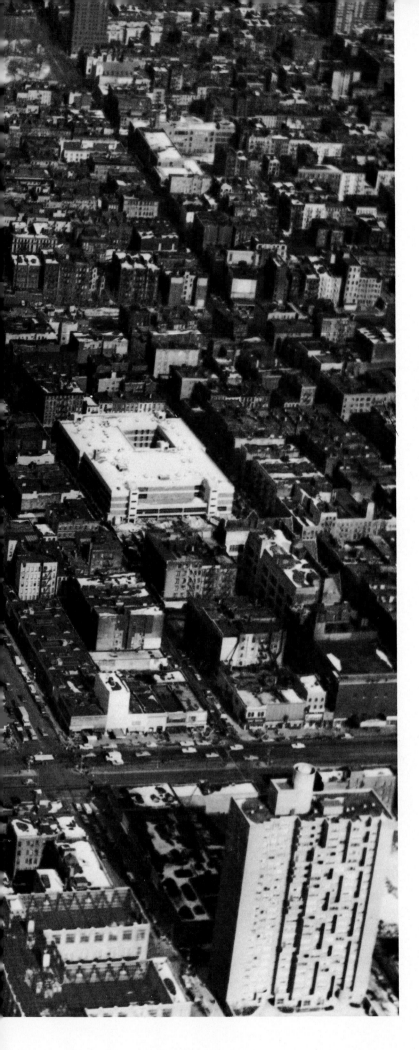

20
The Lower East Side, north across Delancey Street, February 10, 1976

1 Allen Street.
2 First Avenue.
3 East 10th Street.
4 Tompkins Square Park.
5 Avenue B.
6 Avenue A.
7 Essex Street.
8 Orchard Street.
9 Delancey Street.
10 Most Holy Redeemer R.C. Church.
11 Intermediate School No. 25.
12 Seward Park Houses.

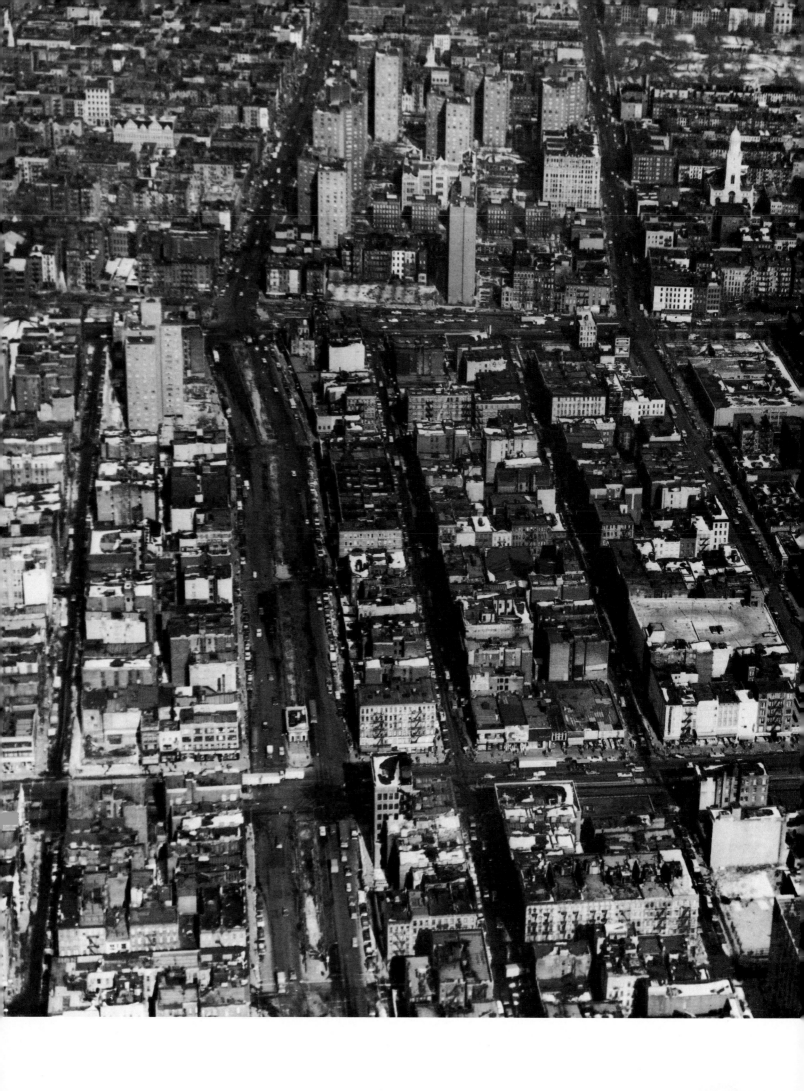

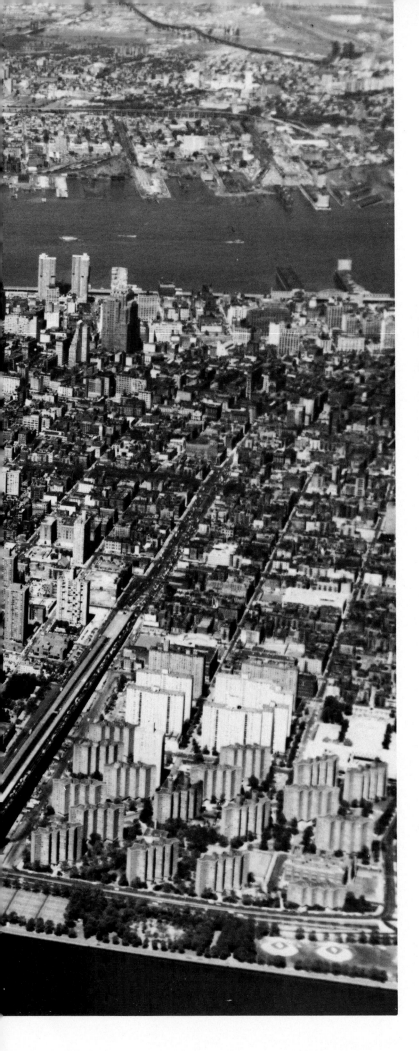

19
West across lower Manhattan, June 15, 1978

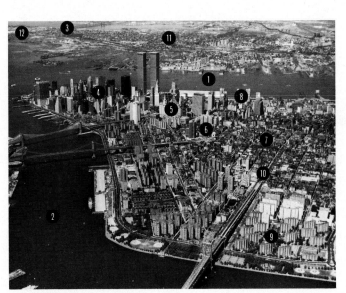

1 Hudson River.
2 East River.
3 Newark Bay.
4 Financial District.
5 Civic Center.
6 Chinatown.
7 Little Italy.
8 Independence Plaza North.
9 Baruch Houses.
10 Delancey Street.
11 Jersey City, New Jersey.
12 Bayonne, New Jersey.

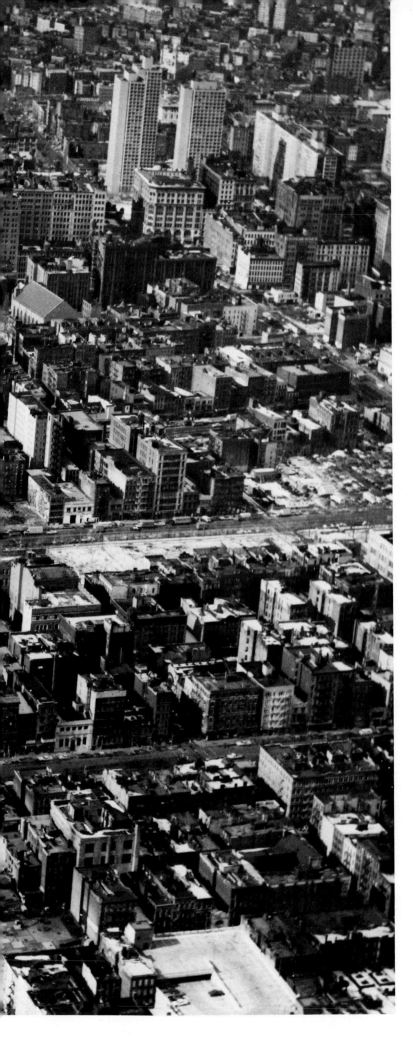

21
The Lower East Side, west across Allen Street,
February 10, 1976

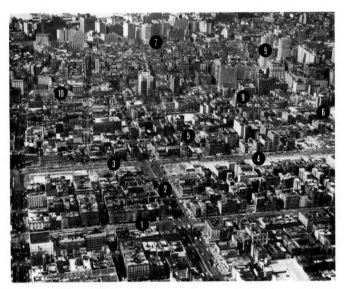

1 Allen Street.
2 Delancey Street.
3 Chrystie Street.
4 Sara D. Roosevelt Parkway.
5 The Bowery.
6 East Houston Street.
7 Avenue of the Americas (Sixth Avenue).
8 University Village.
9 Old St. Patrick's Cathedral.
10 Former Police Headquarters.

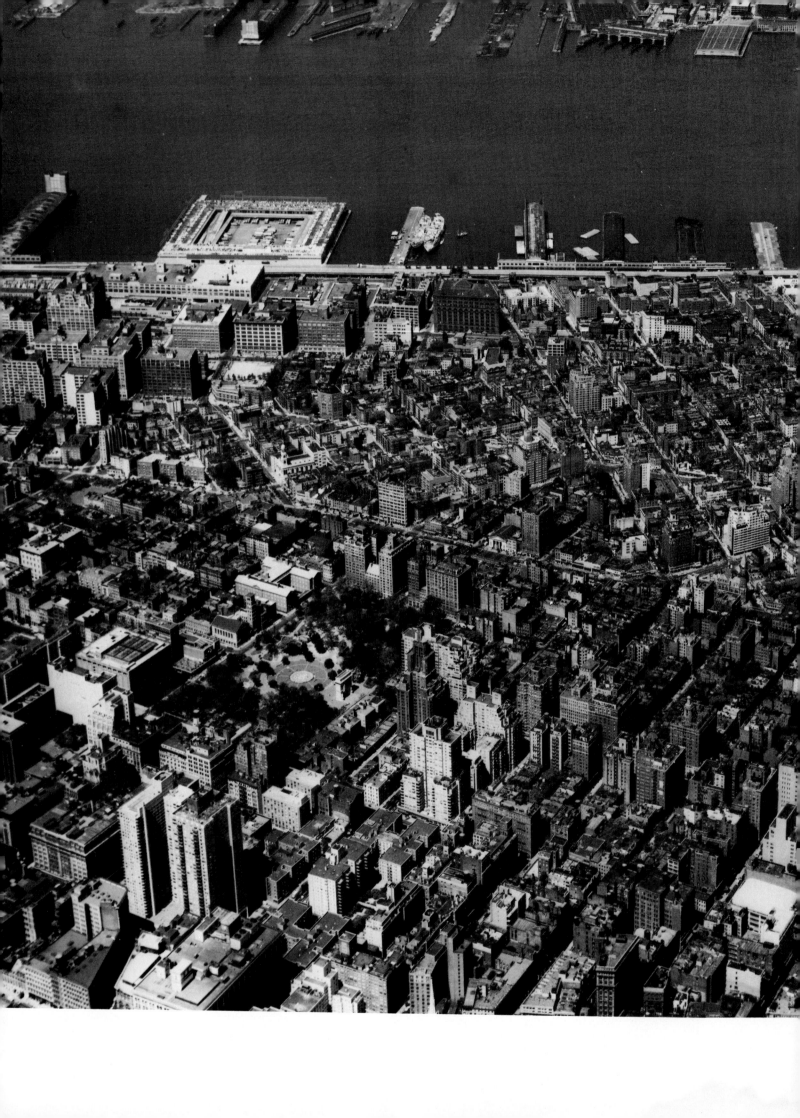

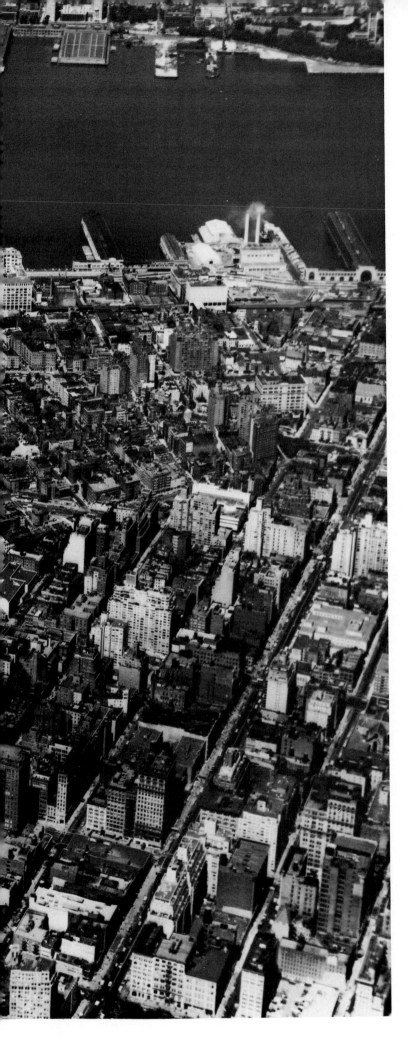

22
Greenwich Avenue, west from Fourth Avenue,
June 15, 1978

1 Hudson River.
2 Pier 40.
3 West Side Highway.
4 Christopher Street.
5 Seventh Avenue South.
6 West Houston Street.
7 Avenue of the Americas (Sixth Avenue).
8 West 9th Street.
9 Greenwich Avenue.
10 Washington Square Park.
11 Fifth Avenue.
12 14th Street.
13 Hoboken, New Jersey.

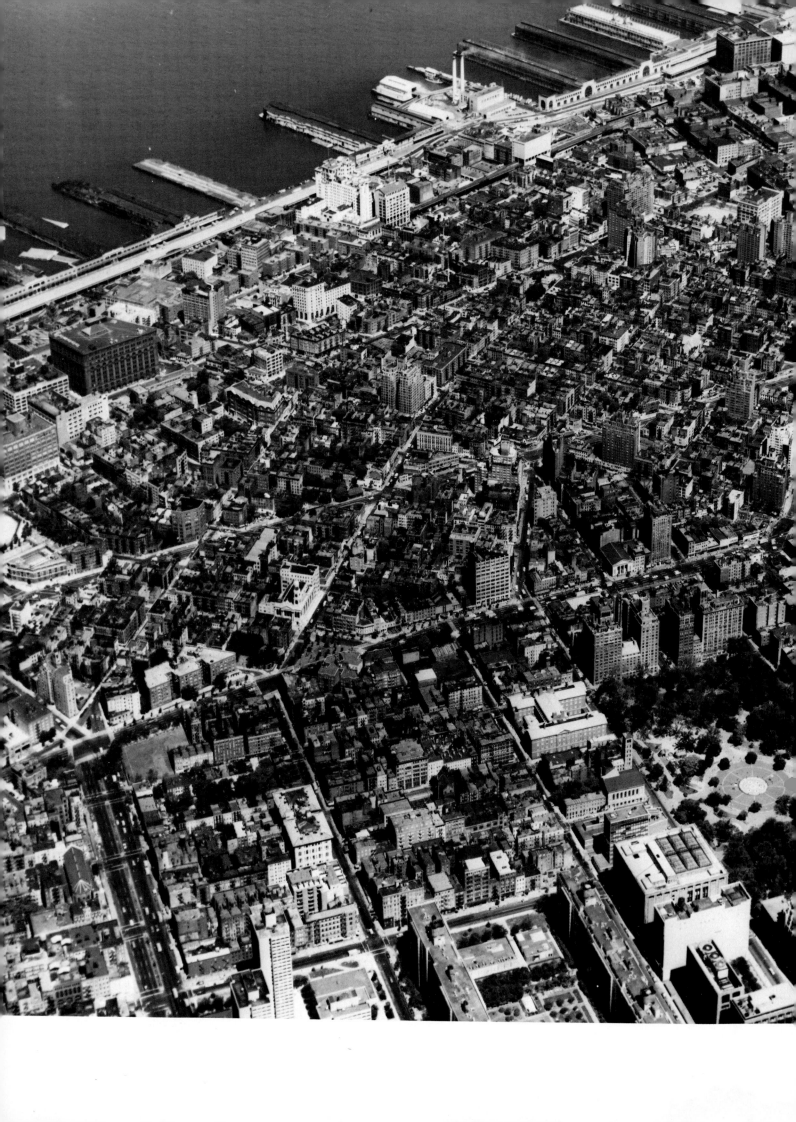

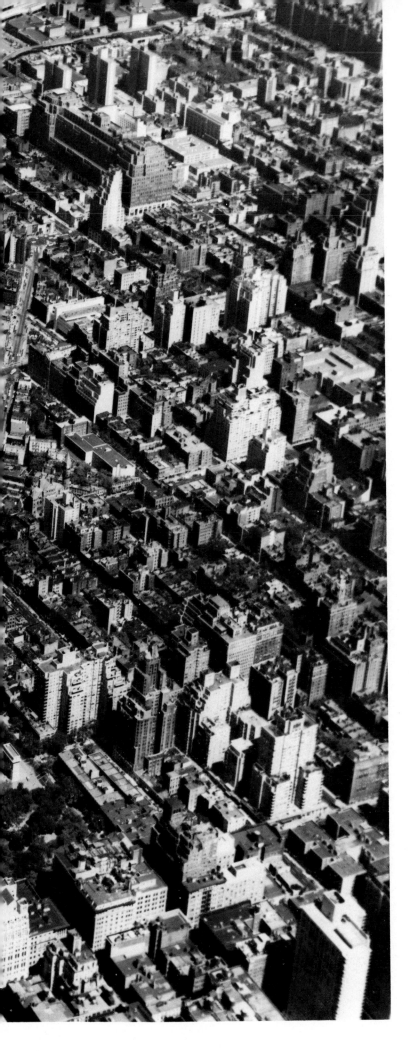

23
Northwest across Greenwich Village, June 15, 1978

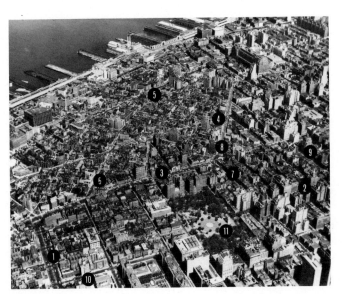

1 West Houston Street.
2 Fifth Avenue.
3 Avenue of the Americas (Sixth Avenue).
4 Seventh Avenue South.
5 Abingdon Square.
6 Bleecker Street.
7 West 8th Street.
8 Greenwich Avenue.
9 West 14th Street.
10 University Village.
11 Washington Square Park.

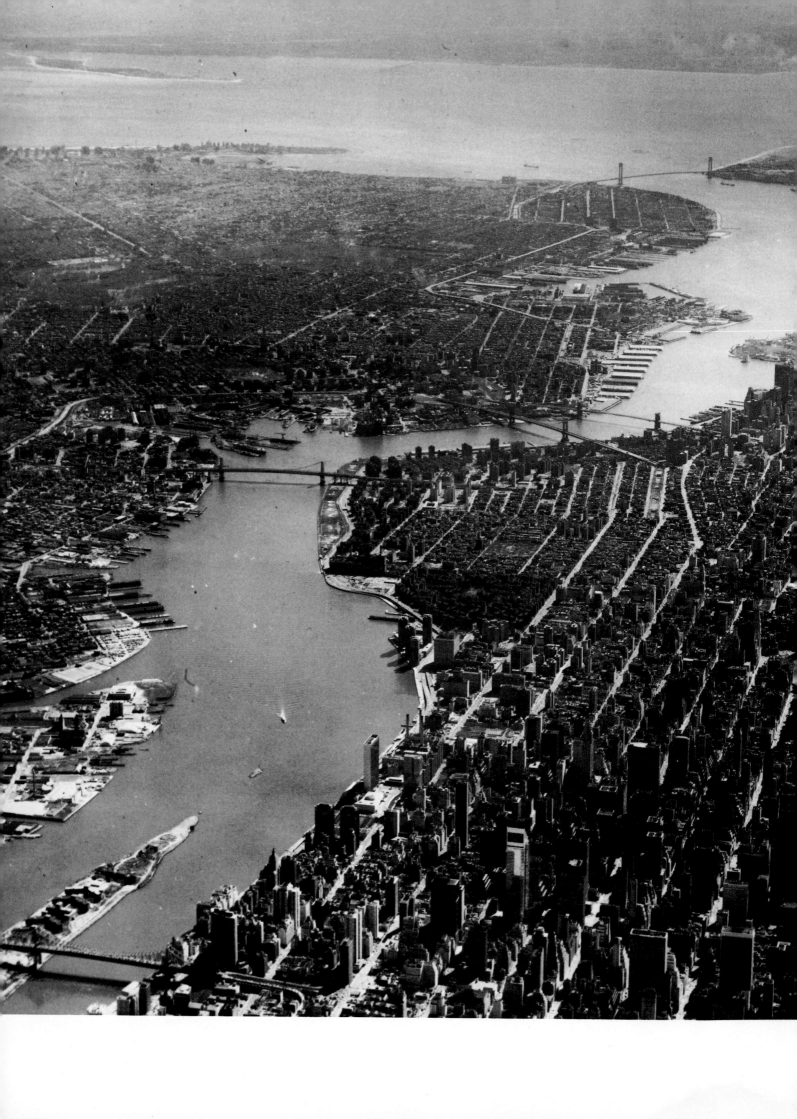

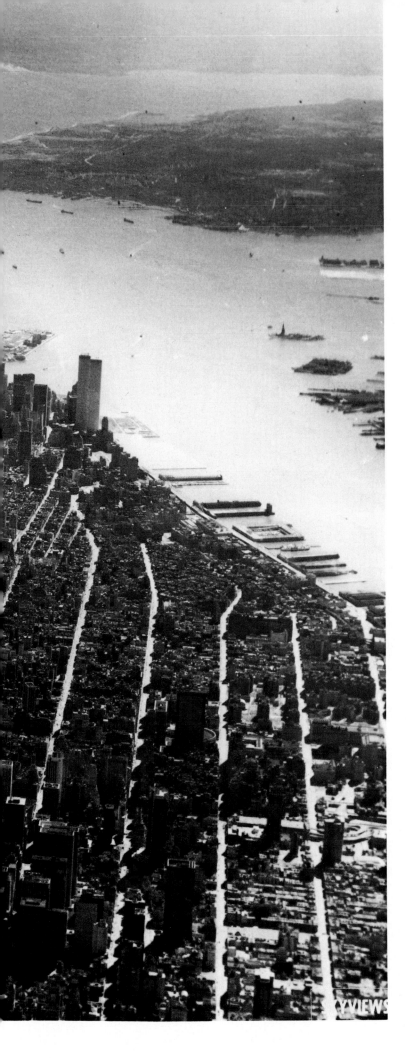

24

Manhattan, south from 59th Street, including Brooklyn, Staten Island and New Jersey, April 9, 1978

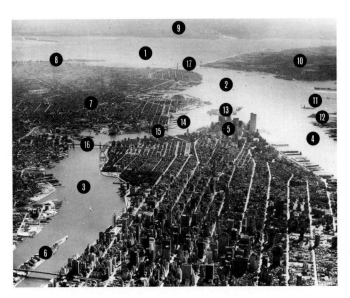

1 Lower New York Bay.
2 Upper New York Bay.
3 East River.
4 Hudson River.
5 Financial District.
6 Roosevelt Island.
7 Brooklyn.
8 Coney Island.
9 New Jersey.
10 Staten Island.
11 Statue of Liberty (Liberty Island).
12 Ellis Island.
13 Governors Island.
14 Brooklyn Bridge.
15 Manhattan Bridge.
16 Williamsburg Bridge.
17 Verrazano-Narrows Bridge.

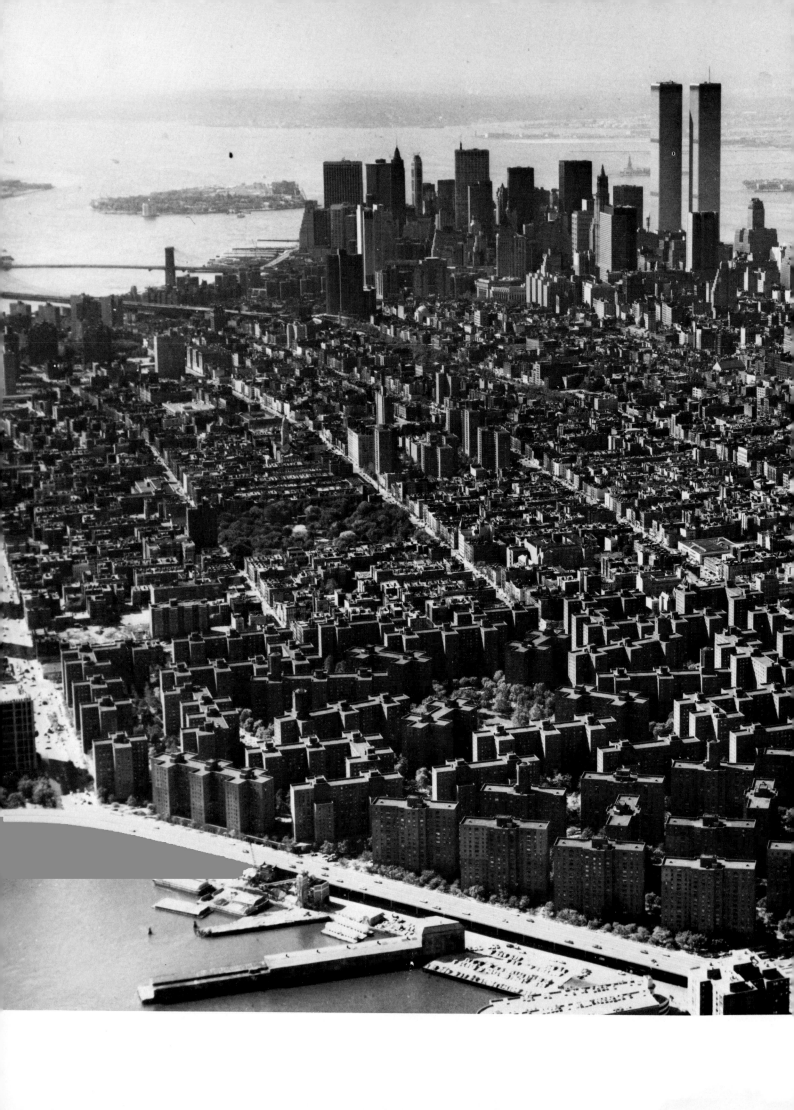

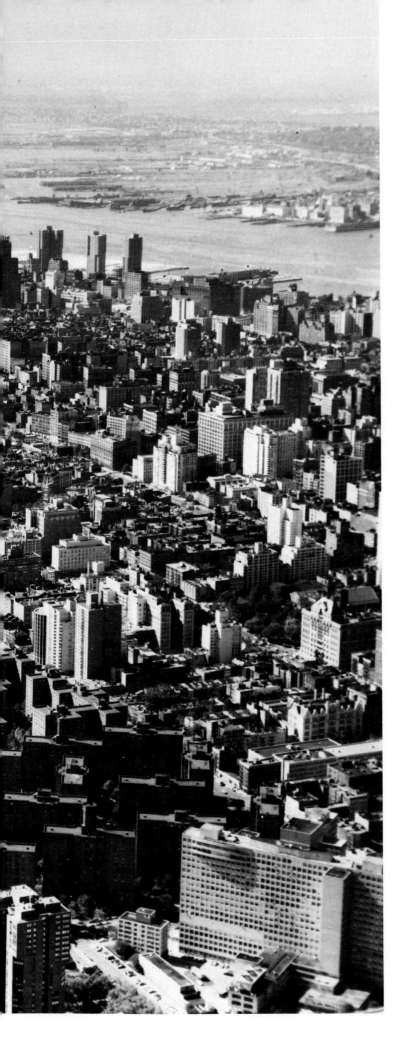

25
Manhattan, south from East 23rd Street,
October 4, 1976

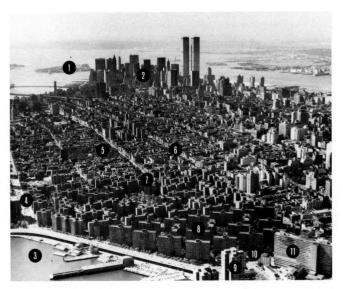

1 Governors Island.
2 Financial District.
3 East River.
4 Avenue C.
5 Tompkins Square Park.
6 First Avenue.
7 Stuyvesant Town.
8 Peter Cooper Village.
9 Waterside Apartments.
10 East 23rd Street.
11 Veterans Hospital.

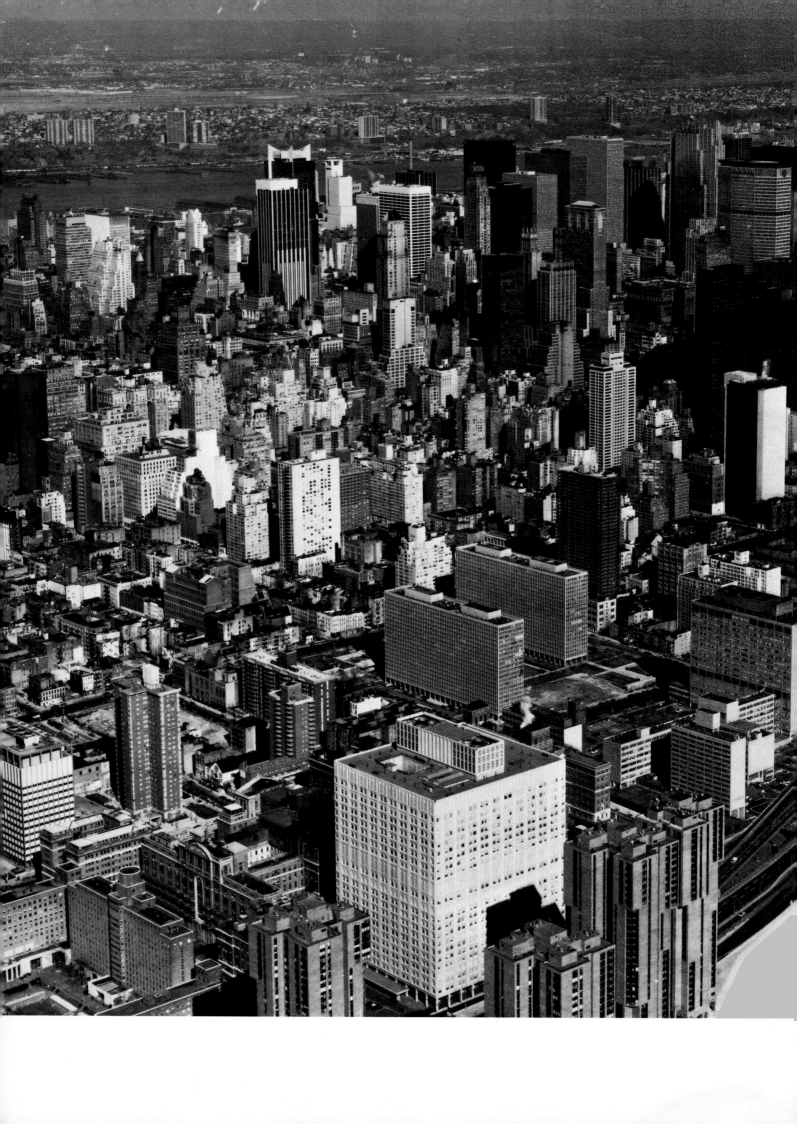

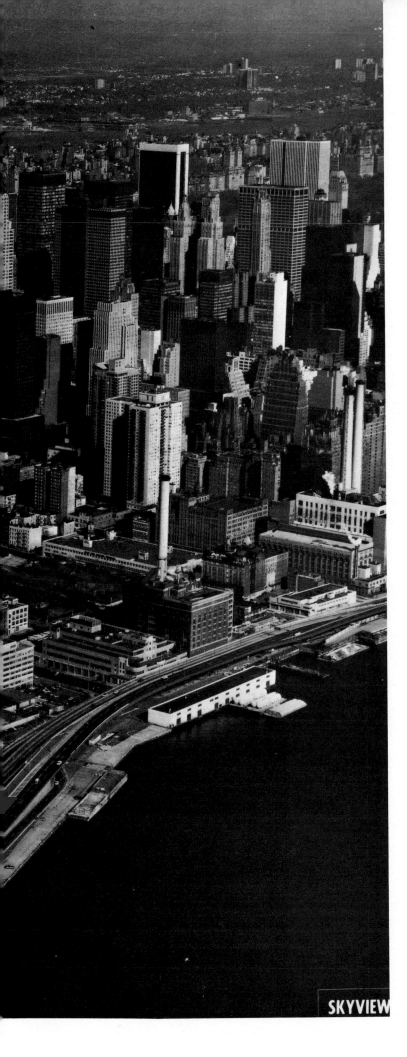

26
Lower midtown Manhattan, northwest from
Bellevue Hospital Center, February 24, 1974

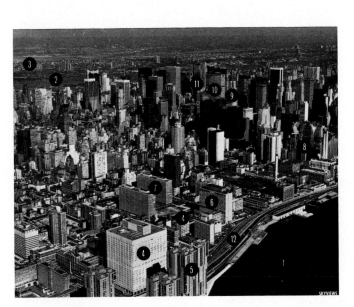

1 East River.
2 Hudson River.
3 New Jersey.
4 Bellevue Hospital Center.
5 Waterside Towers.
6 N.Y.U. Medical Center.
7 Kips Bay Plaza Apartments.
8 Tudor City.
9 Chrysler Building.
10 Pan Am Building.
11 RCA Building.
12 Franklin D. Roosevelt Drive.

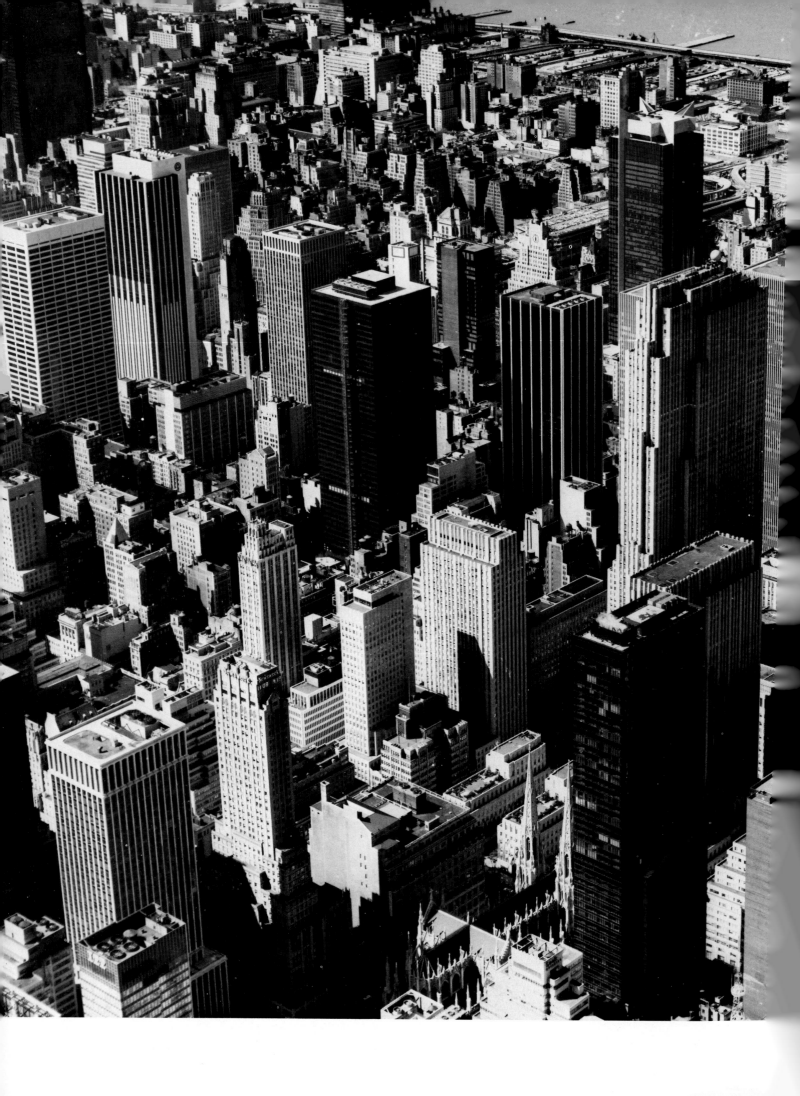

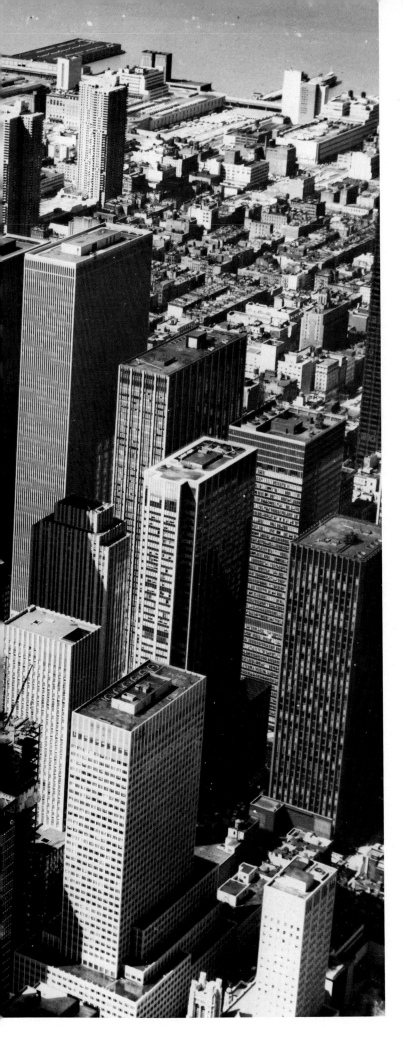

27
Midtown Manhattan, southwest from East 53rd
Street, March 21, 1977

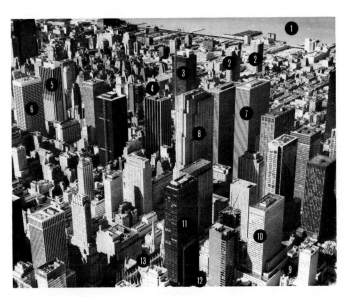

1 Hudson River.
2 Manhattan Plaza Apartments.
3 1 Astor Plaza, Times Square.
4 Paramount Building.
5 New York Telephone Building.
6 Grace Building.
7 Exxon Building.
8 RCA Building, Rockefeller Center.
9 West 53rd Street.
10 Tishman Building.
11 Olympic Tower.
12 Fifth Avenue.
13 St. Patrick's Cathedral.

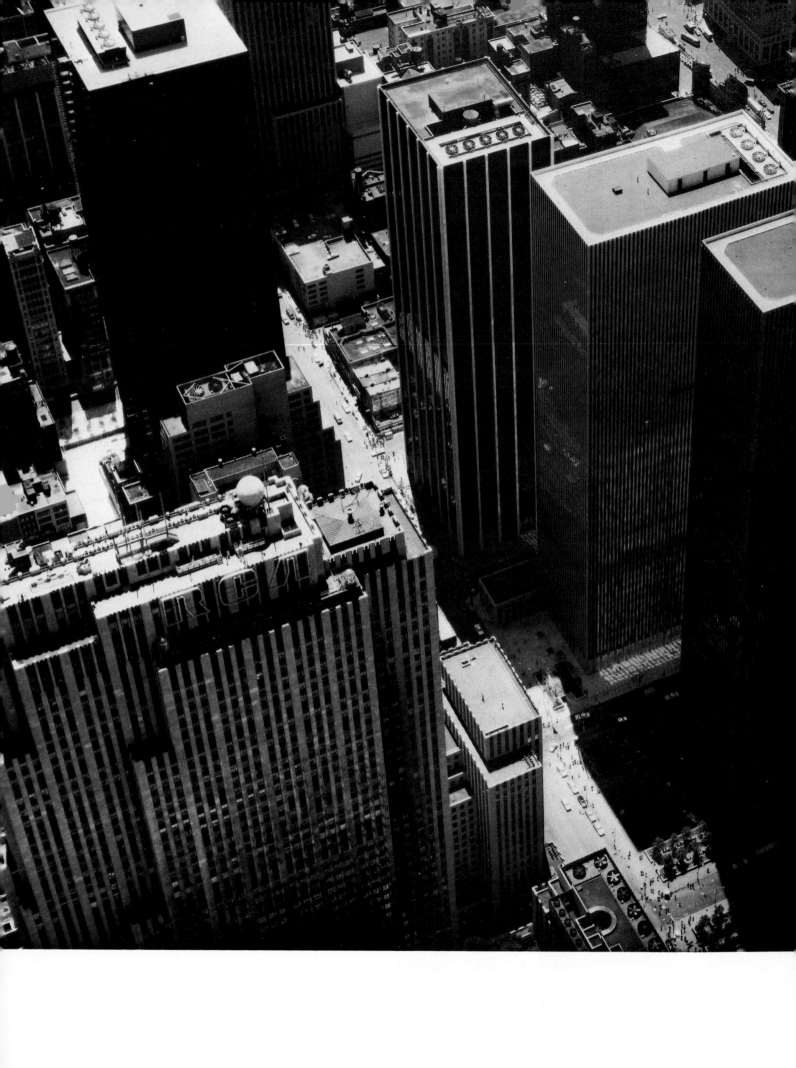

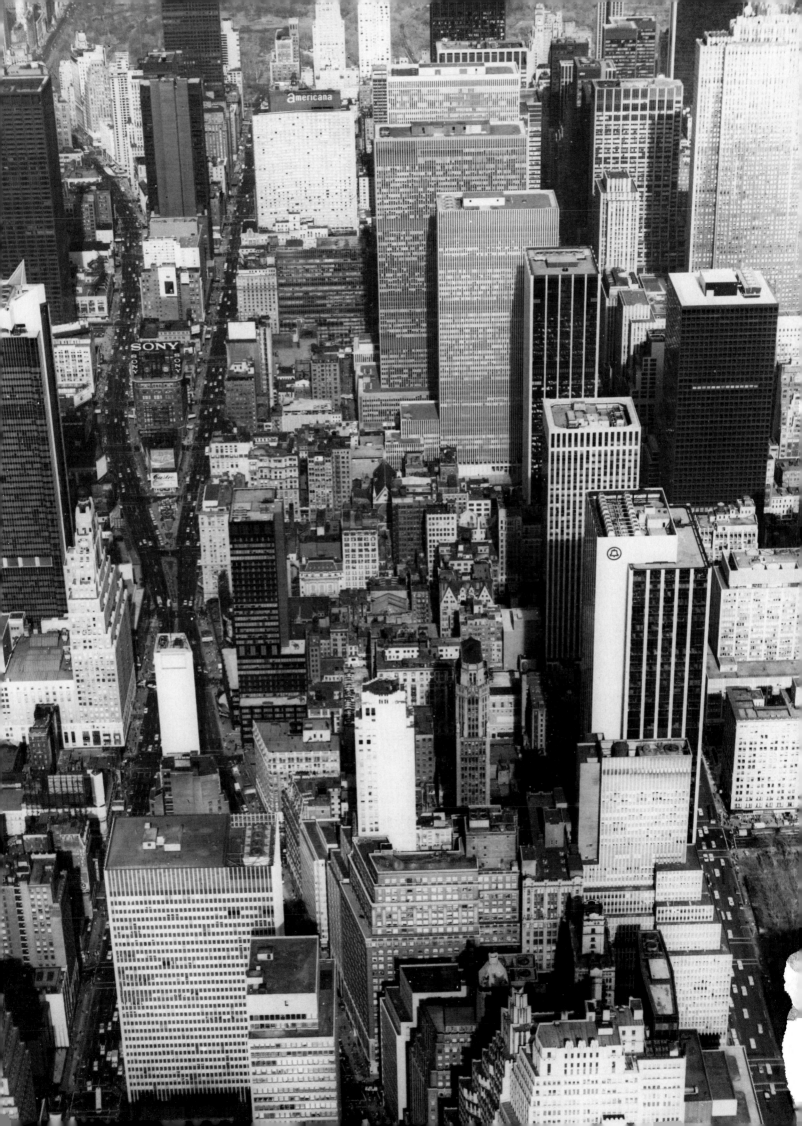

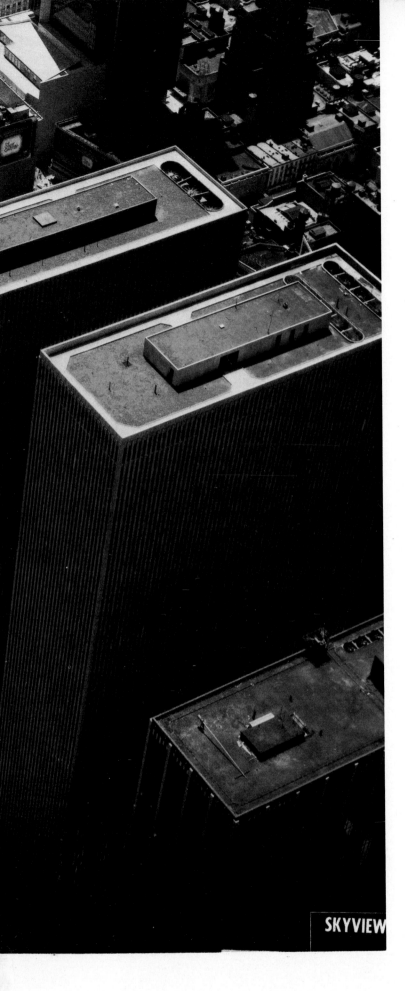

28
Southwest across the Avenue of the Americas
at West 49th Street, June 3, 1974

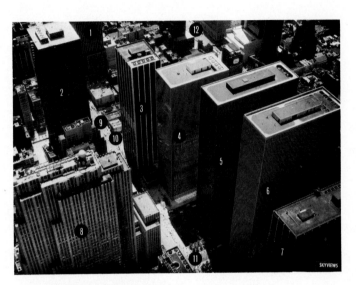

1 1133 West 44th Street.
2 1166 West 46th Street.
3 Stevens Tower.
4 Celanese Building.
5 McGraw-Hill Building.
6 Exxon Building.
7 Time-Life Building.
8 RCA Building.
9 Avenue of the Americas (Sixth Avenue).
10 West 46th Street.
11 West 49th Street.
12 Seventh Avenue.

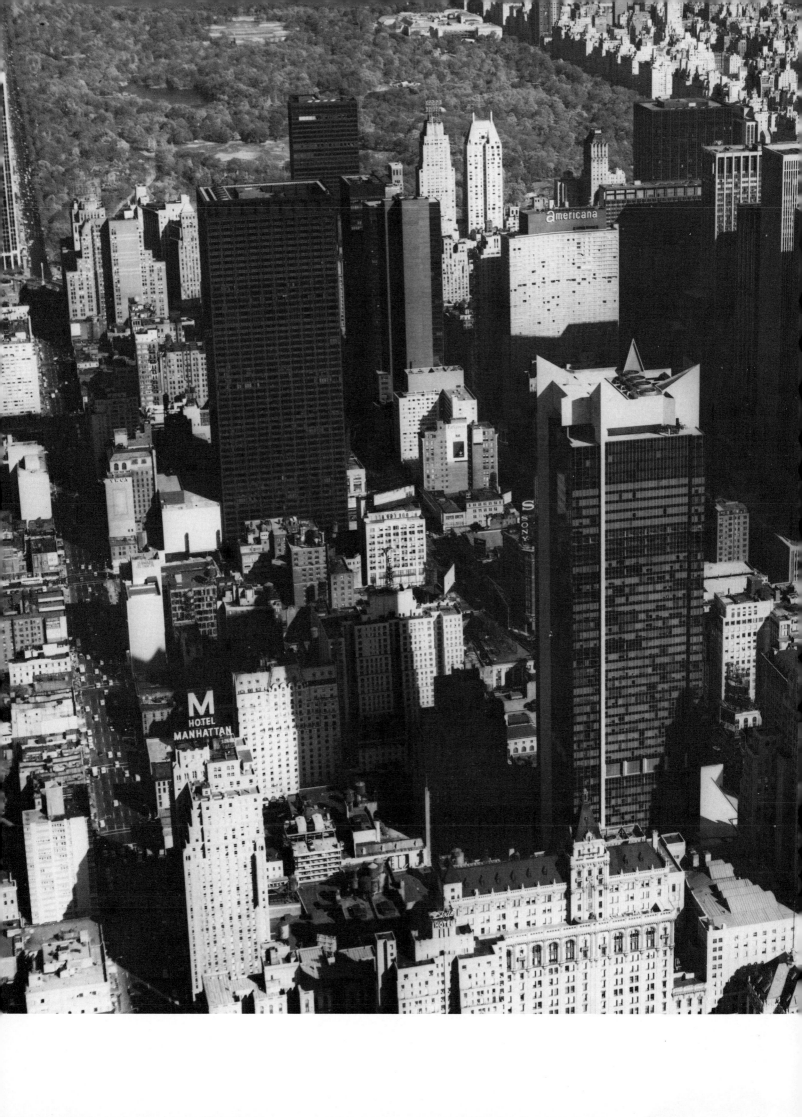

29
The Times Square area, north from West 40th
Street, February 18, 1977

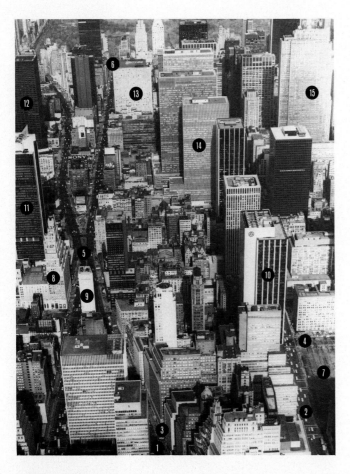

1 Broadway.
2 Avenue of the Americas (Sixth Avenue).
3 West 40th Street.
4 West 42nd Street.
5 Times Square.
6 Central Park South.
7 Bryant Park.
8 Paramount Building.
9 1 Times Square.
10 New York Telephone Building.
11 1 Astor Plaza.
12 Uris Building.
13 Americana Hotel (now Sheraton Centre).
14 Celanese Building.
15 RCA Building.

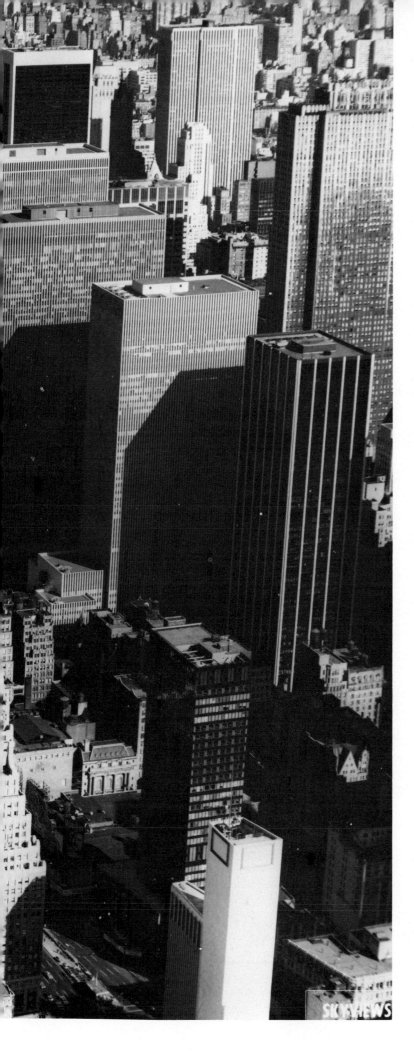

30
North from West 43rd Street, November 6, 1976

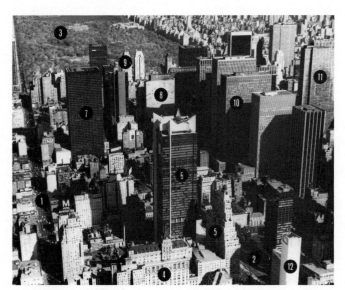

1 Eighth Avenue.
2 Times Square.
3 Central Park.
4 Hotel Dixie.
5 Paramount Building.
6 1 Astor Plaza.
7 Uris Building.
8 Americana Hotel (now Sheraton Centre).
9 Essex House.
10 McGraw-Hill Building.
11 RCA Building.
12 1 Times Square.

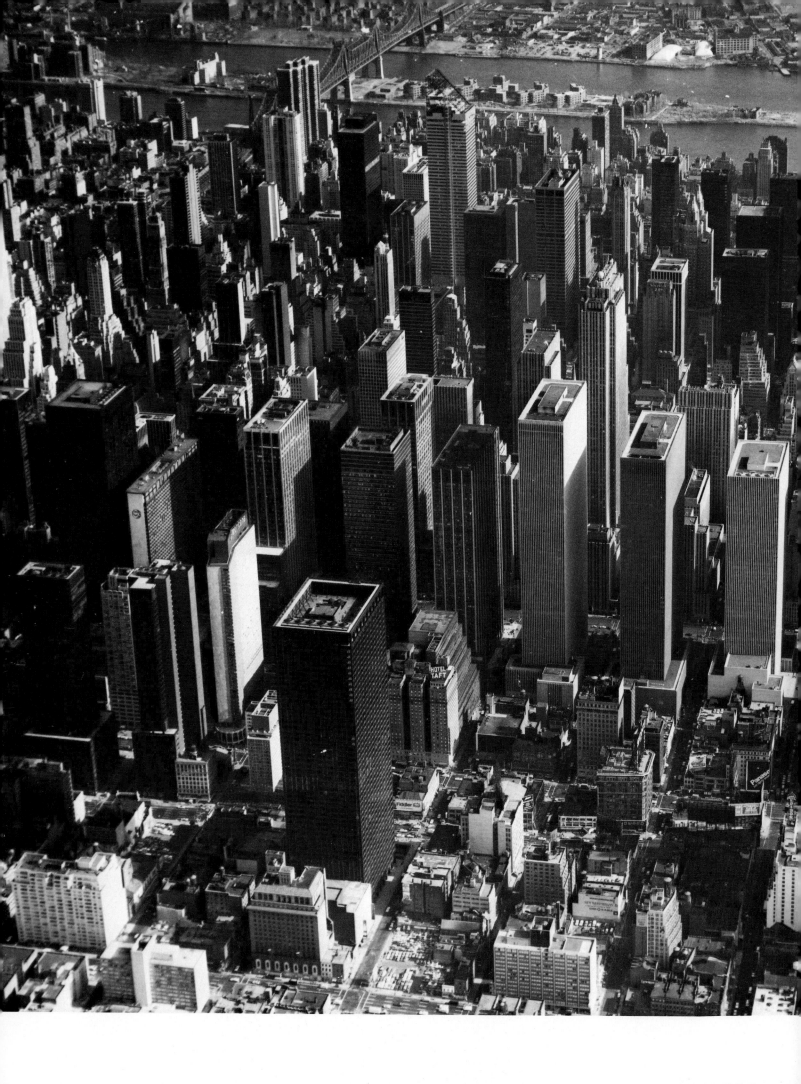

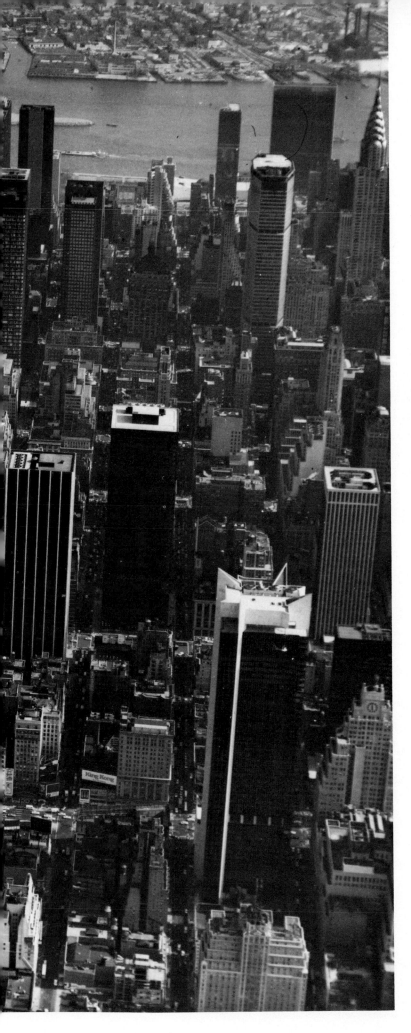

31
Midtown Manhattan, east from Eighth Avenue,
February 18, 1977

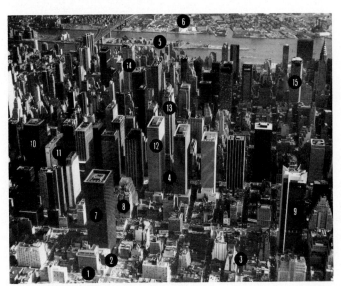

1 Eighth Avenue.
2 West 50th Street.
3 West 47th Street.
4 Avenue of the Americas (Sixth Avenue).
5 Roosevelt Island.
6 Long Island City, Queens.
7 Uris Building.
8 Hotel Taft.
9 1 Astor Plaza.
10 Burlington House.
11 Hilton Hotel.
12 Exxon Building.
13 RCA Building.
14 Citicorp Building.
15 Pan Am Building.

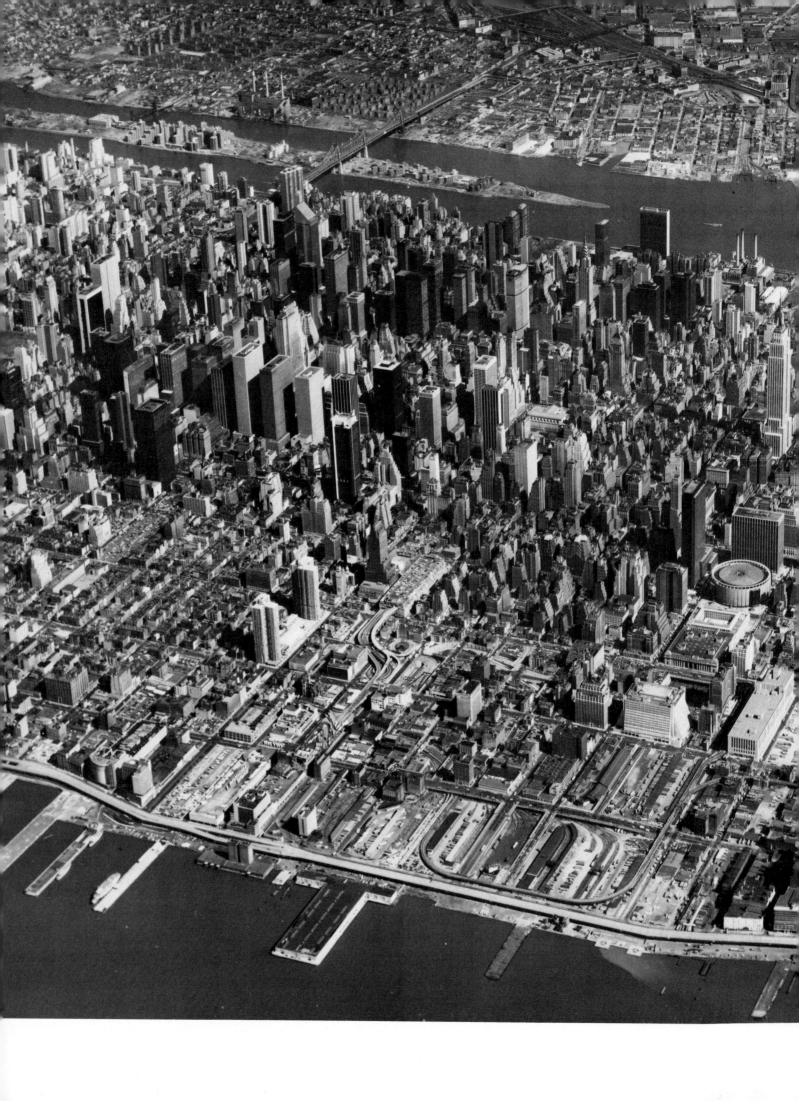

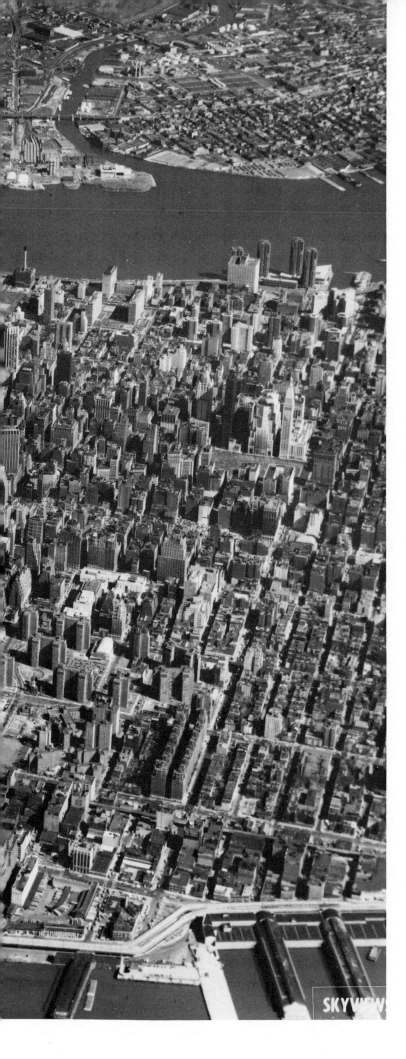

32
East over midtown Manhattan from the Hudson
River, March 30, 1978

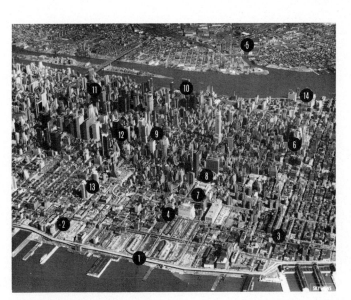

1 West Side Highway.
2 West 42nd Street.
3 West 23rd Street.
4 Tenth Avenue.
5 Newtown Creek.
6 Madison Square.
7 General Post Office.
8 Madison Square Garden and Pennsylvania Station.
9 New York Public Library.
10 United Nations.
11 Citicorp Building.
12 Times Square.
13 Manhattan Plaza Apartments.
14 Waterside Apartments.

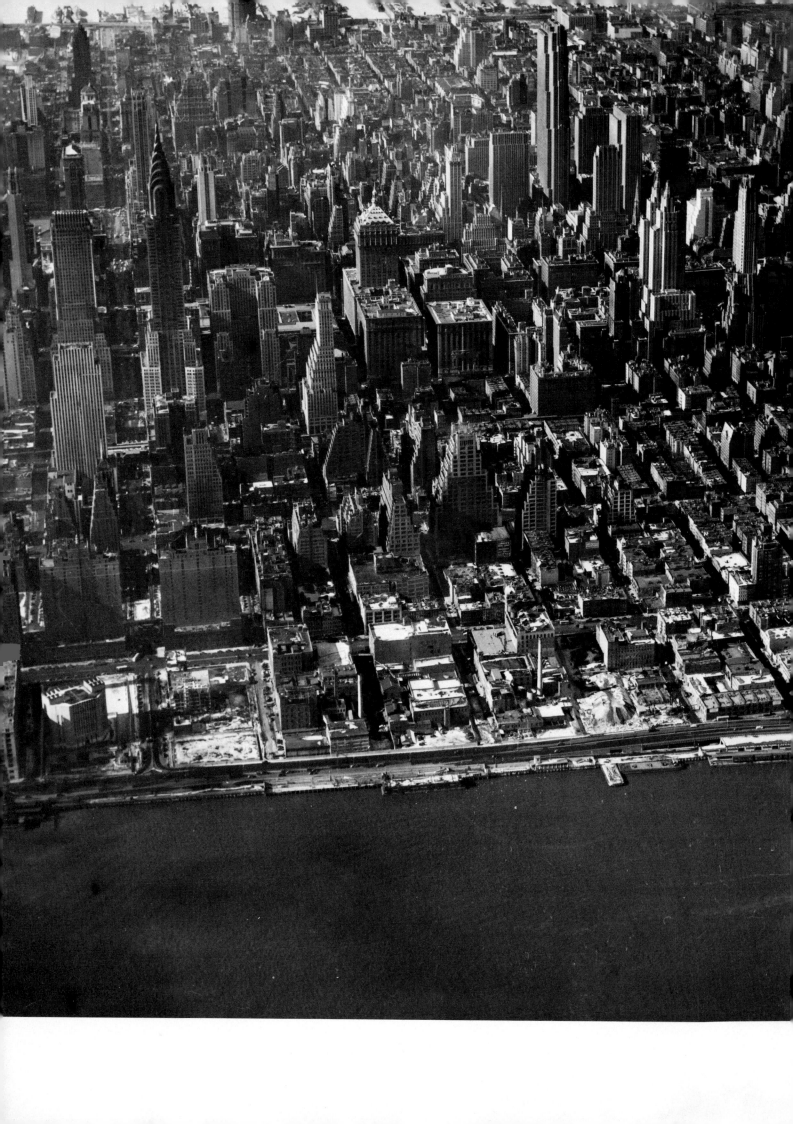

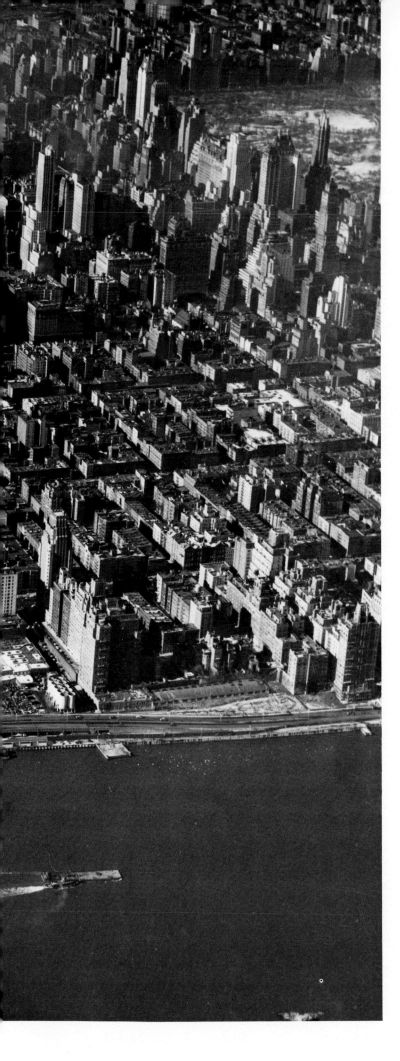

33
Midtown Manhattan, west from the East River,
February 11, 1946

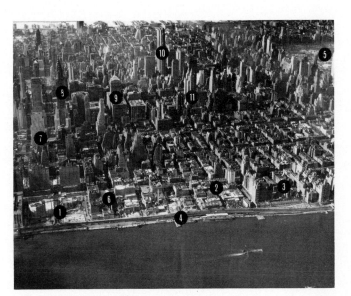

1 East 42nd Street.
2 East 48th Street.
3 Beekman Place.
4 Franklin D. Roosevelt Drive.
5 Central Park.
6 Site of the United Nations.
7 Daily News Building.
8 Chrysler Building.
9 Former New York Central Building.
10 RCA Building.
11 Waldorf-Astoria Hotel.

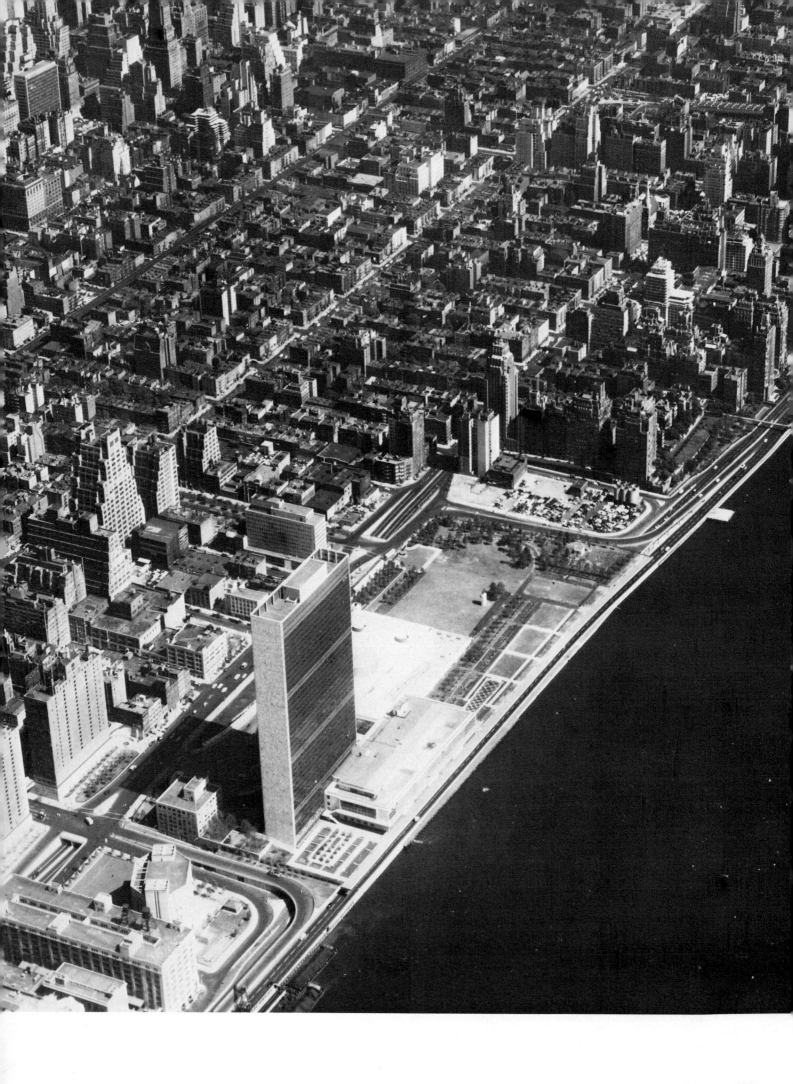

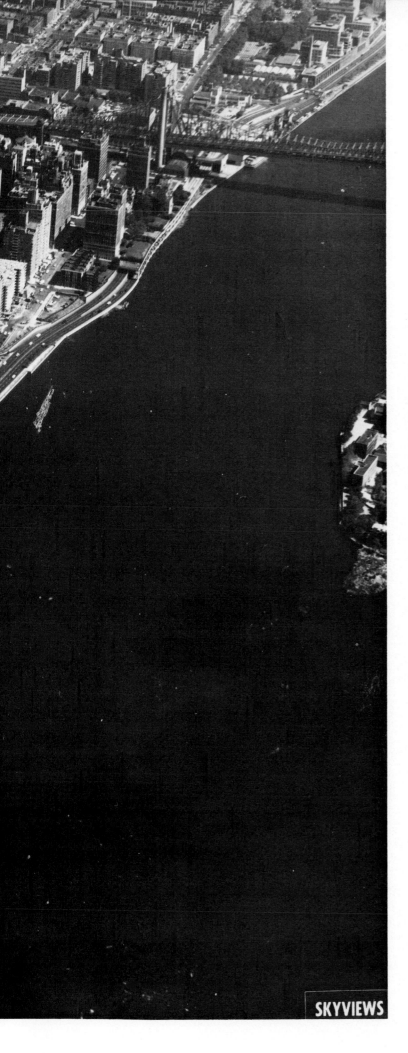

34
Midtown Manhattan, north along the East River, August 9, 1955

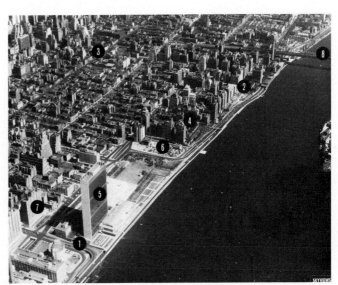

1 East 42nd Street.
2 York Avenue.
3 Third Avenue.
4 Beekman Place.
5 Secretariat Building, United Nations.
6 Site of the United Nations Apartments.
7 Tudor City.
8 Queensboro Bridge.

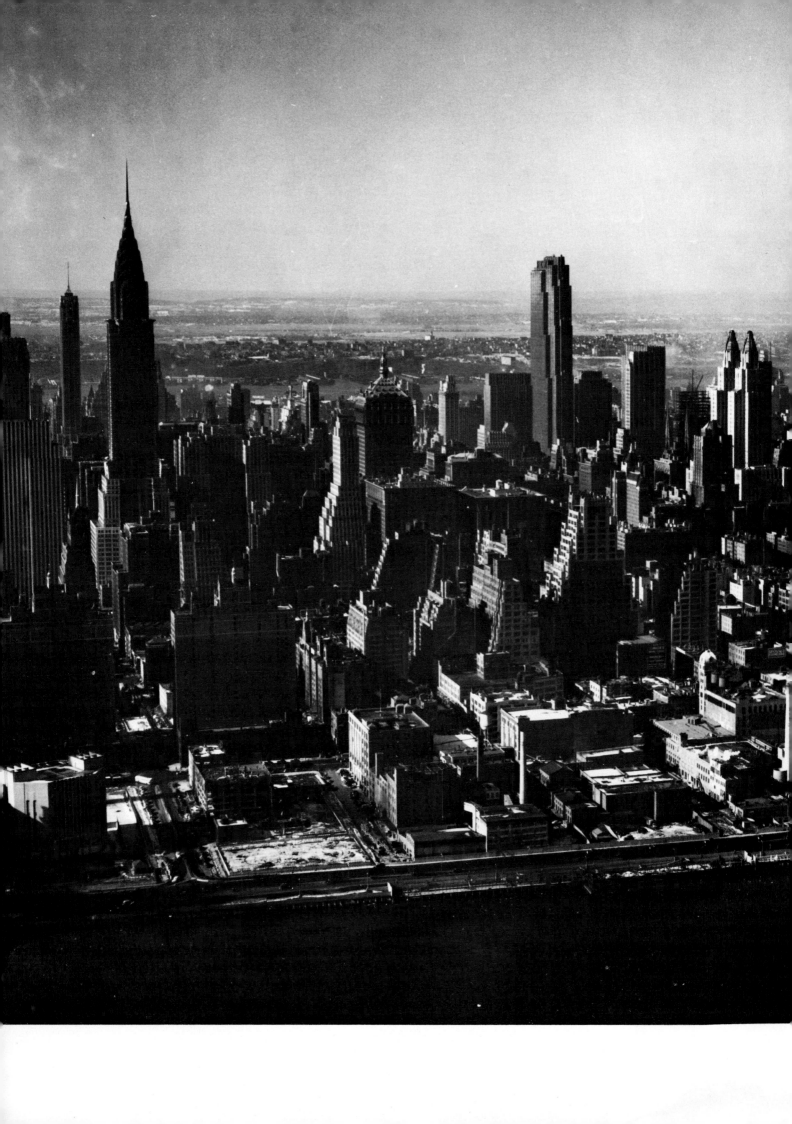

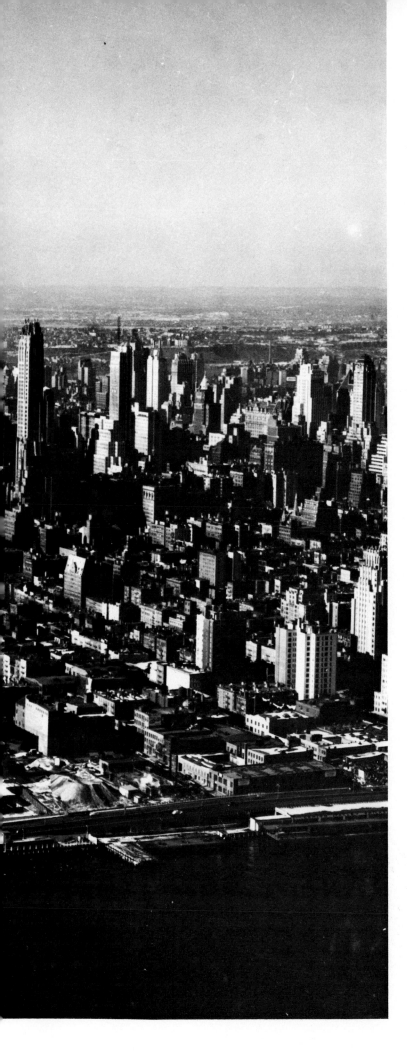

35
Midtown Manhattan, northwest from the East River, February 11, 1947

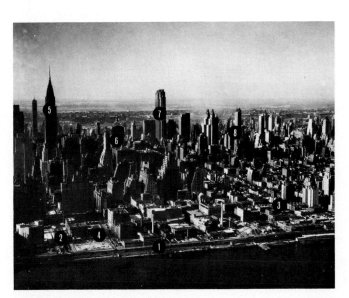

1 Franklin D. Roosevelt Drive.
2 East 42nd Street.
3 West 48th Street.
4 Site of the United Nations.
5 Chrysler Building.
6 Former New York Central Building.
7 RCA Building.
8 General Electric Tower.

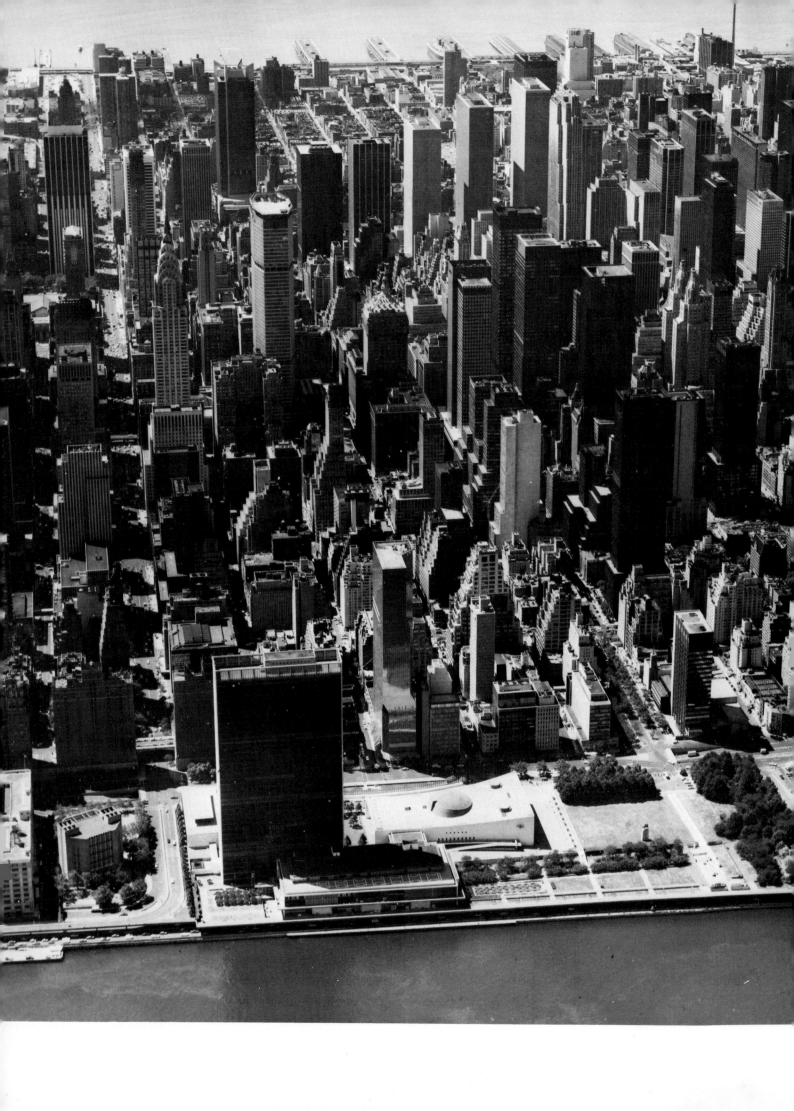

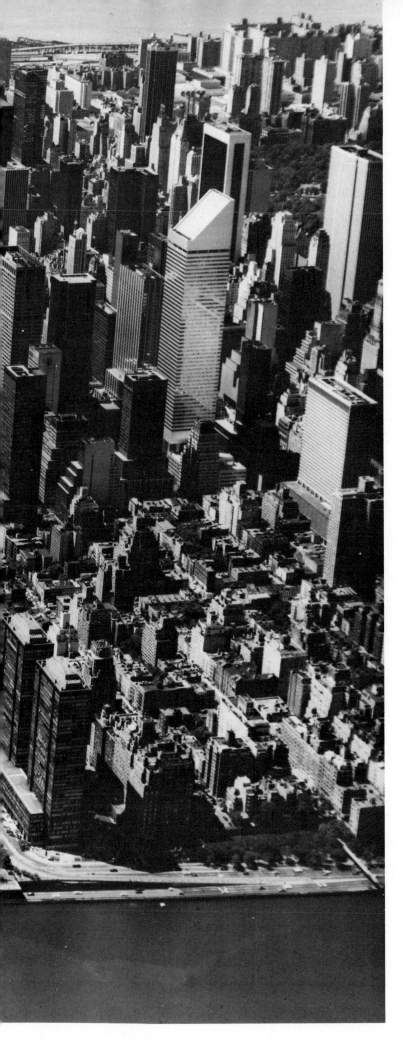

36
Midtown Manhattan, northwest from the East River, June 15, 1978

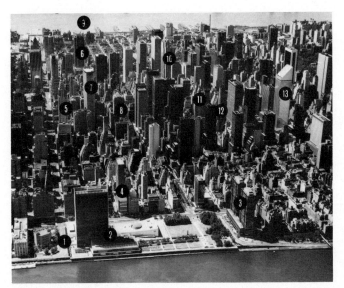

1 East 42nd Street.
2 United Nations.
3 United Nations Apartments.
4 One United Nations Plaza.
5 Chrysler Building.
6 1 Astor Plaza.
7 Pan Am Building.
8 Former New York Central Building.
9 Hudson River.
10 RCA Building.
11 Waldorf-Astoria Hotel.
12 General Electric Tower.
13 Citicorp Building.

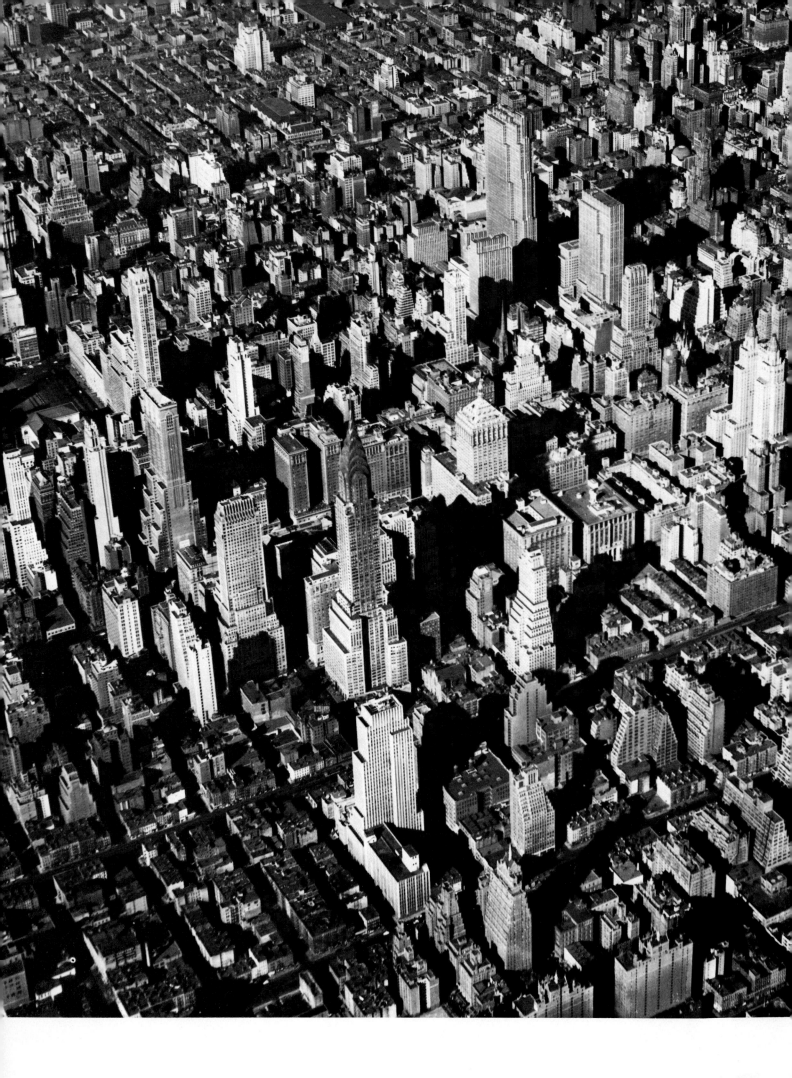

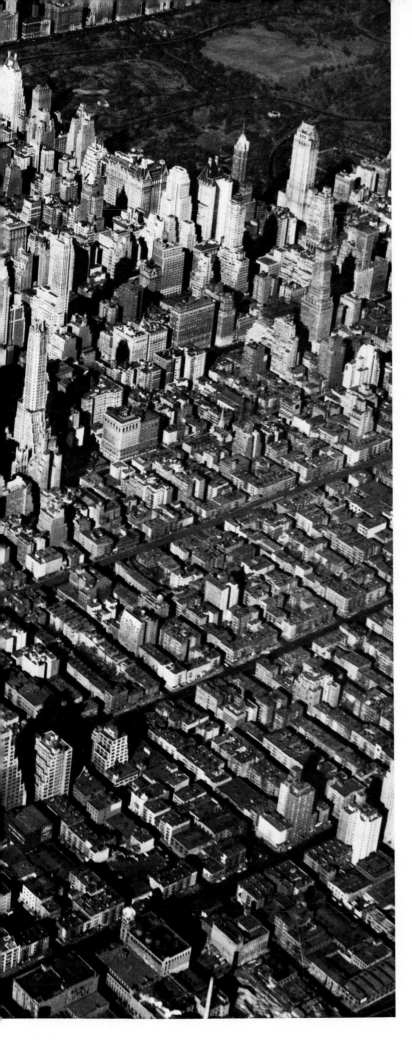

37
Midtown Manhattan, northwest across East 42nd Street, December 25, 1946

1 East 42nd Street.
2 Third Avenue.
3 East 57th Street.
4 Central Park.
5 General Electric Building.
6 Waldorf-Astoria Hotel.
7 Former New York Central Building.
8 Daily News Building.
9 Chrysler Building.
10 Lincoln Building.
11 500 Fifth Avenue.
12 Paramount Building.
13 RCA Building.
14 International Building.
15 Chanin Building.
16 Old Madison Square Garden.

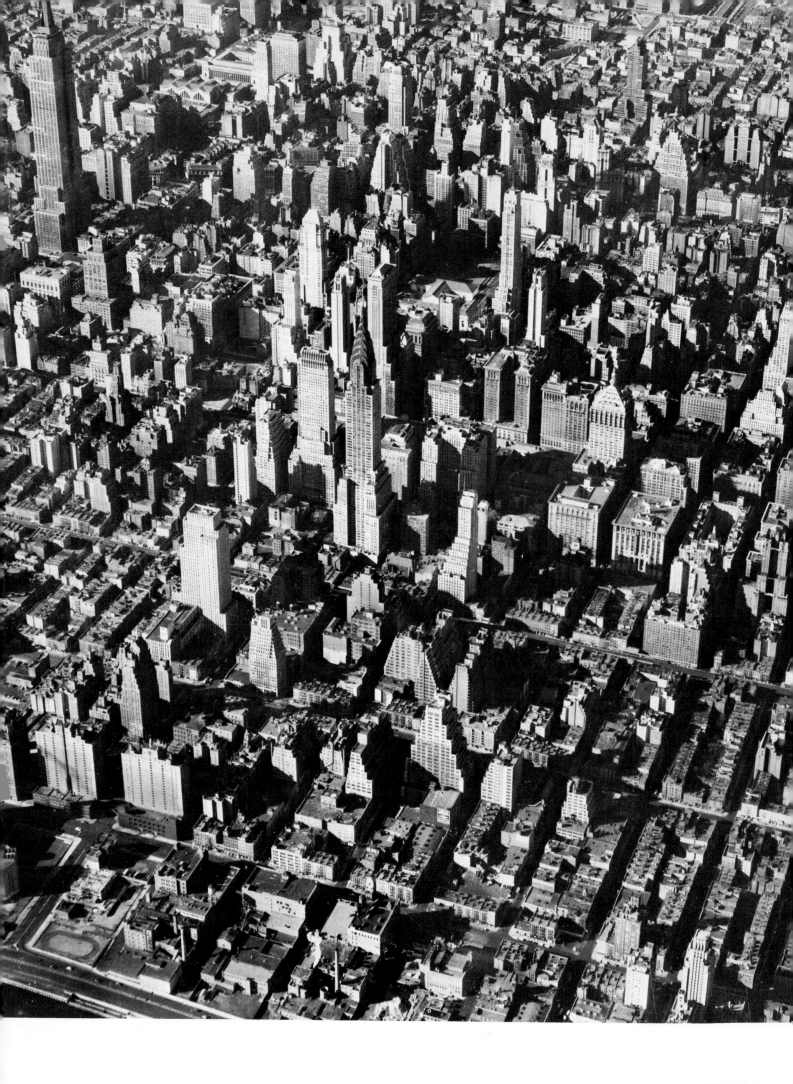

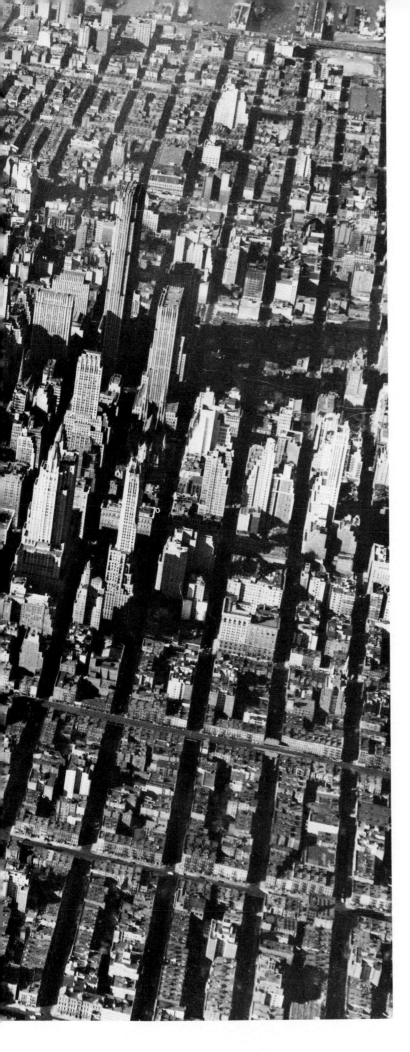

38
Midtown Manhattan, west from the East River,
December 25, 1946

1 East 42nd Street.
2 Franklin D. Roosevelt Drive.
3 East 52nd Street.
4 Third Avenue.
5 Empire State Building.
6 Former Pennsylvania Station.
7 Tudor City.
8 Chrysler Building.
9 Biltmore Hotel.
10 Paramount Building.
11 RCA Building.
12 Former New York Central Building.
13 Grand Central Palace.
14 Waldorf-Astoria Hotel.

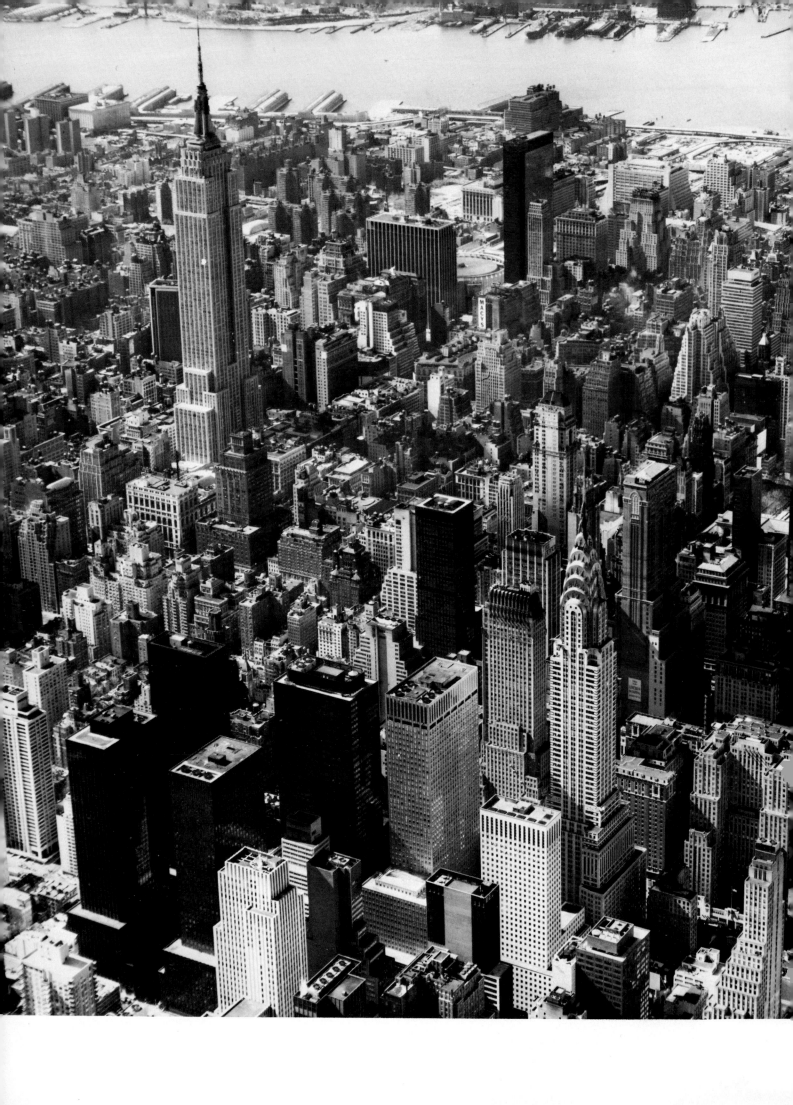

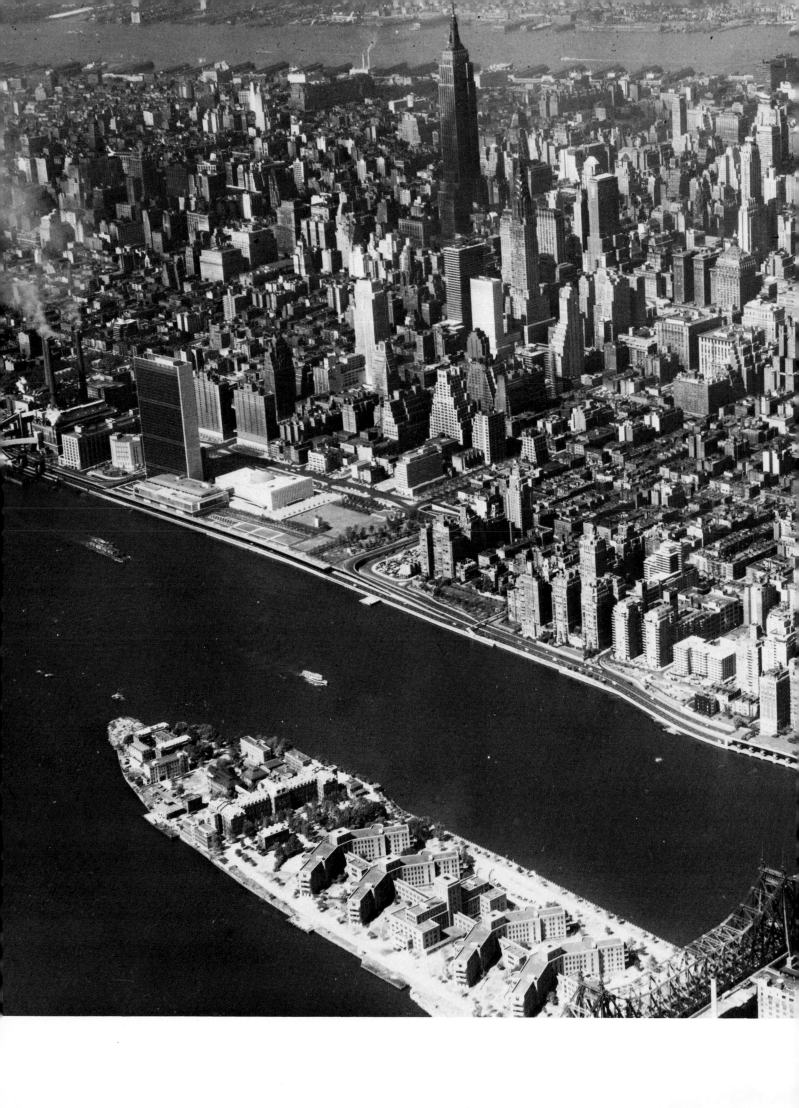

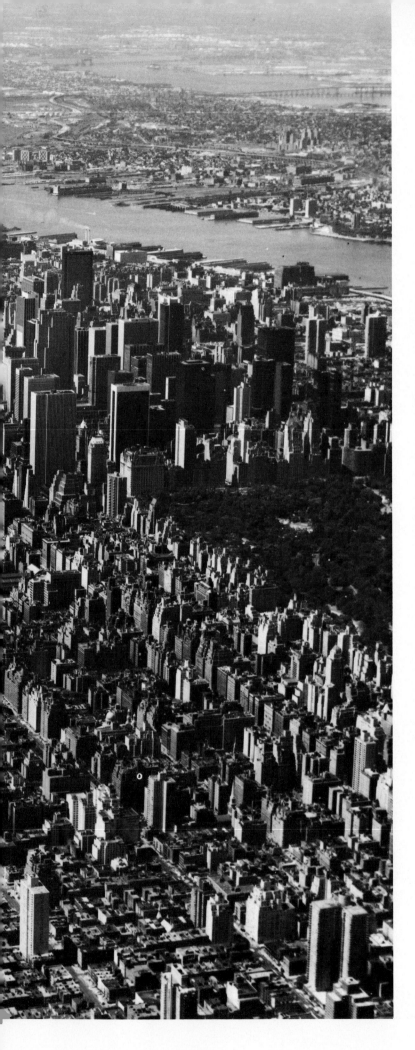

40
Manhattan, southwest from East 86th Street,
June 15, 1978

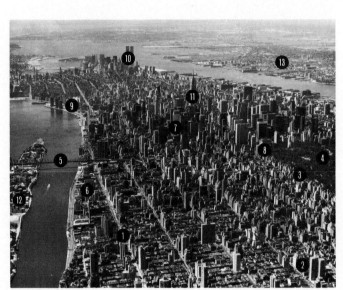

1 York Avenue.
2 East 84th Street.
3 Fifth Avenue.
4 Central Park.
5 Queensboro Bridge.
6 New York Hospital/Cornell Medical College.
7 Citicorp Building.
8 Plaza Hotel.
9 Bellevue Hospital Center.
10 World Trade Center.
11 Empire State Building.
12 Roosevelt Island.
13 Jersey City, New Jersey.

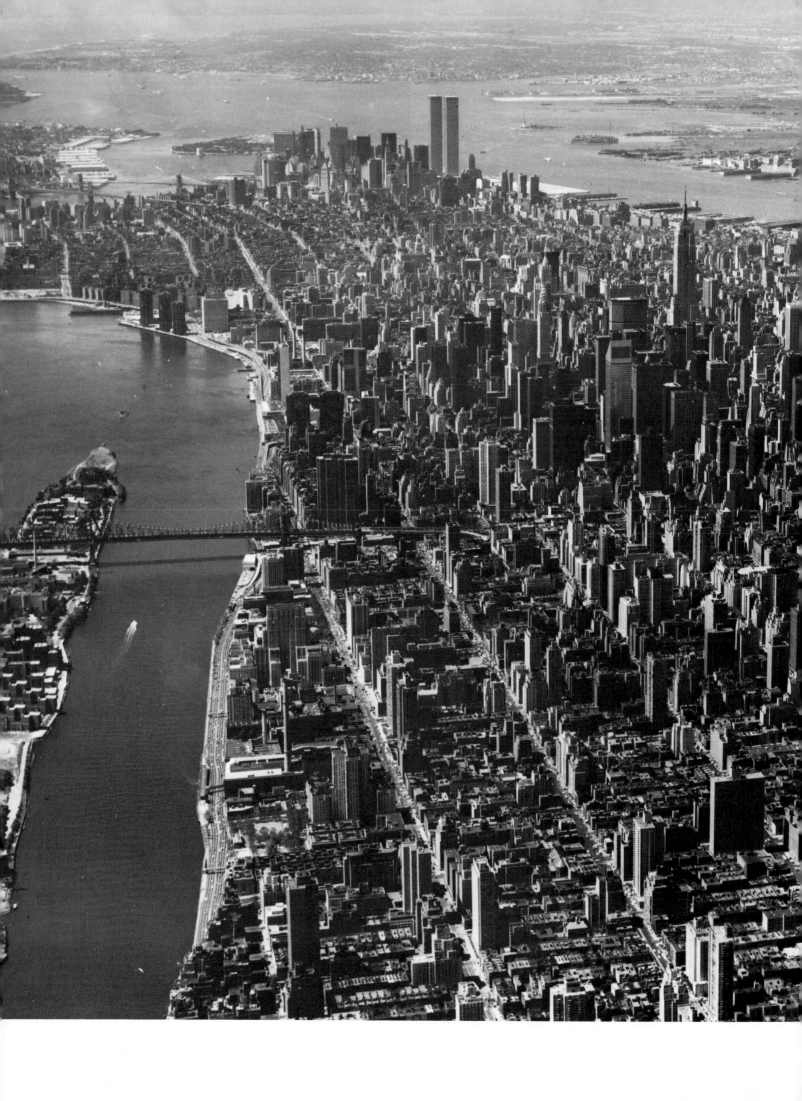

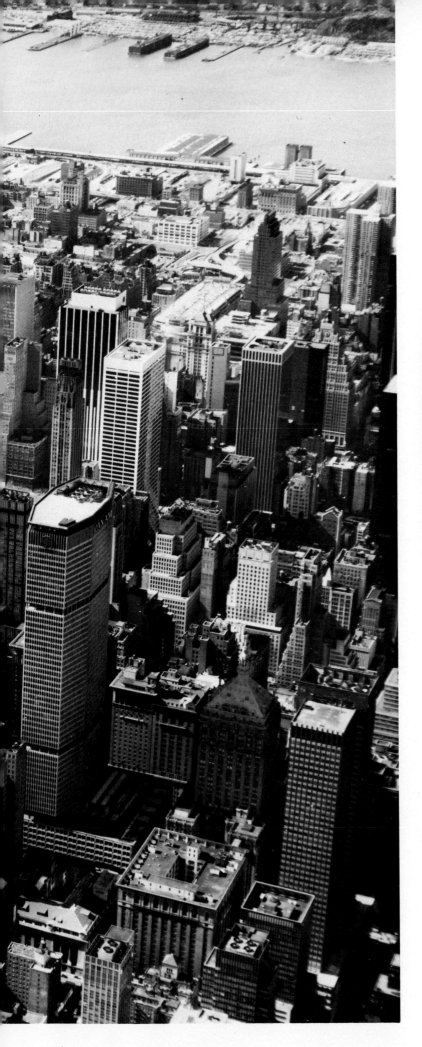

39
Midtown Manhattan, southwest from Third Avenue, March 2, 1978

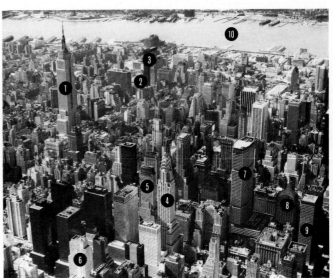

1 Empire State Building.
2 Madison Square Garden.
3 1 Penn Plaza.
4 Chrysler Building.
5 Chanin Building.
6 Daily News Building.
7 Pan Am Building.
8 Former New York Central Building.
9 117 Park Avenue.
10 Hudson River.

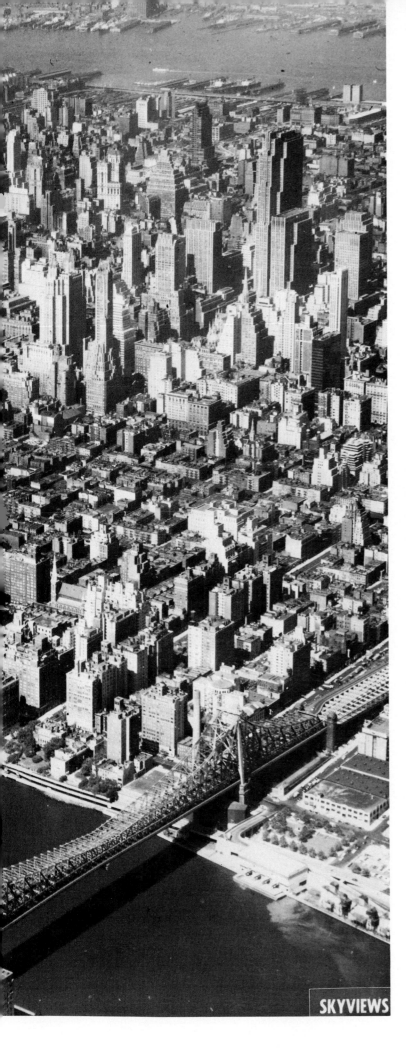

41
Midtown Manhattan, southwest from the East River, August 9, 1955

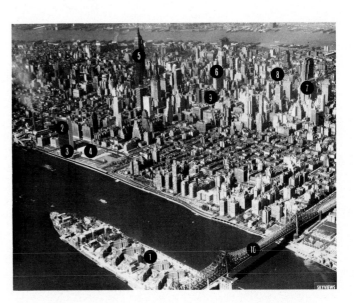

1 Goldwater Memorial Hospital, Roosevelt Island.
2 U.N. Secretariat Building.
3 U.N. Conference Building.
4 U.N. General Assembly Building.
5 Empire State Building.
6 500 Fifth Avenue.
7 RCA Building.
8 Paramount Building.
9 Former New York Central Building.
10 Queensboro Bridge.

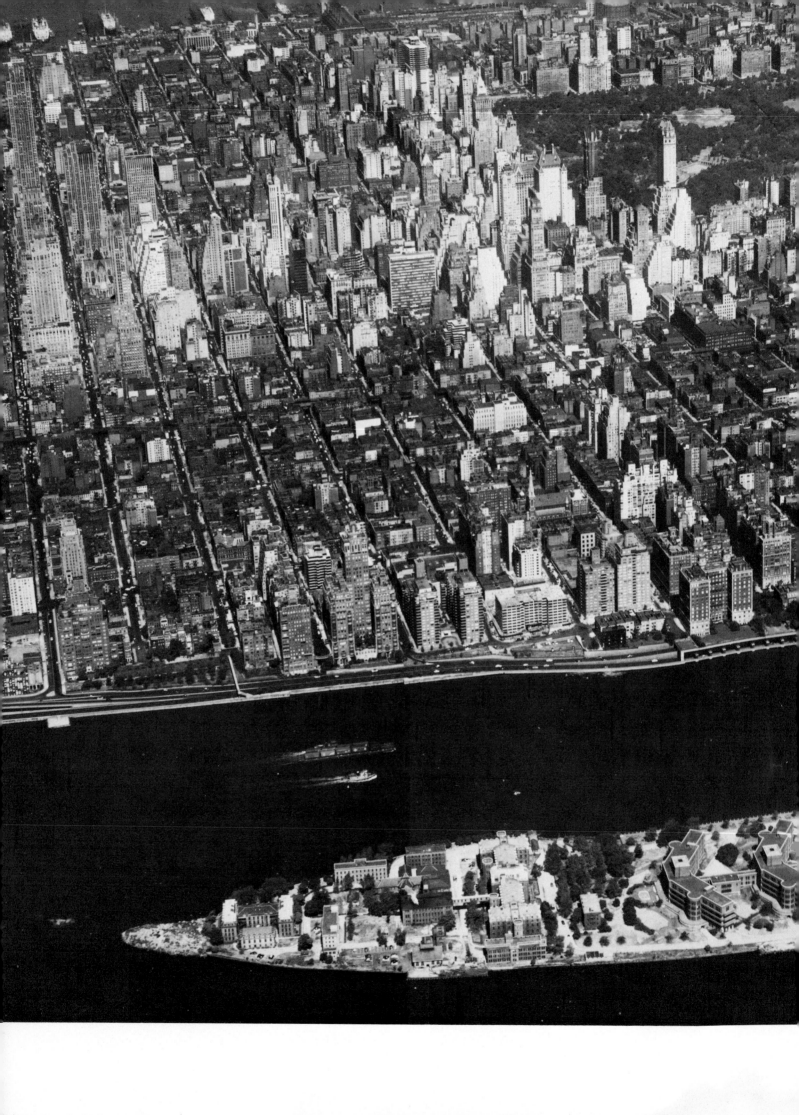

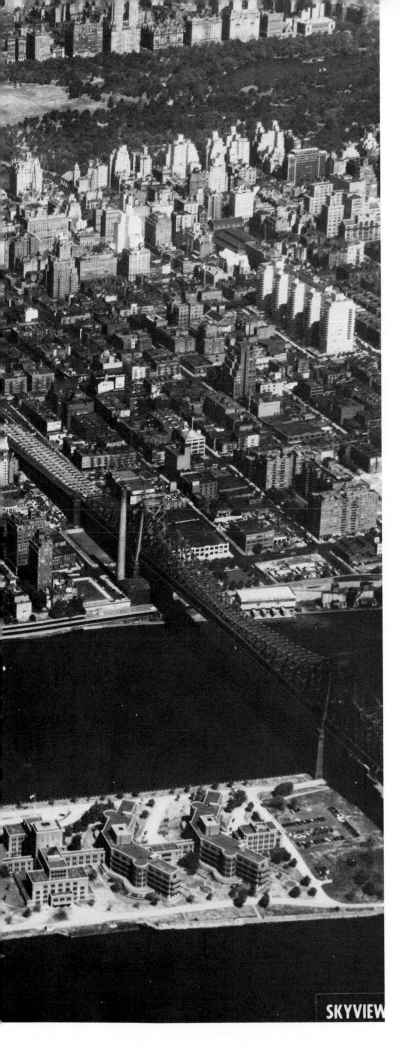

42
Midtown Manhattan and the East Side, north-west from the East River, August 9, 1955

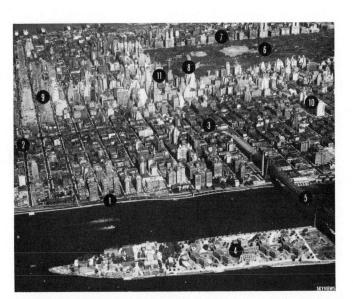

1 Franklin D. Roosevelt Drive.
2 East 49th Street.
3 East 59th Street.
4 Goldwater Memorial Hospital, Roosevelt Island.
5 Queensboro Bridge.
6 Central Park.
7 Central Park West.
8 Hotel Pierre.
9 St. Patrick's Cathedral.
10 Manhattan House.
11 Savoy-Plaza Hotel.

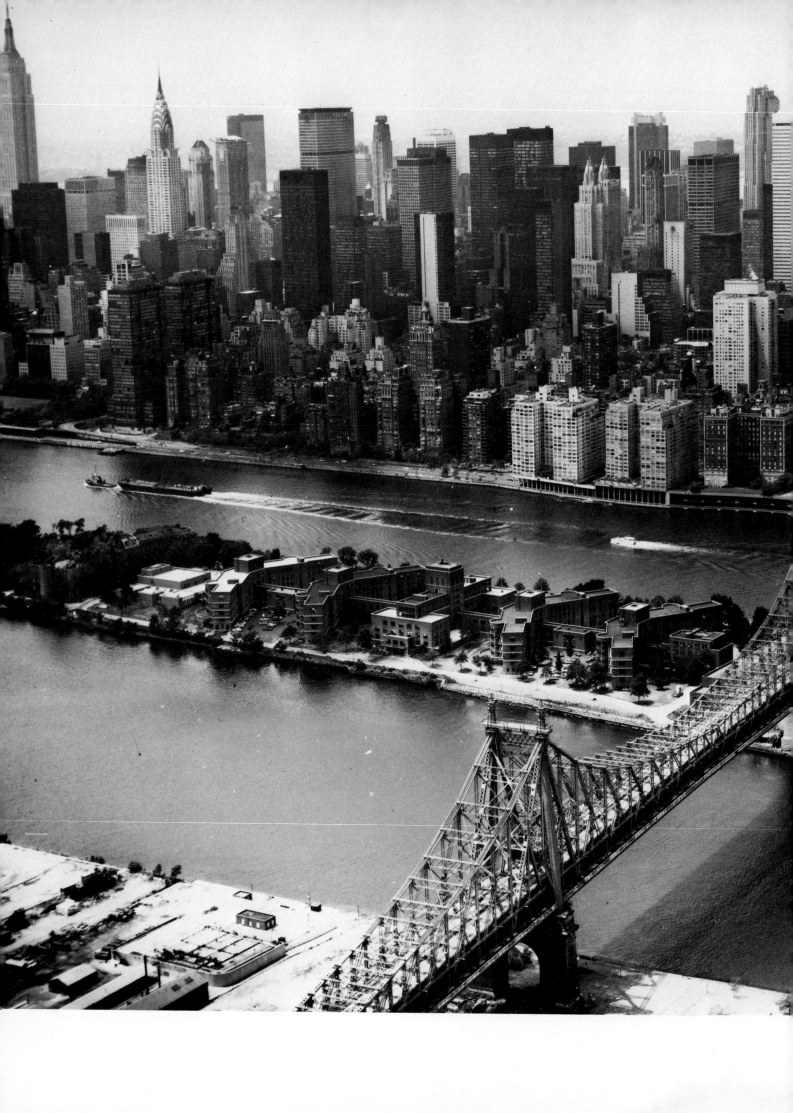

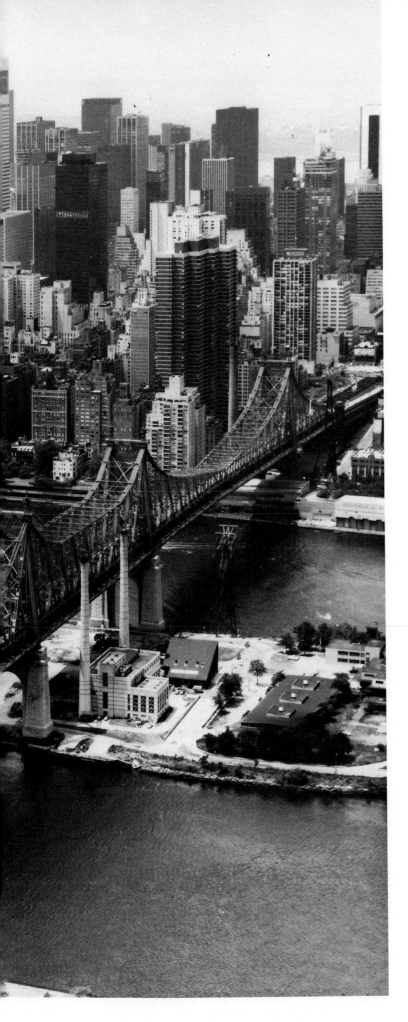

43
The East Side and midtown Manhattan, west from Long Island City, July 10, 1977

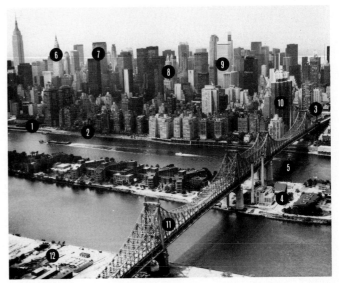

1 East 48th Street.
2 Franklin D. Roosevelt Drive.
3 East 59th Street.
4 Roosevelt Island.
5 Roosevelt Island tramway.
6 Chrysler Building.
7 Pan Am Building.
8 Waldorf-Astoria Hotel.
9 Citicorp Building.
10 Sovereign Apartments.
11 Queensboro Bridge.
12 Long Island City, Queens.

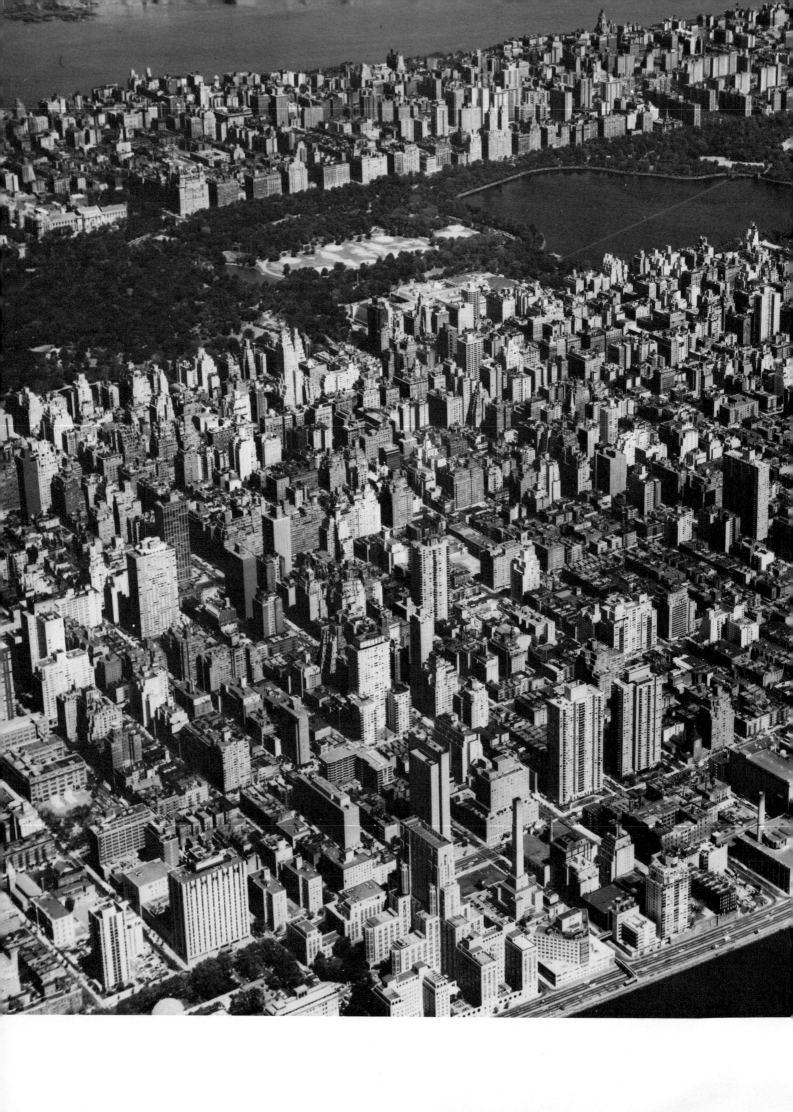

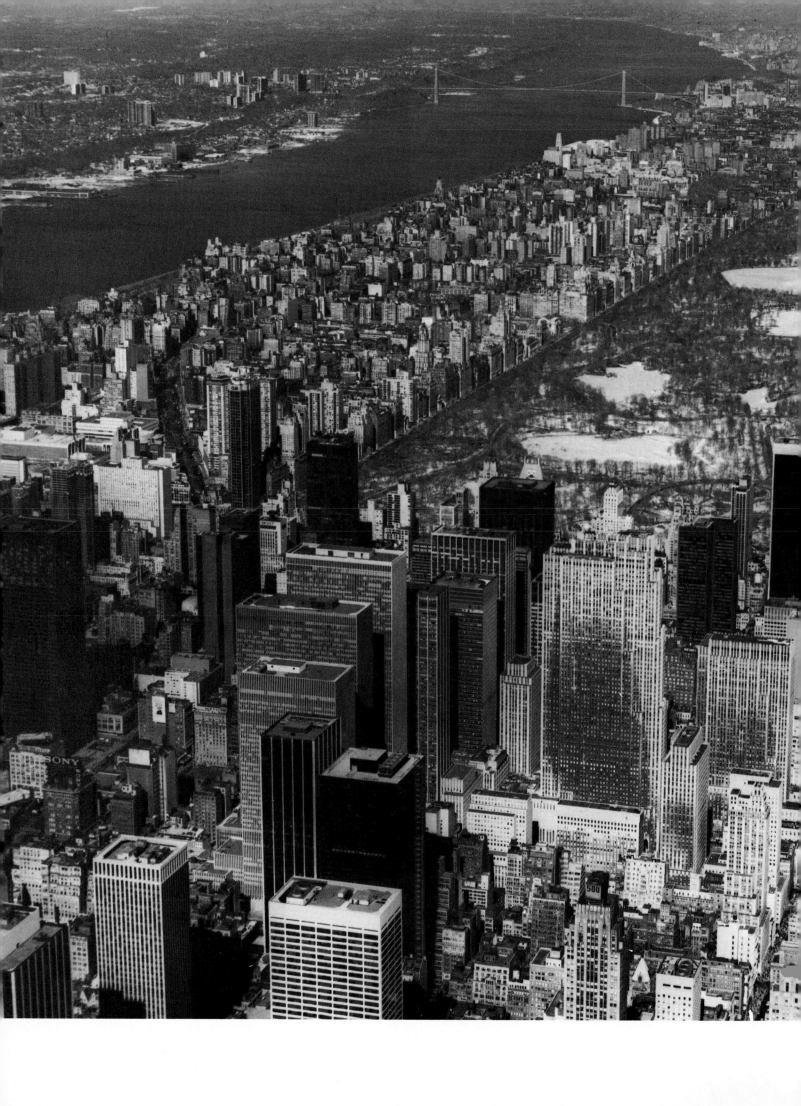

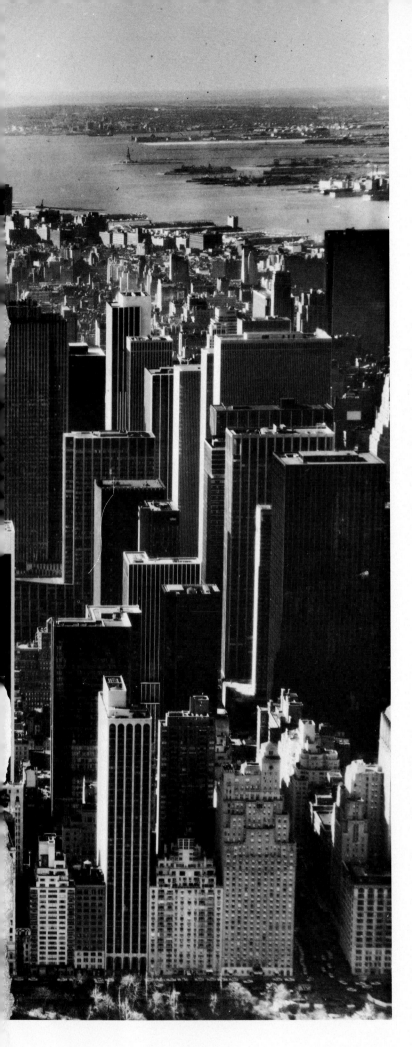

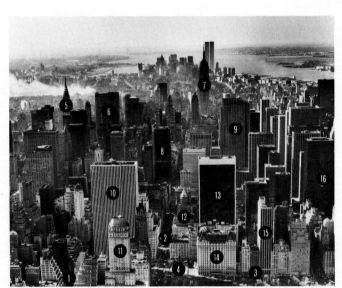

45
Midtown Manhattan, south from Central Park,
February 27, 1975

1 Madison Avenue.
2 Fifth Avenue.
3 Central Park South.
4 Grand Army Plaza.
5 Chrysler Building.
6 Pan Am Building.
7 Empire State Building.
8 Olympic Tower.
9 RCA Building.
10 General Motors Building.
11 Hotel Pierre.
12 Heckscher Building.
13 9 West 57th Street.
14 Plaza Hotel.
15 Park Lane Hotel.
16 Burlington House.

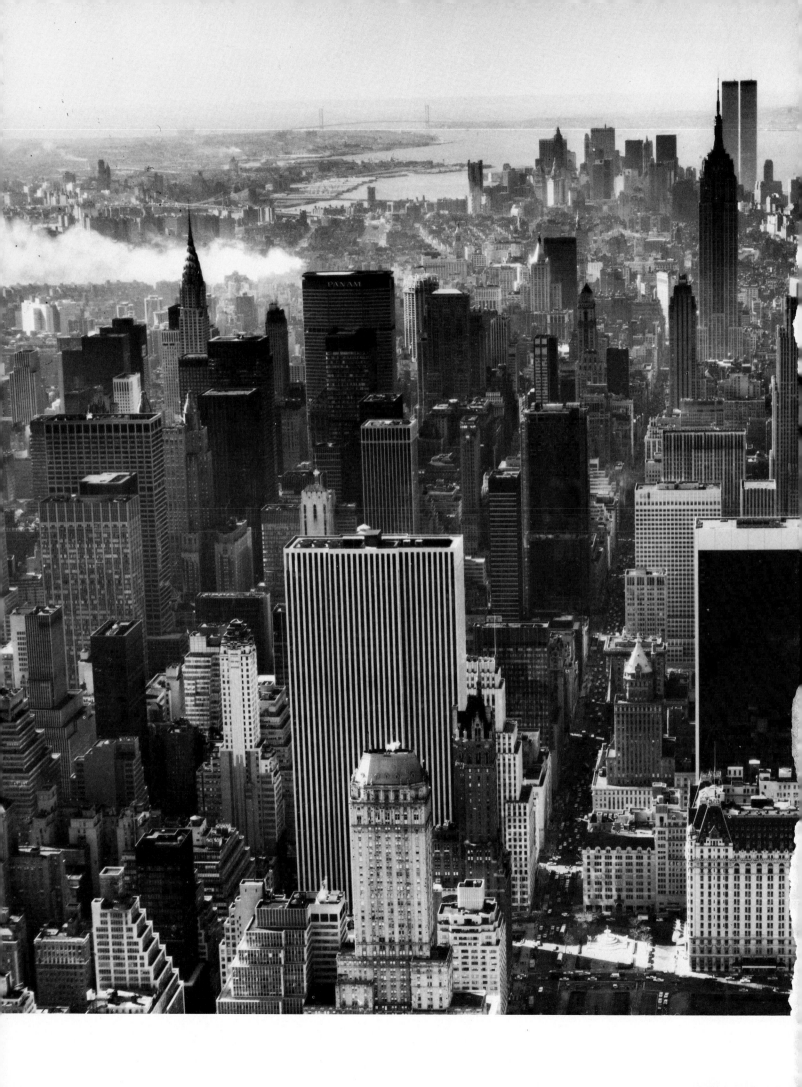

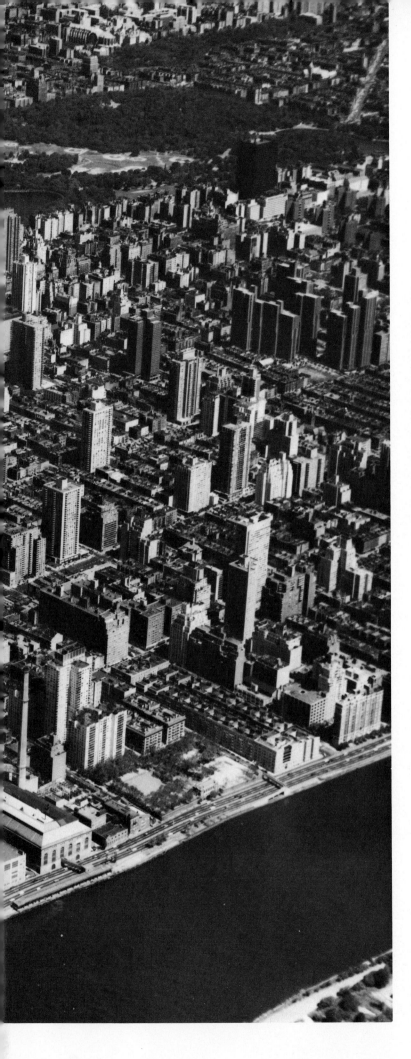

44
Upper midtown Manhattan, north from the East River, June 15, 1978

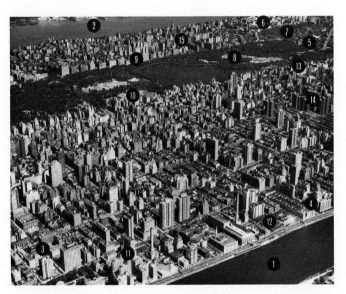

1 East River.
2 Hudson River.
3 East 67th Street.
4 East 79th Street.
5 West 110th Street.
6 Columbia University.
7 Morningside Park.
8 Central Park.
9 Central Park West.
10 Metropolitan Museum of Art.
11 New York Hospital/Cornell Medical College.
12 John Jay Park.
13 Mt. Sinai Hospital.
14 George Washington Houses.
15 Upper West Side.

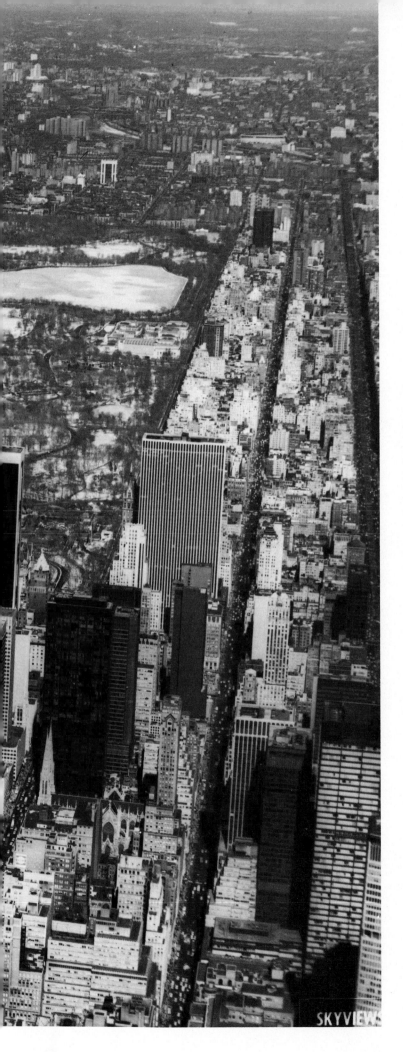

46
Manhattan, north from 43rd Street, March 2, 1978

1 Fifth Avenue.
2 Madison Avenue.
3 Broadway.
4 Central Park West.
5 Central Park.
6 Upper West Side.
7 Gulf & Western Building.
8 Uris Building.
9 Stevens Tower.
10 RCA Building.
11 9 West 57th Street.
12 Olympic Tower.
13 General Motors Building.
14 George Washington Bridge.
15 Fort Lee, New Jersey.

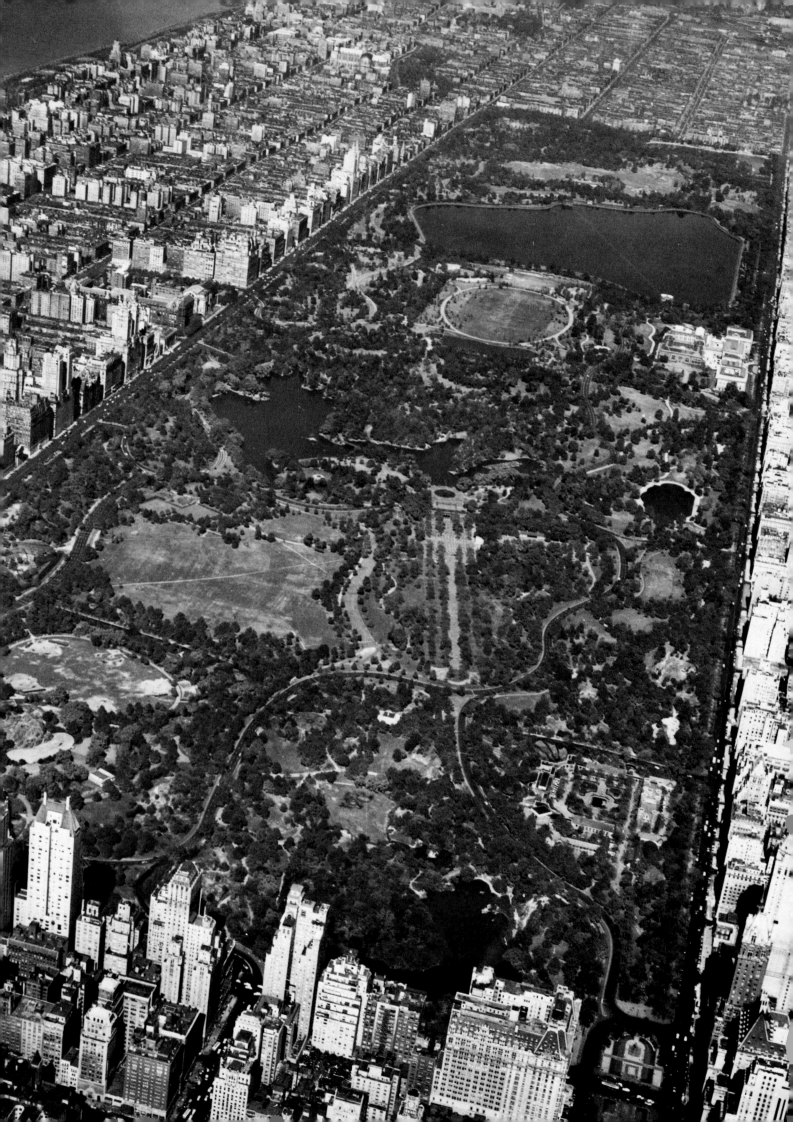

47
Central Park, north from West 57th Street,
September 25, 1946

1 Central Park West.
2 Central Park North (West 110th Street).
3 Fifth Avenue.
4 Hudson River.
5 The Pond.
6 The Zoo.
7 The Sheep Meadow.
8 The Mall.
9 The Lake.
10 The Ramble.
11 Bethesda Fountain.
12 Conservatory Water (Model Boat Pond).
13 The Great Lawn.
14 Metropolitan Museum of Art.
15 Reservoir.
16 Harlem Meer.

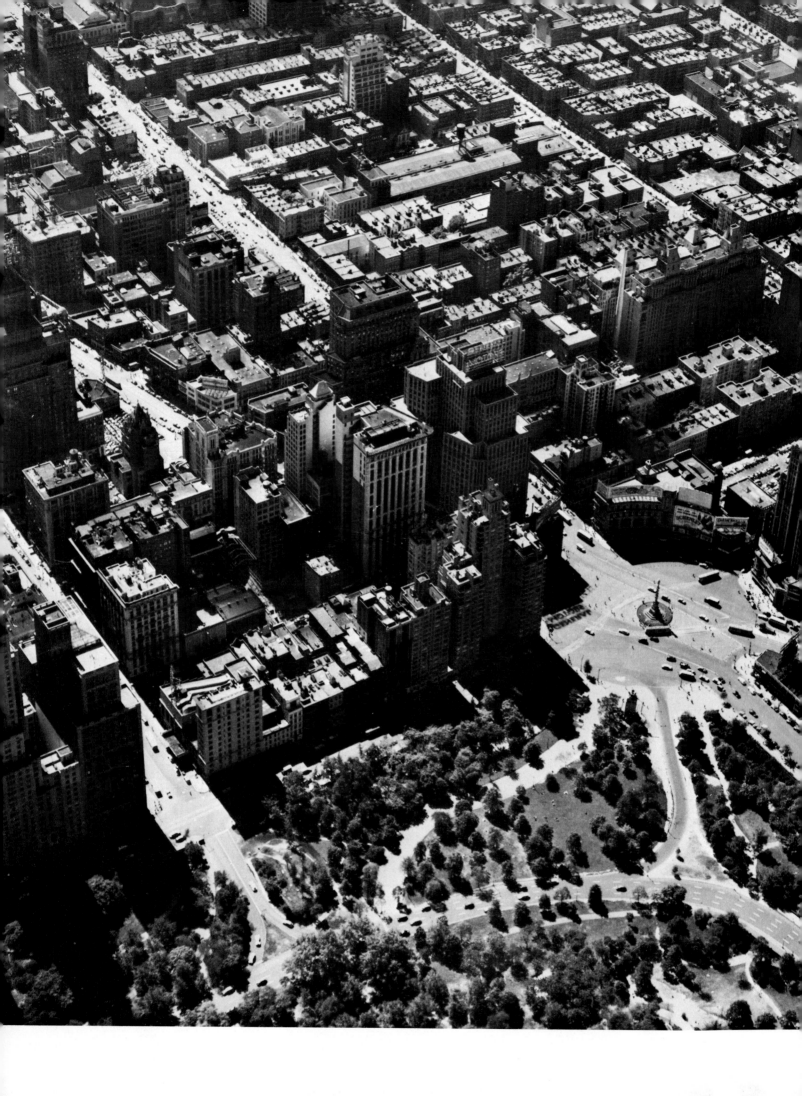

48
Manhattan, southwest across Columbus Circle,
September 13, 1946

1 Seventh Avenue.
2 Central Park South.
3 Central Park West.
4 Broadway.
5 Eighth Avenue.
6 Central Park.
7 Columbus Circle.
8 Century Apartments.
9 Mayflower Hotel.
10 General Motors Building.
11 Park Vendome Apartments.
12 Hotel Henry Hudson.
13 New York Sheraton.

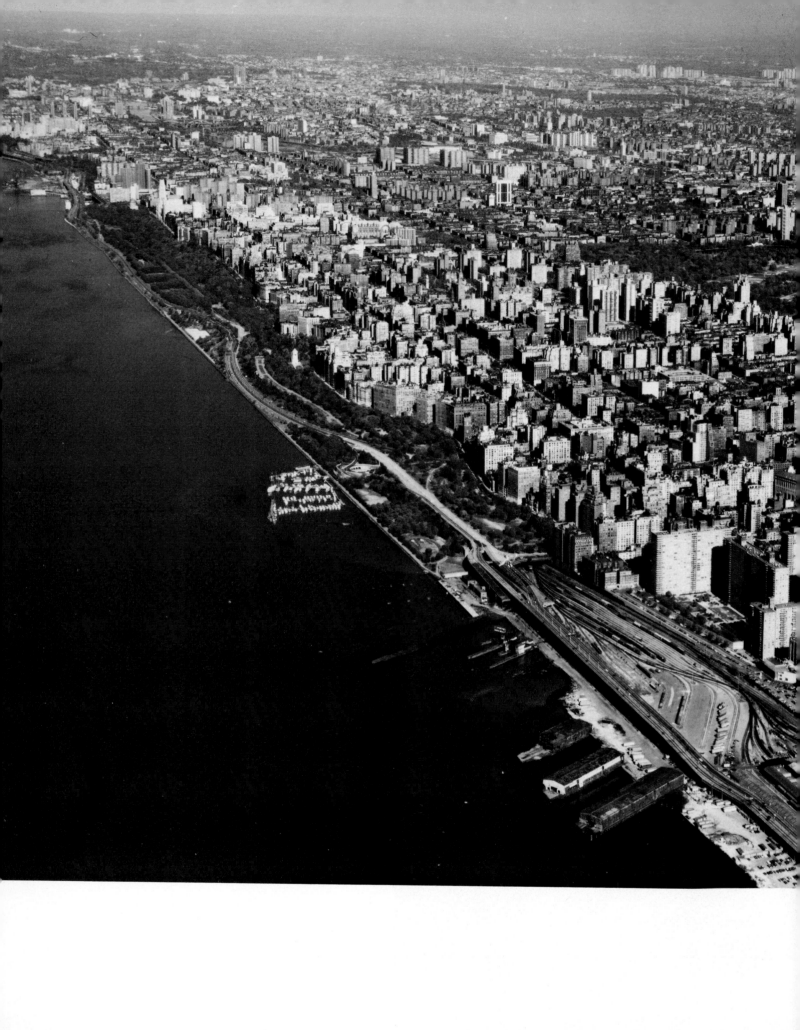

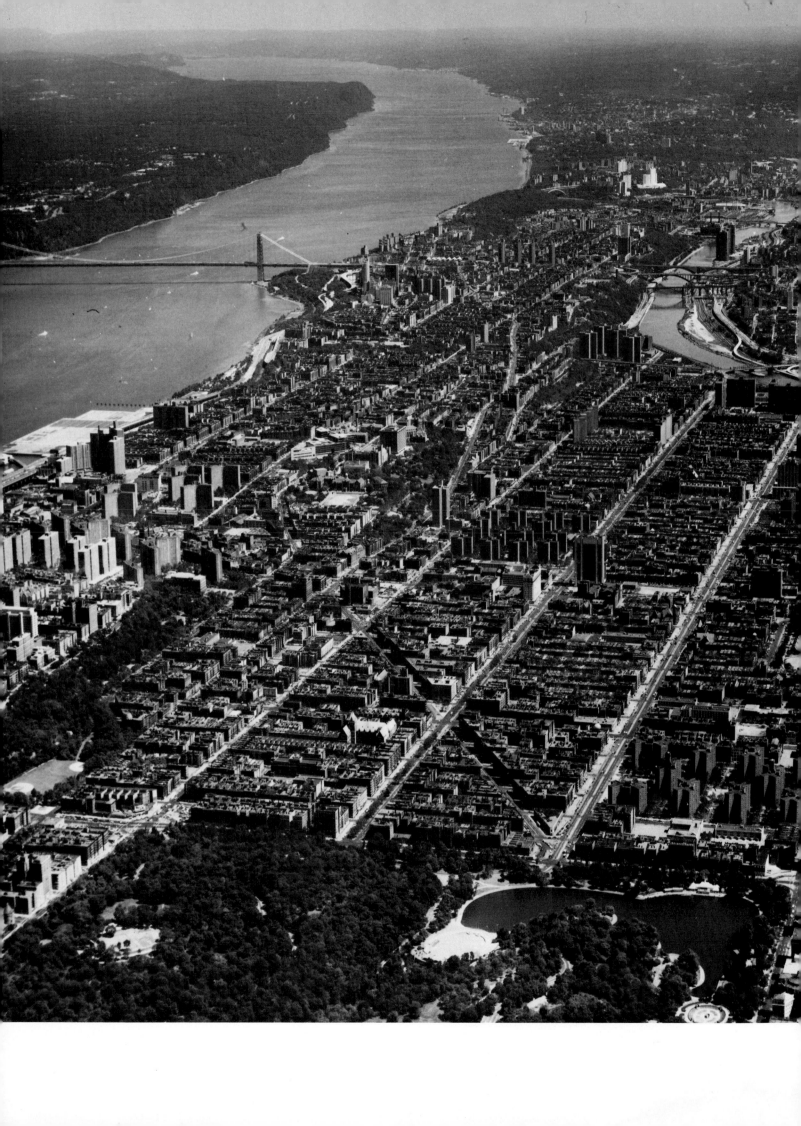

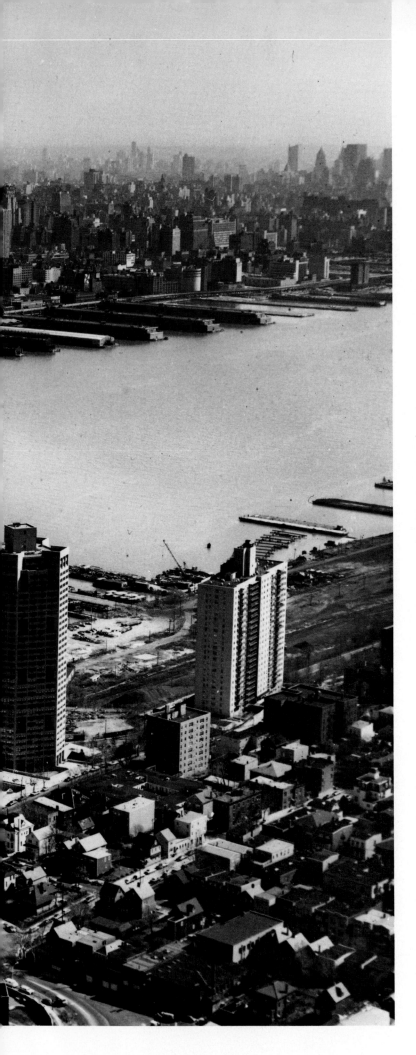

50
Midtown Manhattan, southeast across the Hudson River from New Jersey, March 29, 1977

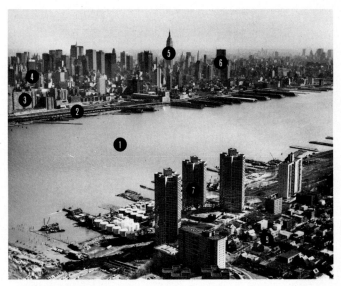

1 Hudson River.
2 West Side Highway.
3 Lincoln Towers.
4 Gulf & Western Building.
5 Empire State Building.
6 1 Penn Plaza.
7 Galaxie Apartments.
8 Guttenberg, New Jersey.

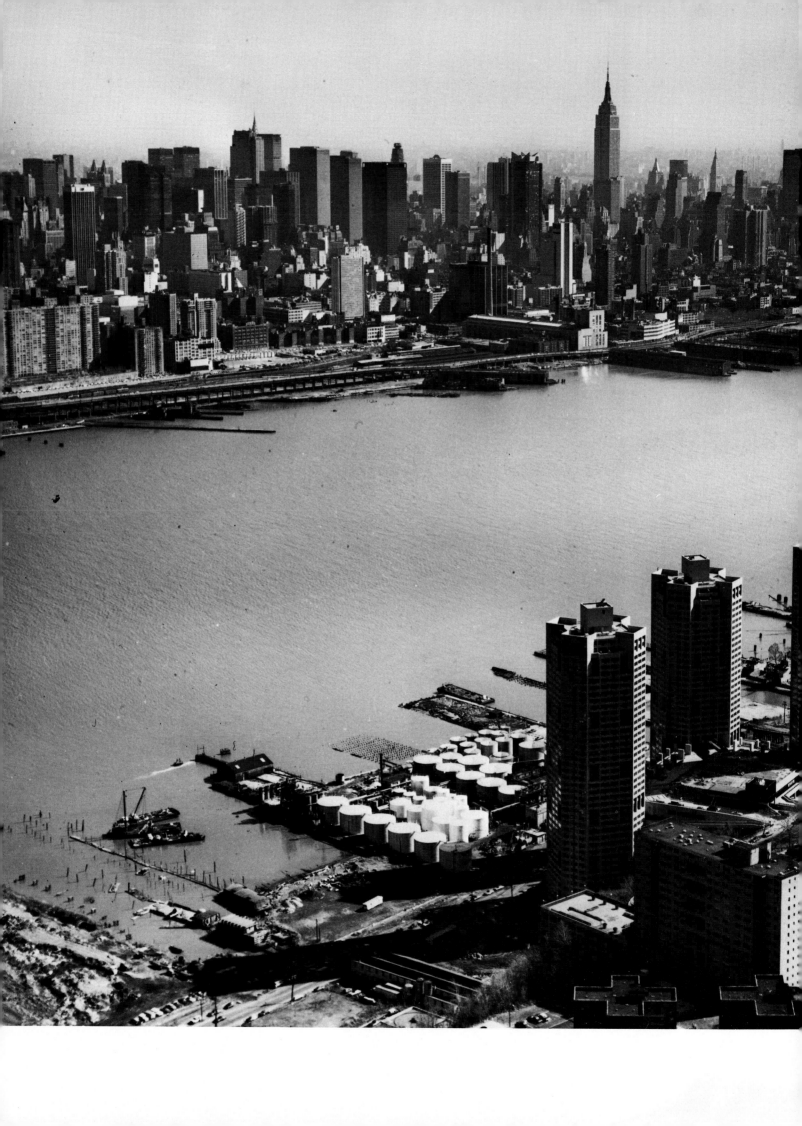

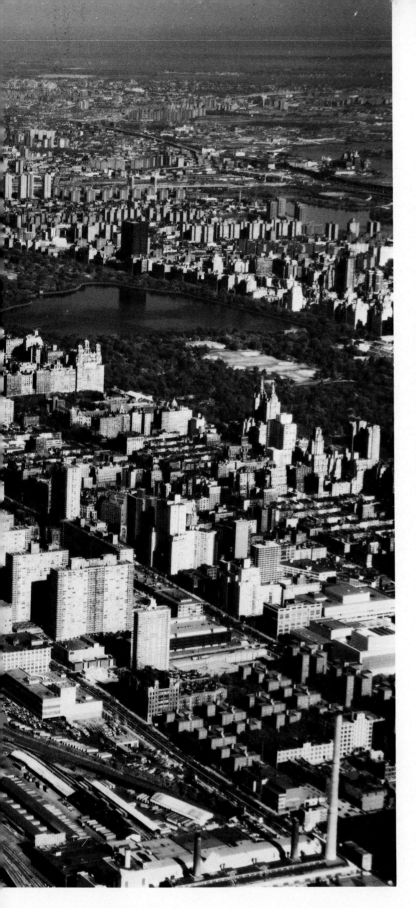

49
Manhattan, northeast across the Upper West Side from the Hudson River at West 59th Street, October 24, 1974

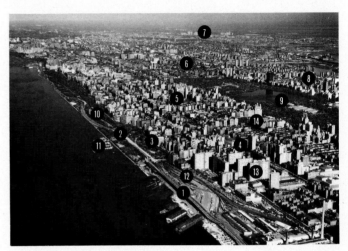

 1 West Side Highway.
 2 Henry Hudson Parkway.
 3 Riverside Drive.
 4 Verdi Square.
 5 Upper West Side.
 6 Harlem.
 7 The Bronx.
 8 Upper East Side.
 9 Central Park.
10 Riverside Park.
11 79th Street Boat Basin.
12 Conrail Freight Yard.
13 Lincoln Towers Apartments.
14 American Museum of Natural History.

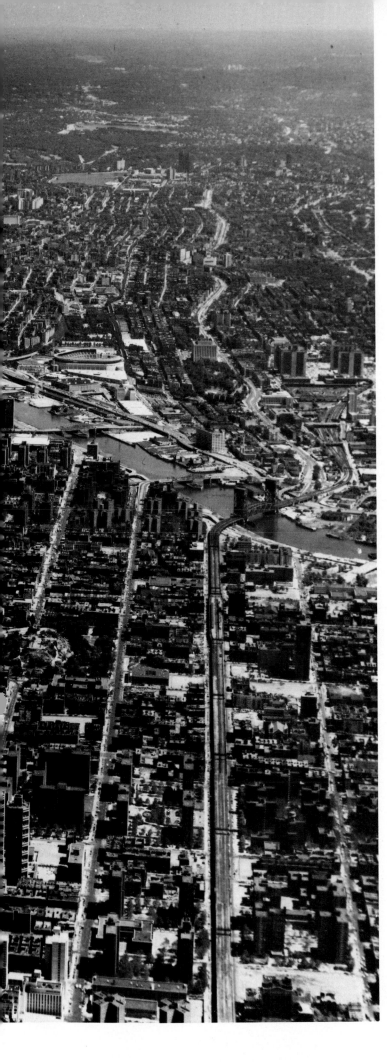

51
Manhattan, north across Harlem from Central Park, June 15, 1978

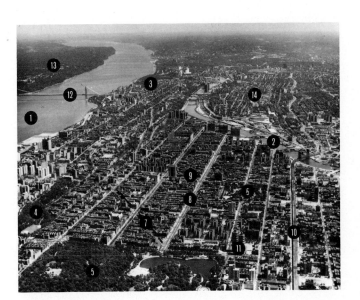

1 Hudson River.
2 Harlem River.
3 Inwood Hill Park.
4 Morningside Park.
5 Central Park.
6 Marcus Garvey Park.
7 St. Nicholas Avenue.
8 Lenox Avenue.
9 West 125th Street.
10 Park Avenue.
11 Arthur A. Schomburg Plaza Apartments.
12 George Washington Bridge.
13 Englewood Cliffs, New Jersey.
14 The Bronx.

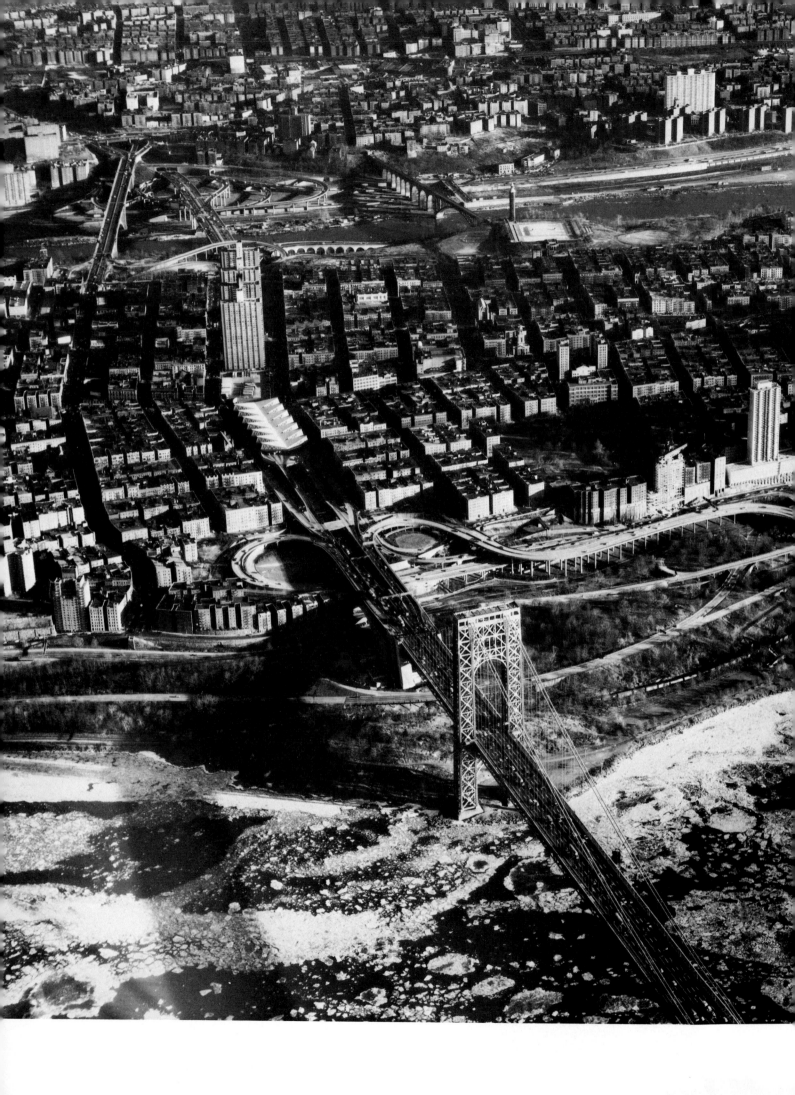

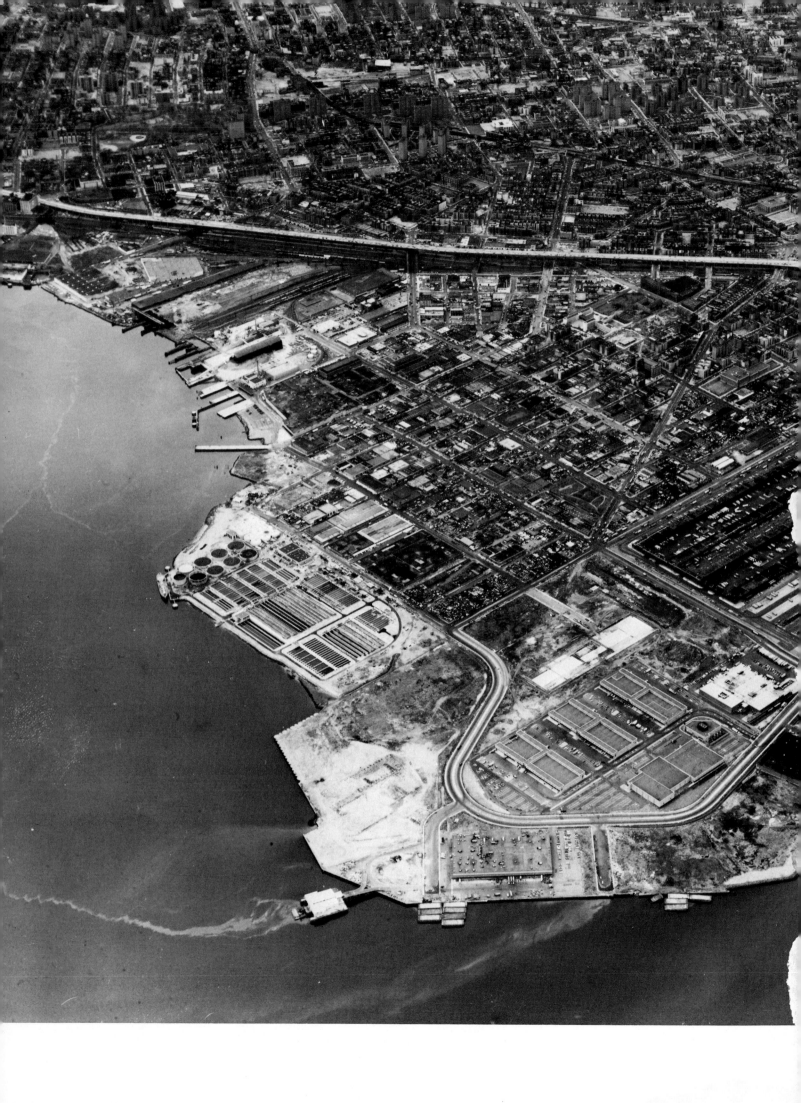

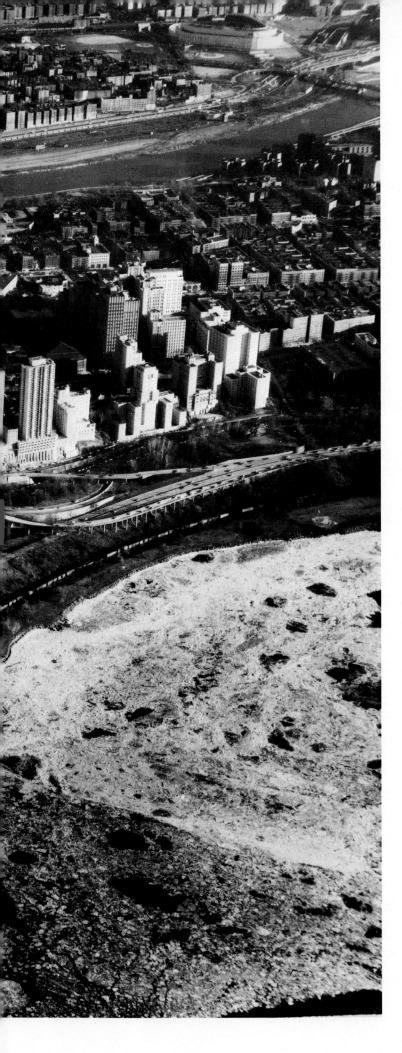

52
West from the Hudson River, across Washington Heights to the Mt. Morris section of The Bronx, January 12, 1973

1 Hudson River.
2 Harlem River.
3 Riverside Park.
4 Henry Hudson Parkway.
5 Riverside Drive.
6 Major Deegan Expressway, The Bronx.
7 Jerome Avenue, The Bronx.
8 High Bridge.
9 George Washington Bridge.
10 Conrail freight cars.
11 Bus Terminal.
12 Bridge Apartments.
13 Columbia-Presbyterian Medical Center.
14 Yankee Stadium.

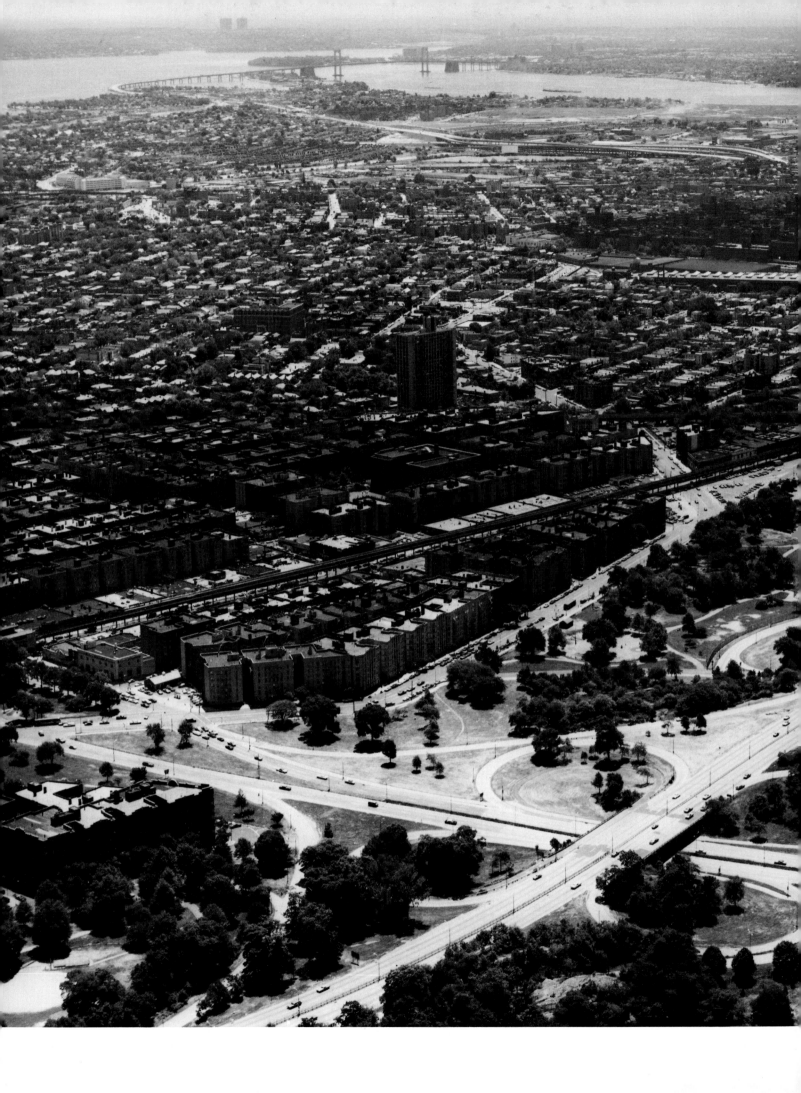

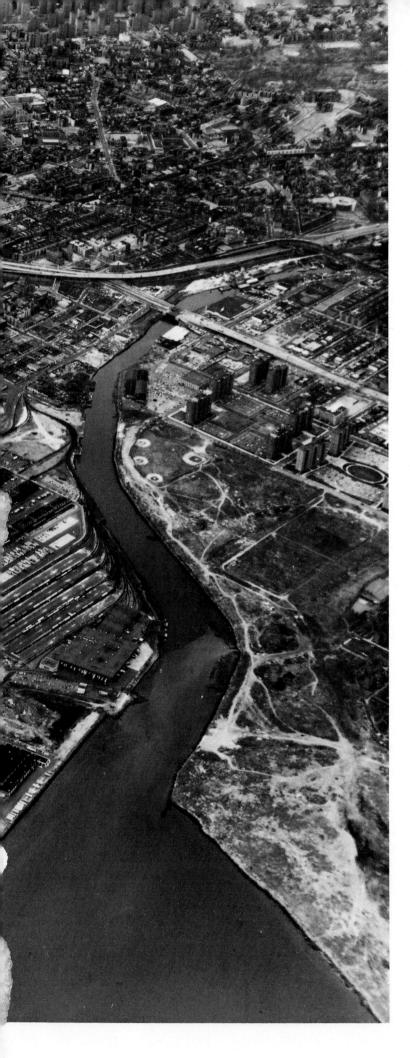

53
The Bronx, west over Hunts Point toward Morrisania, March 29, 1976

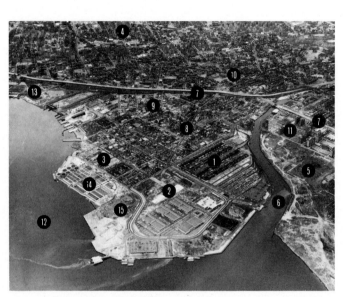

1 New York Terminal Market.
2 Consolidated Edison Co.
3 Hunts Point business district.
4 Morrisania.
5 Sound View Point.
6 Bronx River.
7 Bruckner Expressway.
8 Hunts Point Avenue.
9 Longwood Avenue.
10 Westchester Avenue.
11 Evergreen Gardens Housing.
12 East River.
13 Port Morris.
14 Hunts Point Sewage Treatment Works.
15 Hunts Point Park.

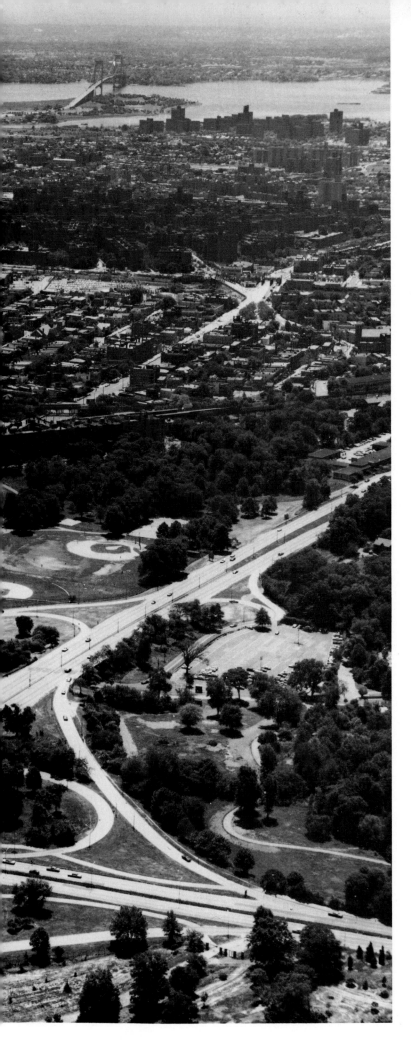

54
The Bronx, south toward Long Island from Bronx Park, May 28, 1975

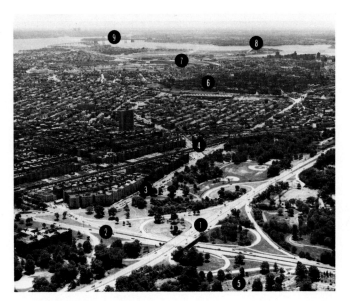

1 Bronx River Parkway.
2 Bronx and Pelham Parkway.
3 Bronx Park East.
4 IRT subway line.
5 Bronx Park.
6 Parkchester.
7 Cross Bronx Expressway.
8 Bronx-Whitestone Bridge.
9 Throgs Neck Bridge.

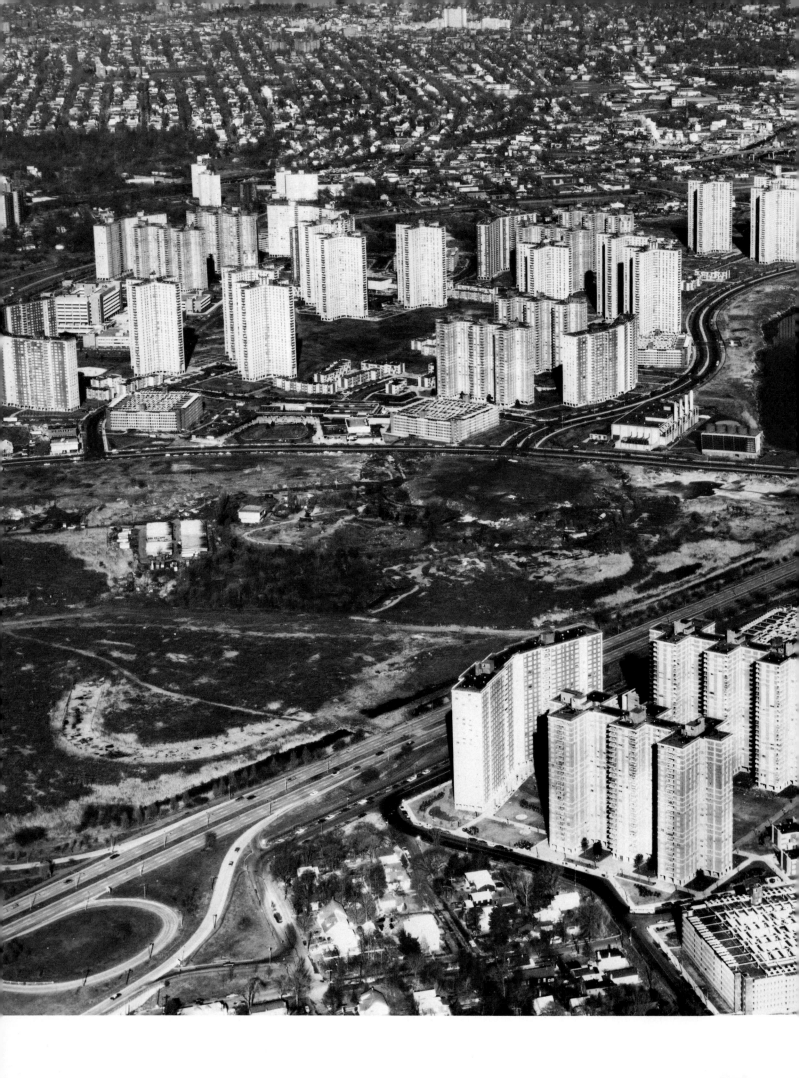

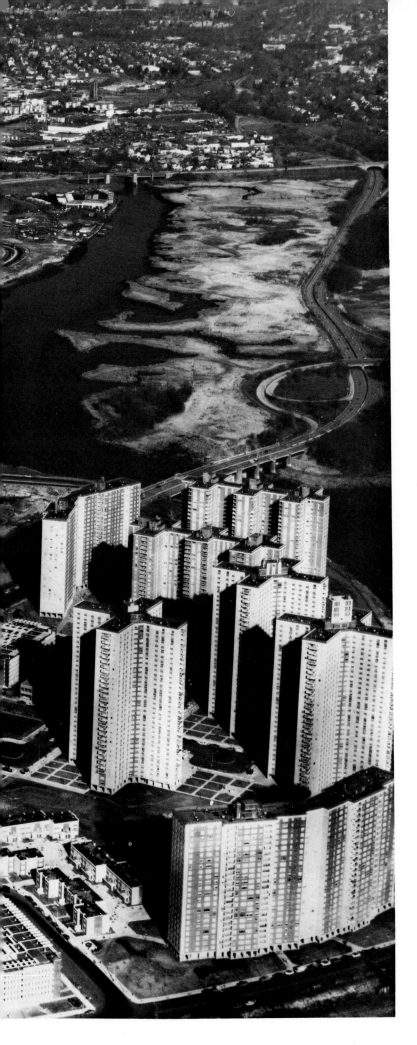

55
The Bronx, north over Baychester, December 14, 1972

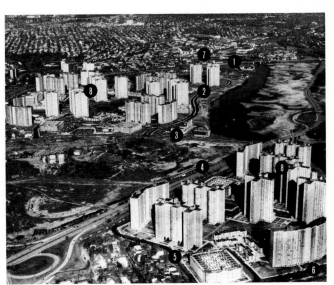

1 New England Thruway.
2 Co-op City Boulevard.
3 Bartow Avenue.
4 Hutchinson River Parkway.
5 Hunter Avenue.
6 Erskine Place.
7 Boston Post Road.
8 Co-op City.

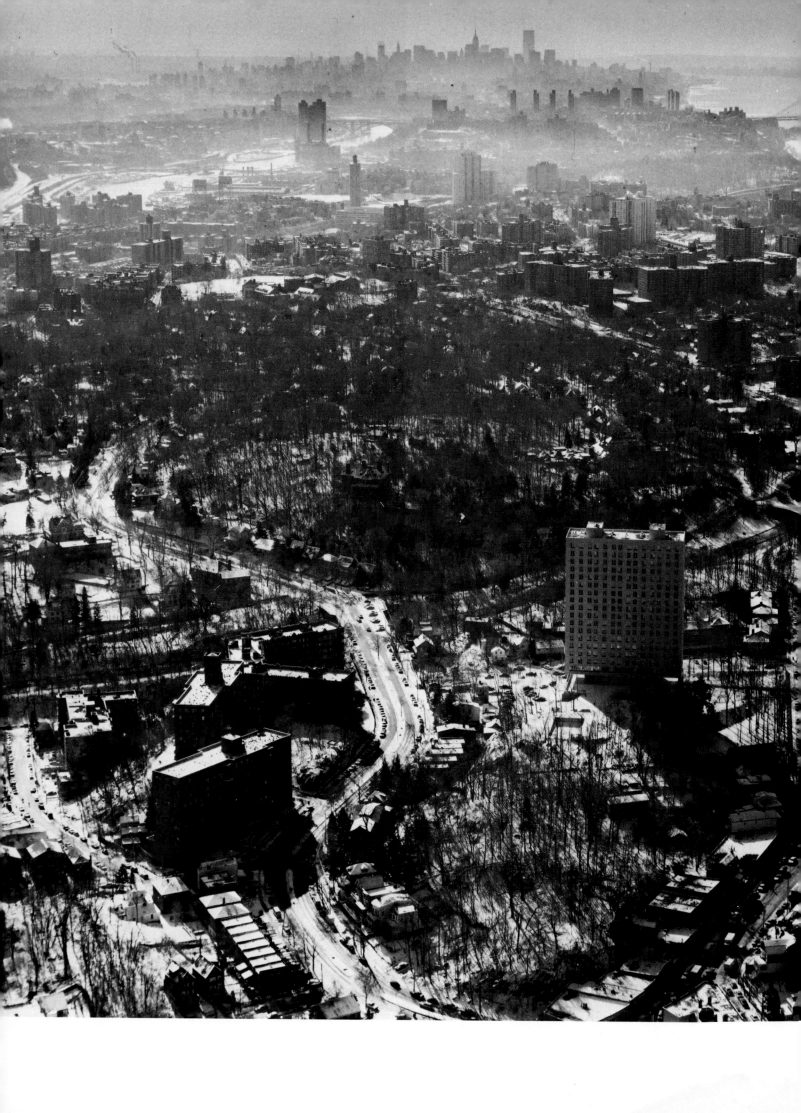

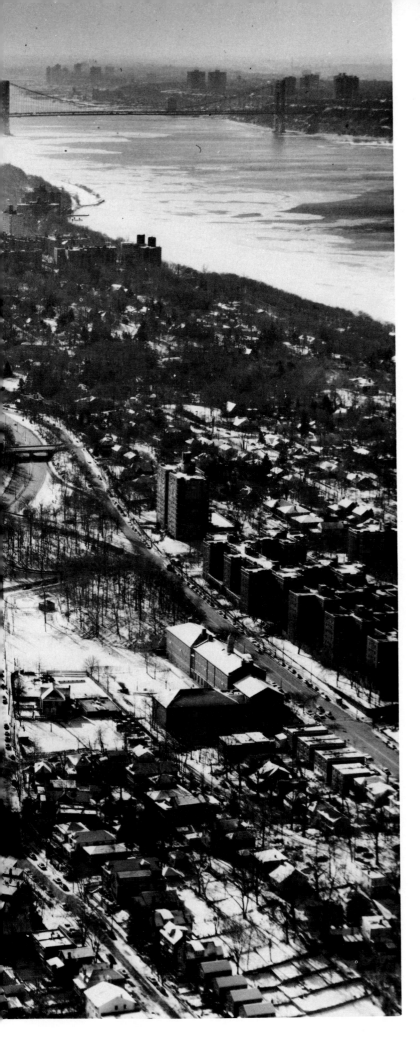

56
The Bronx, south from the Westchester border,
December 31, 1976

1 Hudson River.
2 Harlem River.
3 Upper Manhattan.
4 Riverdale.
5 Mosholu.
6 Henry Hudson Parkway.
7 Riverdale Avenue.
8 Liebig Avenue.
9 Mosholu Parkway.
10 Fieldston Road.
11 Alles Avenue.
12 George Washington Bridge.

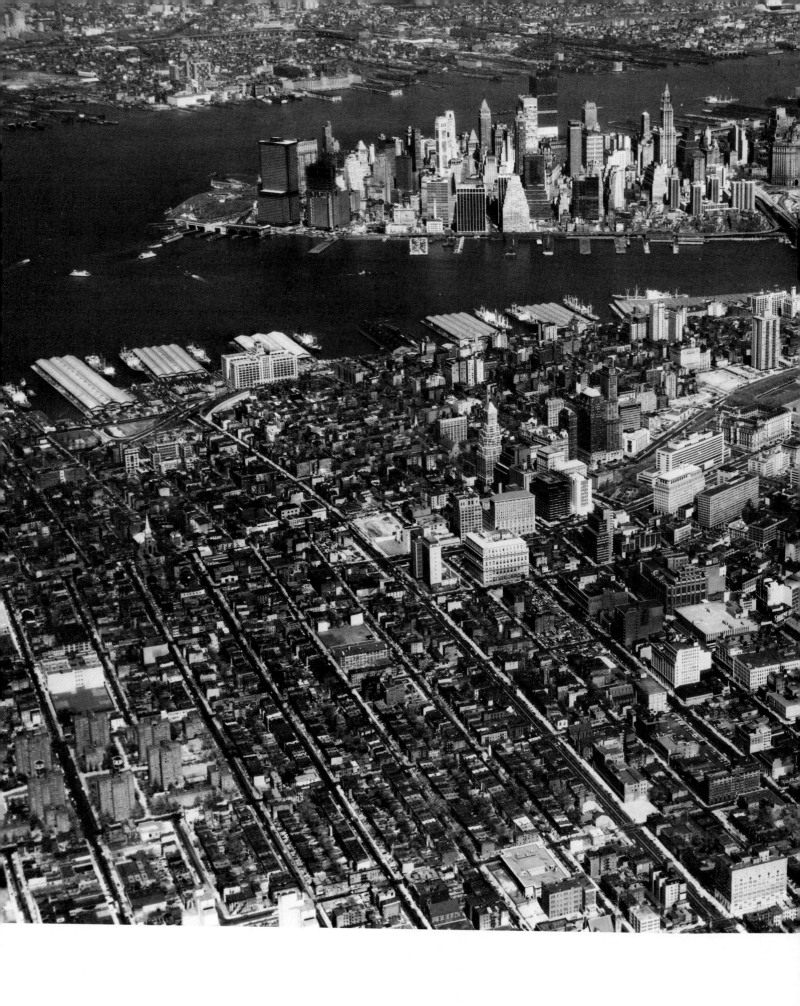

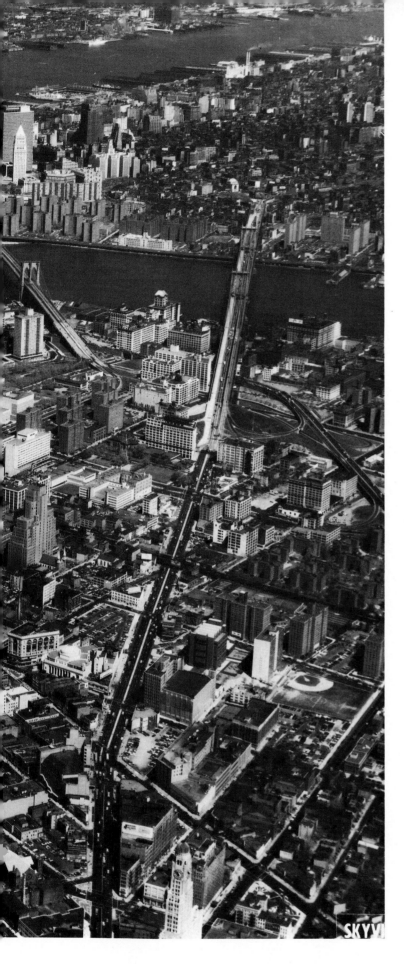

57
Downtown Brooklyn, west toward lower Manhattan, May 7, 1970

1 Brooklyn Heights.
2 Cobble Hill.
3 Boerum Hull.
4 Civic Center.
5 Parkes Cadman Plaza.
6 Borough Hall.
7 Bergen Street.
8 Atlantic Avenue.
9 Fulton Street.
10 Flatbush Avenue.
11 Williamsburgh Savings Bank Tower.
12 Brooklyn Bridge.
13 Manhattan Bridge.
14 Lower Manhattan.

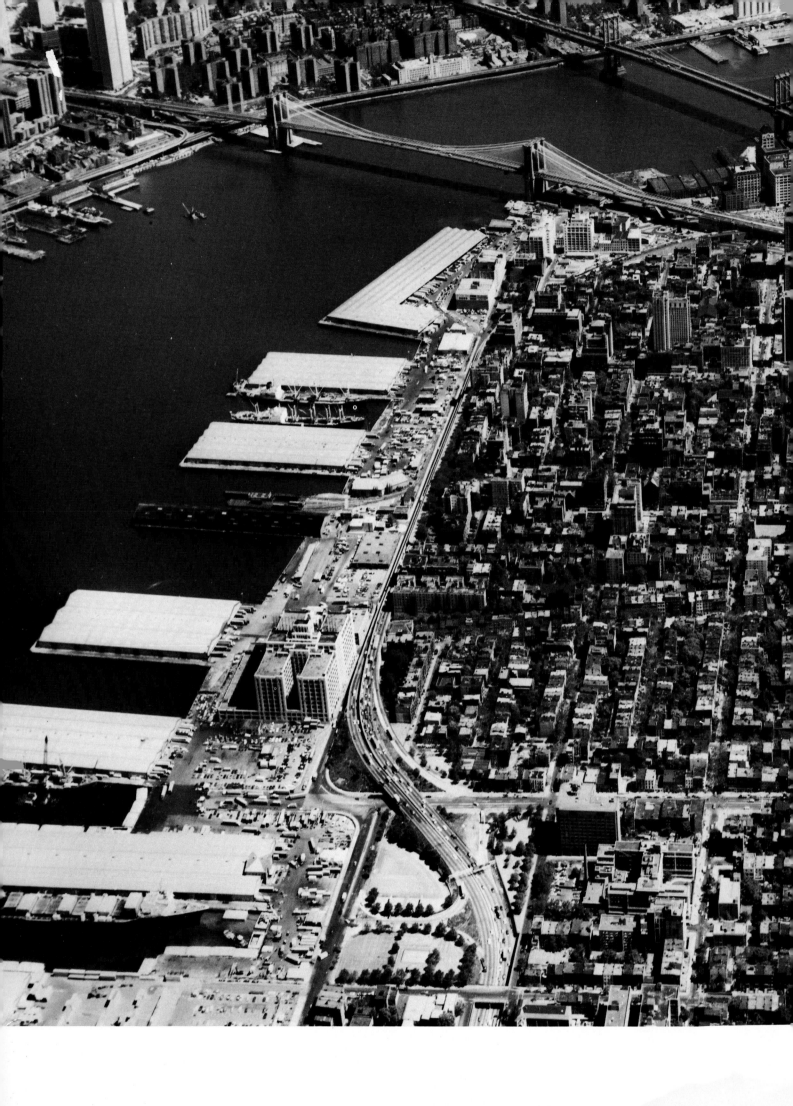

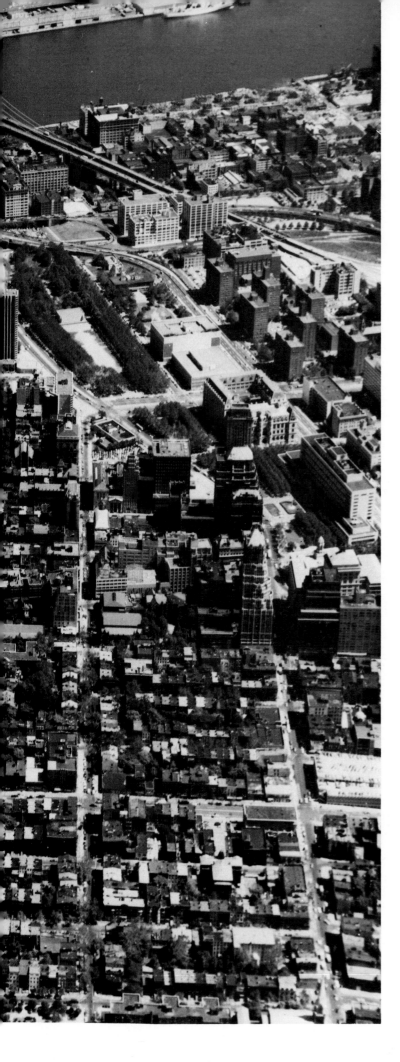

58
North across Brooklyn Heights, June 15, 1978

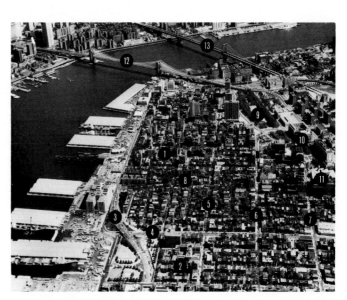

1 Brooklyn Heights.
2 Cobble Hill.
3 Brooklyn-Queens Expressway.
4 Atlantic Avenue.
5 Henry Street.
6 Clinton Street.
7 Court Street.
8 Joralemon Street.
9 Parkes Cadman Plaza.
10 Civic Center.
11 Borough Hall.
12 Brooklyn Bridge.
13 Manhattan Bridge.

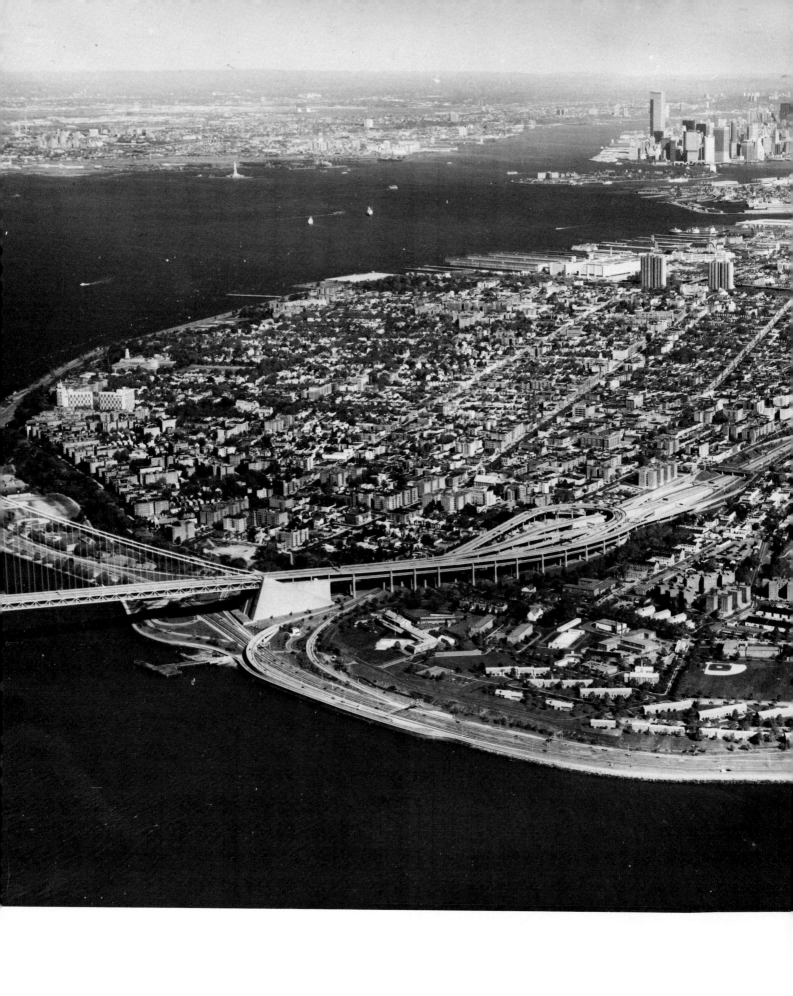

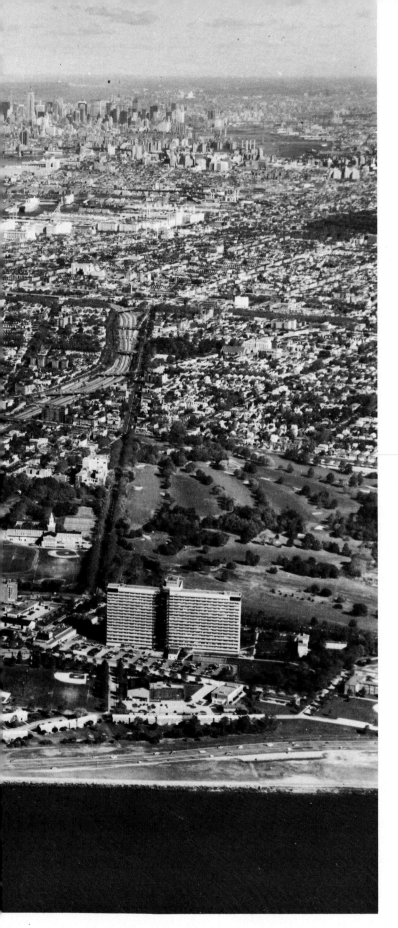

59
Brooklyn, north from Gravesend Bay across Bay Ridge and Dyker Heights, October 18, 1976

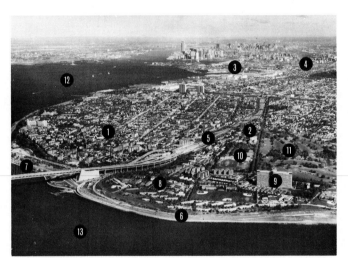

1 Bay Ridge.
2 Dyker Heights.
3 South Brooklyn.
4 Downtown Brooklyn.
5 Gowanus Expressway.
6 Shore Parkway.
7 Verrazano-Narrows Bridge.
8 Fort Hamilton.
9 Veterans Administration Hospital.
10 Poly Prep School.
11 Dyker Beach Golf Course.
12 Upper New York Bay.
13 Gravesend Bay.

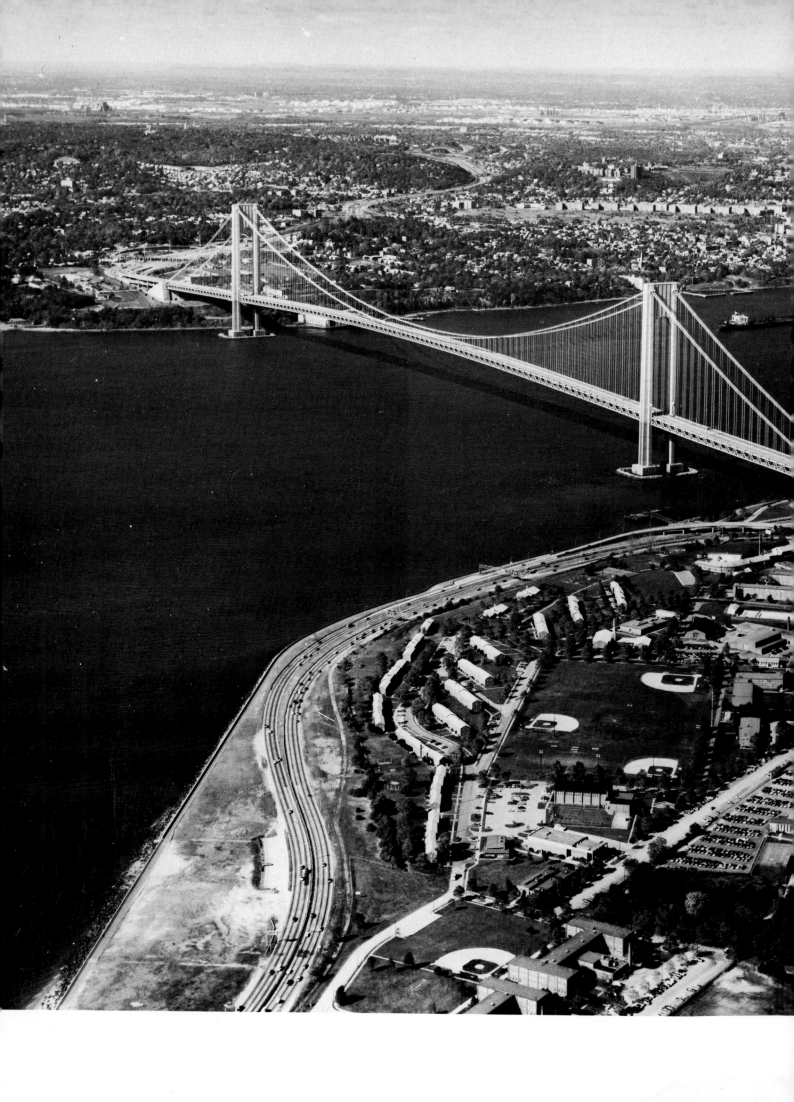

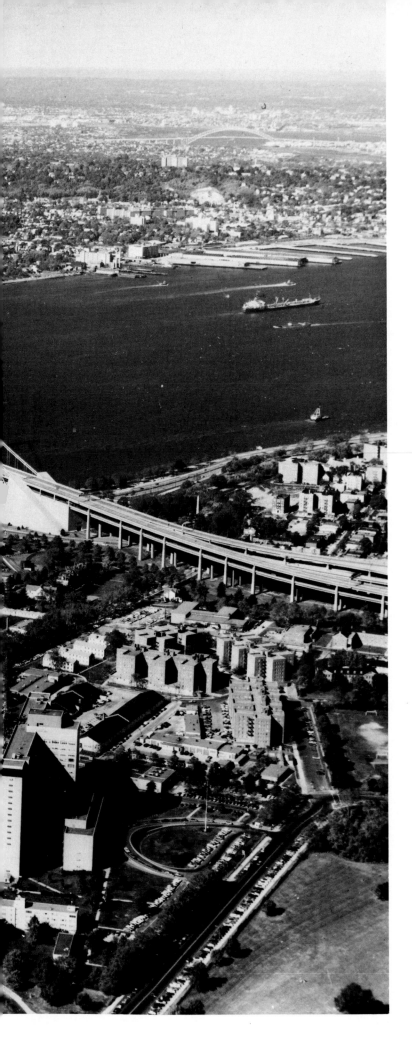

60
Northwest across Fort Hamilton, Brooklyn, toward Staten Island, October 18, 1976

1 Fort Hamilton.
2 Shore Parkway.
3 Veterans Administration Hospital.
4 Poly Place.
5 Dyker Beach Park.
6 Bayonne Bridge.
7 The Narrows.
8 Verrazano-Narrows Bridge.
9 Rosebank, Staten Island.
10 New Jersey.

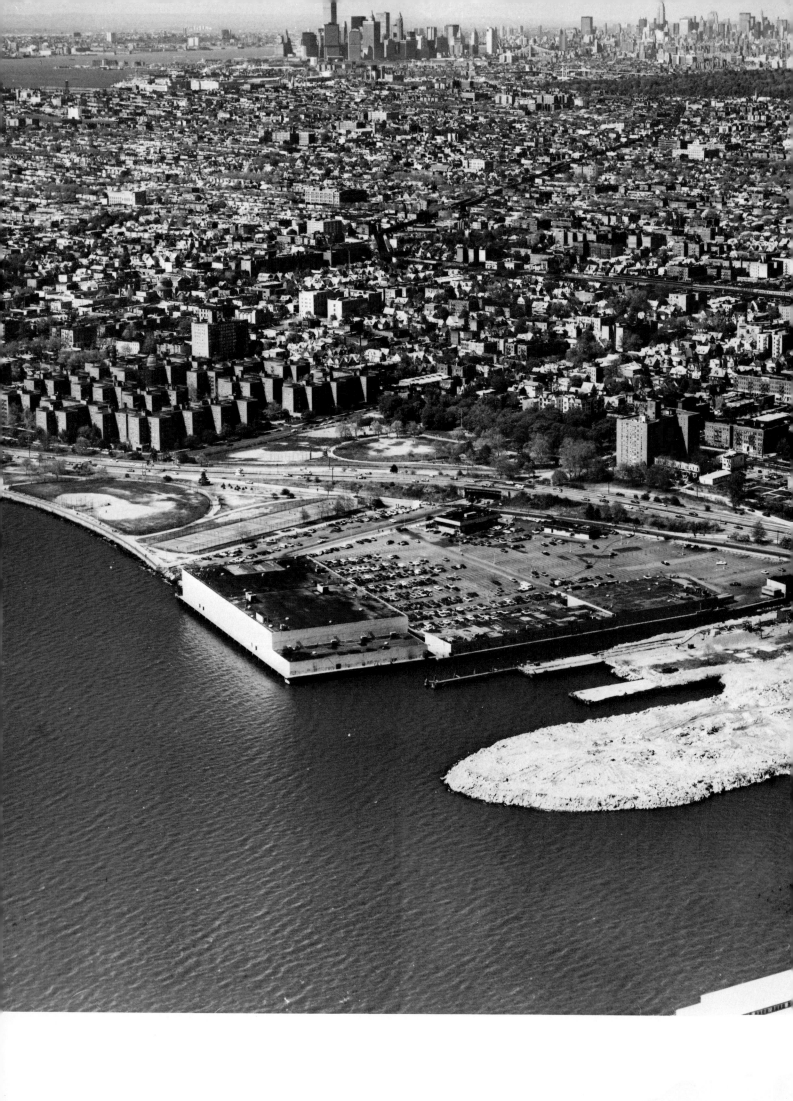

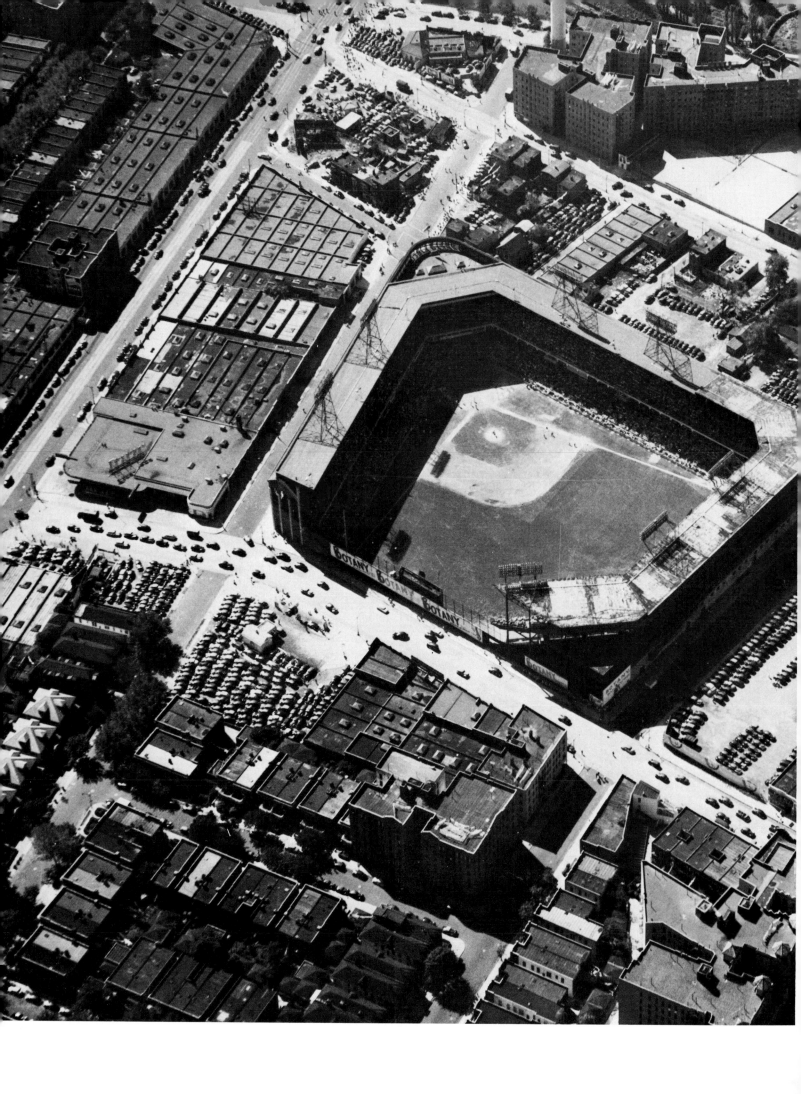

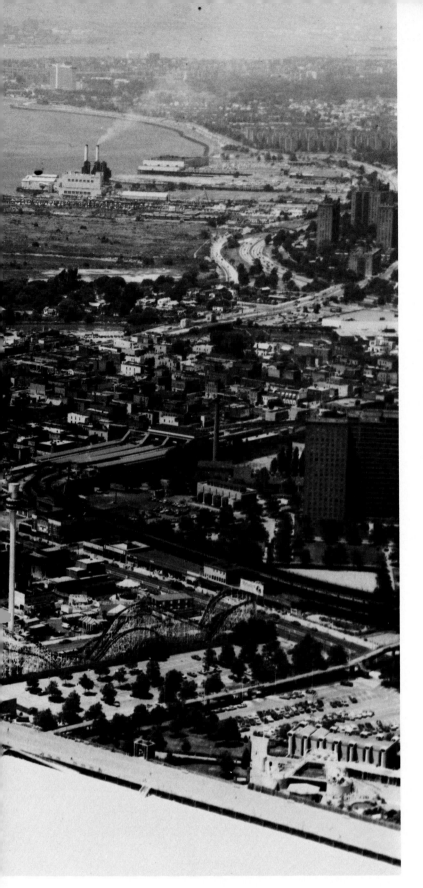

62
Northwest across Coney Island, Brooklyn, July 15, 1977

1 Atlantic Ocean.
2 Gravesend Bay.
3 Coney Island Creek.
4 Coney Island Boat Basin.
5 Beach.
6 Riegelmann Boardwalk.
7 Surf Avenue.
8 Stilwell Avenue Subway Terminal.
9 Amusement area.
10 New York Aquarium.
11 Dreier-Offerman Park.
12 Fort Hamilton.
13 Verrazano-Narrows Bridge.
14 Staten Island.

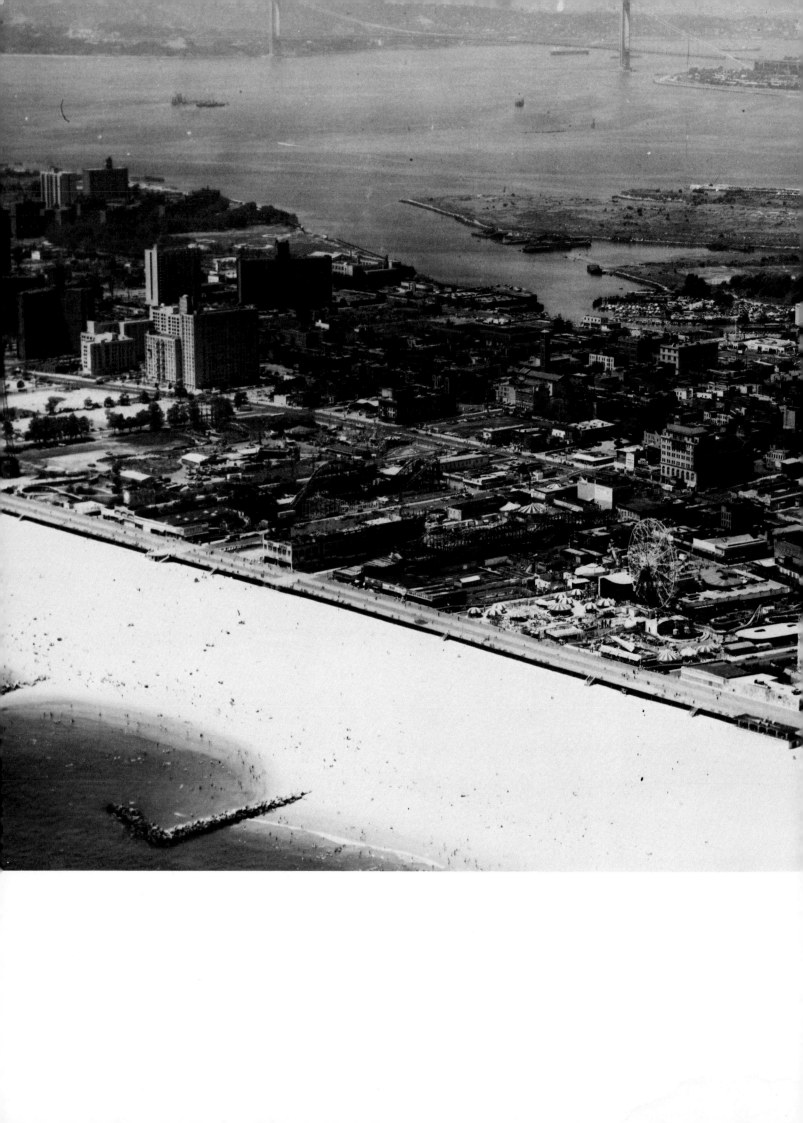

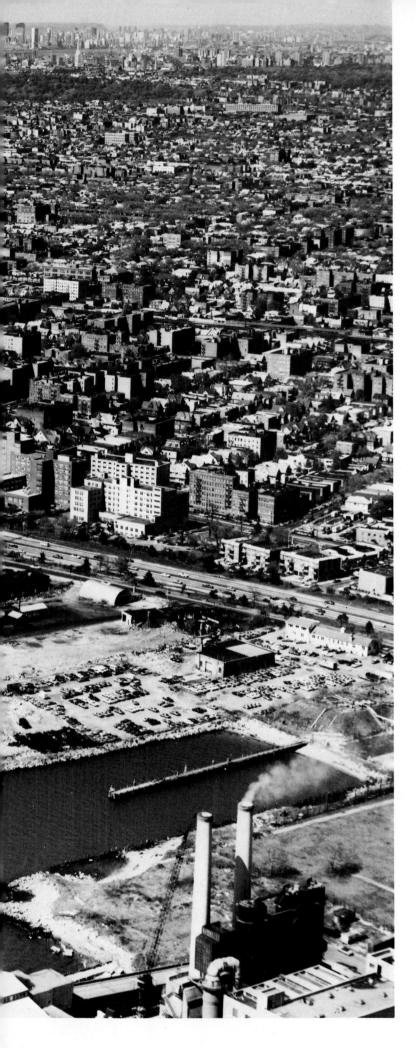

61

Northeast from Gravesend Bay, across Bensonhurst, Brooklyn, April 29, 1977

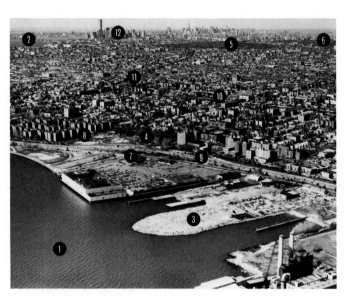

1 Gravesend Bay.
2 Upper New York Bay.
3 Landfill.
4 Bensonhurst Park.
5 Greenwood Cemetery.
6 Prospect Park.
7 Bay Parkway.
8 21st Avenue.
9 Shore Parkway.
10 86th Street.
11 New Utrecht Avenue.
12 Manhattan.

63
West across Ebbets Field, Crown Heights, Brooklyn, September 25, 1946

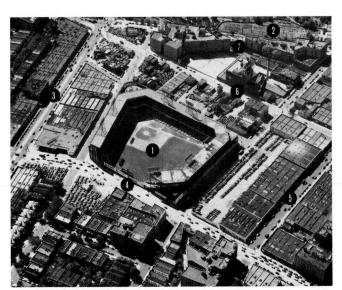

1 Ebbets Field.
2 Brooklyn Botanic Garden.
3 Empire Boulevard.
4 Bedford Avenue.
5 Crown Street.
6 Franklin Avenue.
7 Franklin Avenue Shuttle cut.

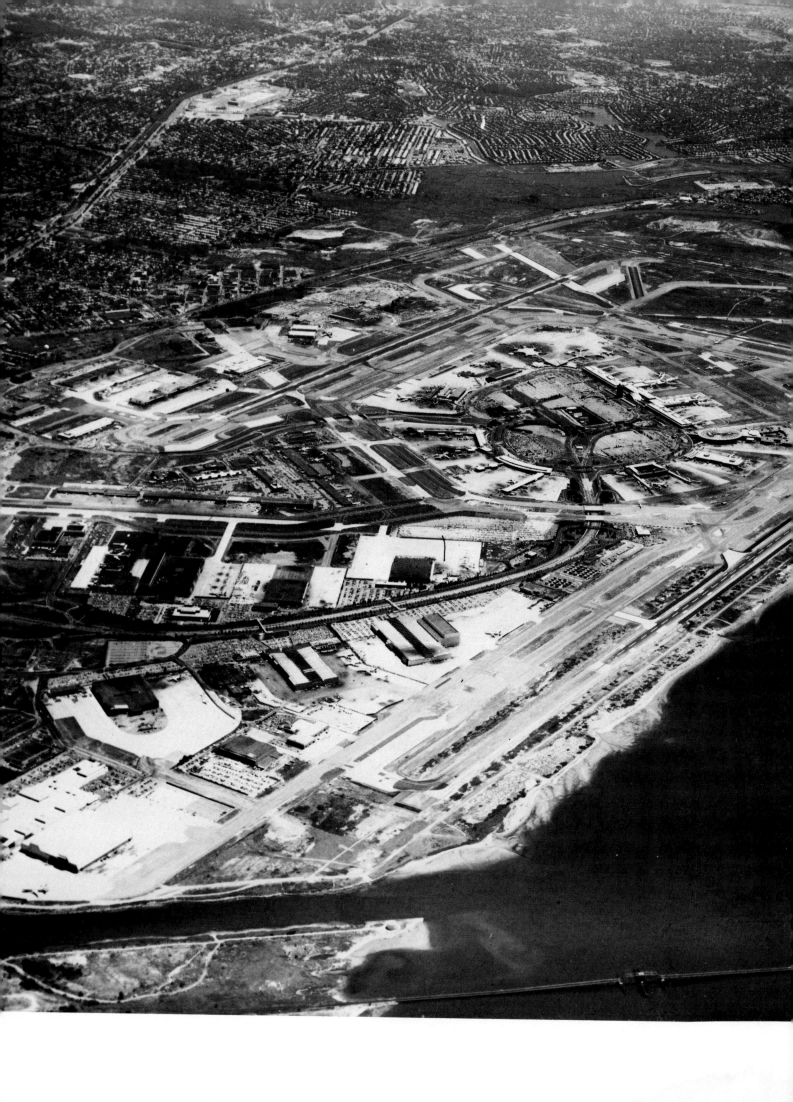

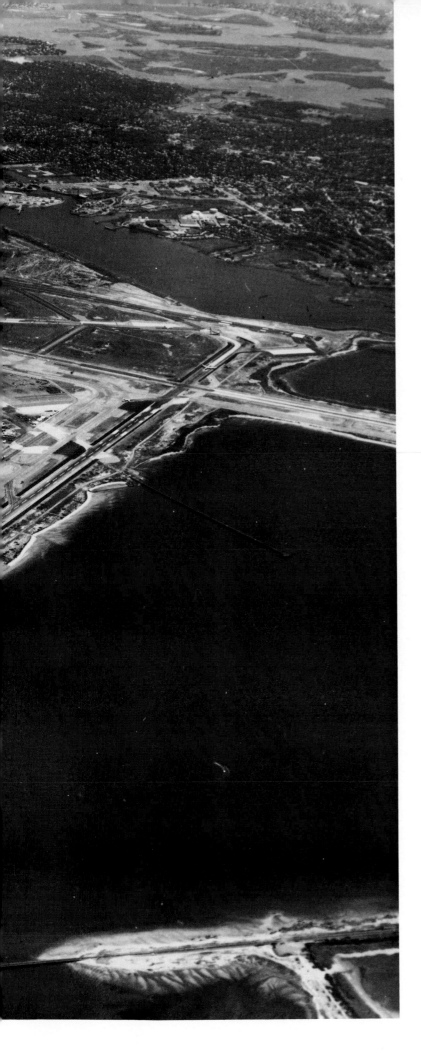

64
East across Kennedy Airport, Queens, July 2, 1979

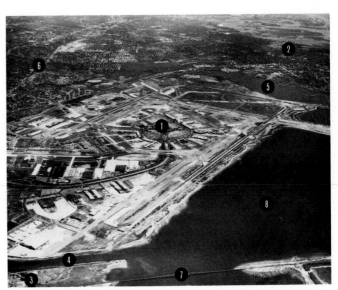

1 John F. Kennedy International Airport.
2 Cedarhurst.
3 Howard Beach.
4 Bergen Basin.
5 Head of Bay.
6 Southern Parkway.
7 IND subway bridge to Rockaway.
8 Jamaica Bay.

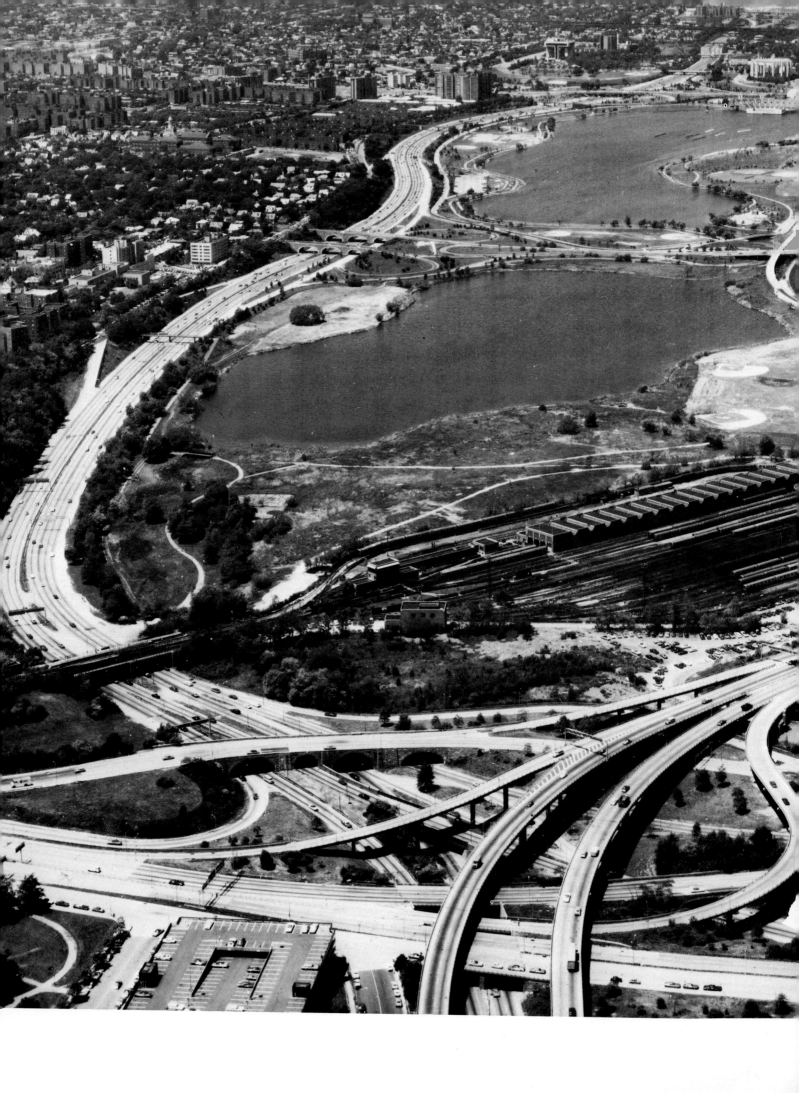

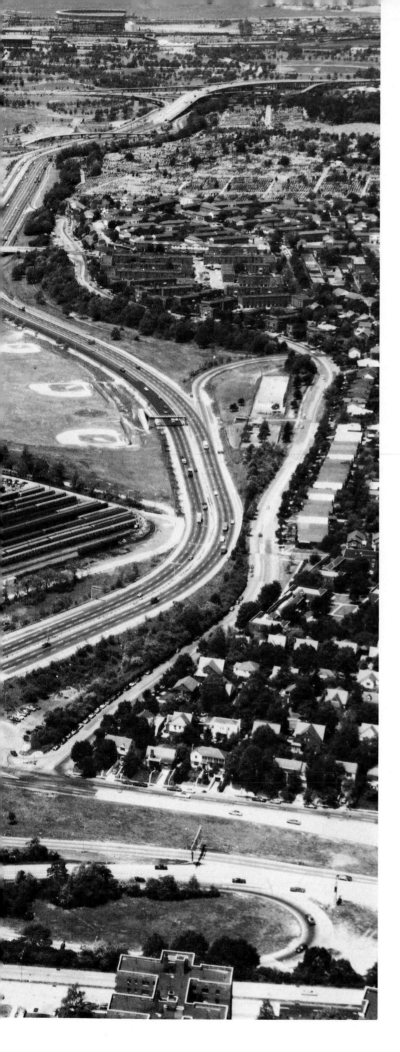

65
North across Flushing Meadows–Corona Park,
Queens, May 21, 1974

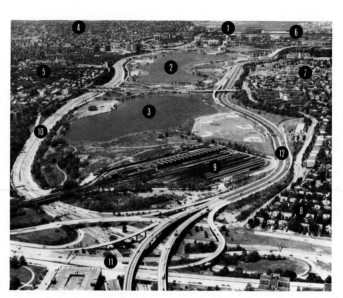

1 Flushing Meadows–Corona Park.
2 Meadow Lake.
3 Willow Lake.
4 Corona.
5 Forest Hills.
6 Flushing.
7 Cedar Grove Cemetery.
8 Jamaica.
9 IND subway yard.
10 Grand Central Parkway.
11 Union Turnpike.
12 Van Wyck Expressway.

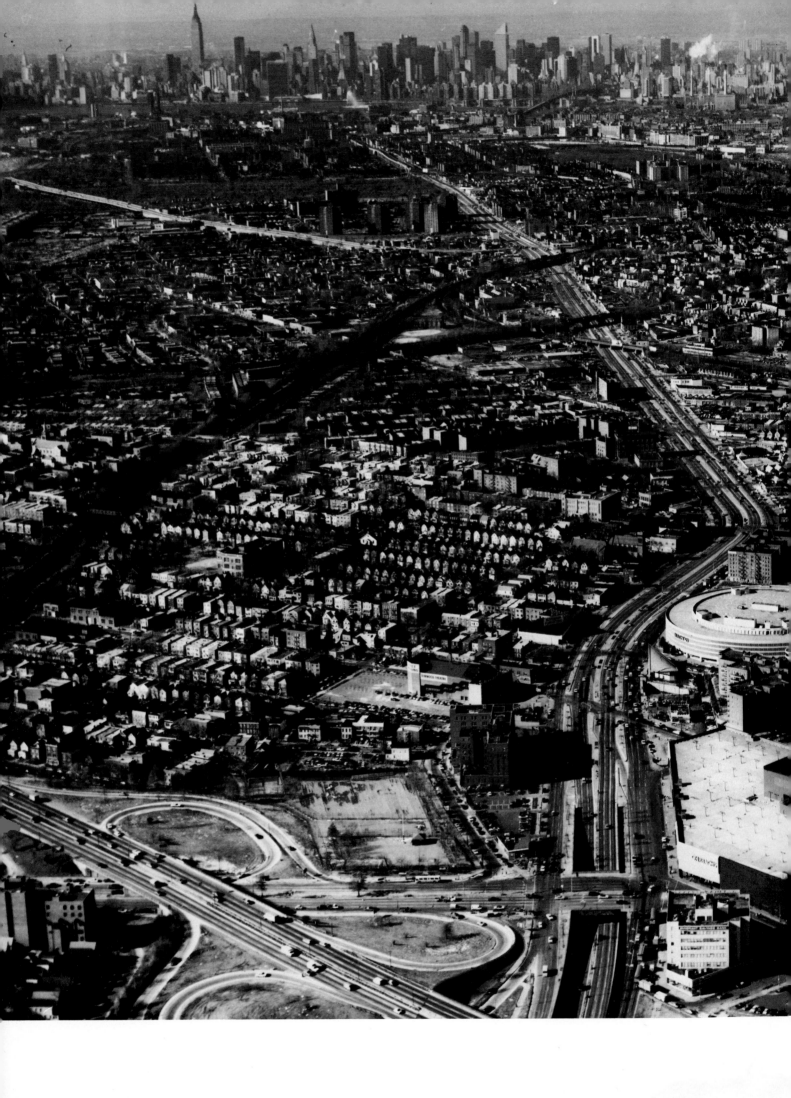

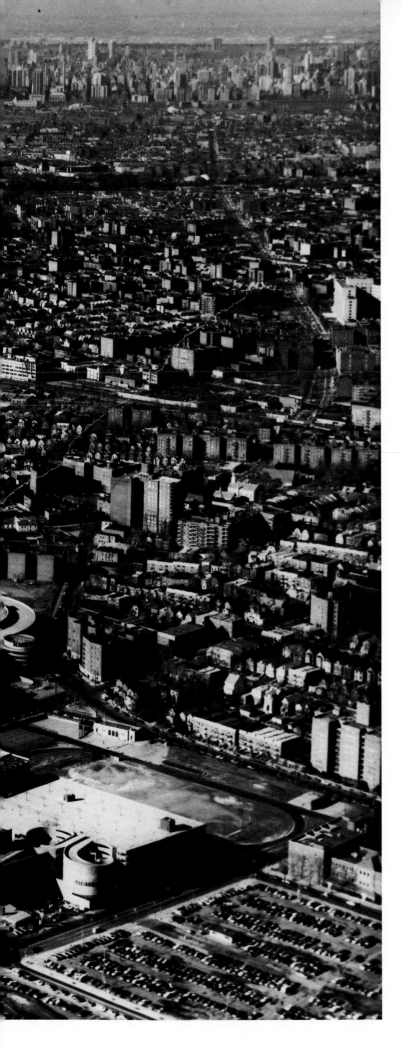

66
Queens, northwest across Elmhurst, January 11, 1978

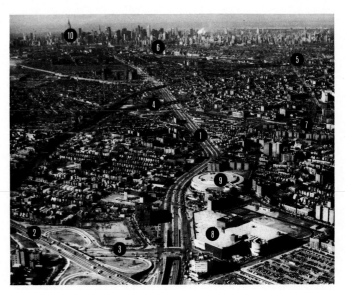

1 Queens Boulevard.
2 Long Island Expressway.
3 Woodhaven Boulevard.
4 Long Island Rail Road tracks.
5 Jackson Heights.
6 Long Island City.
7 Elmhurst.
8 Ohrbach's Department Store.
9 Macy's Department Store.
10 Manhattan.

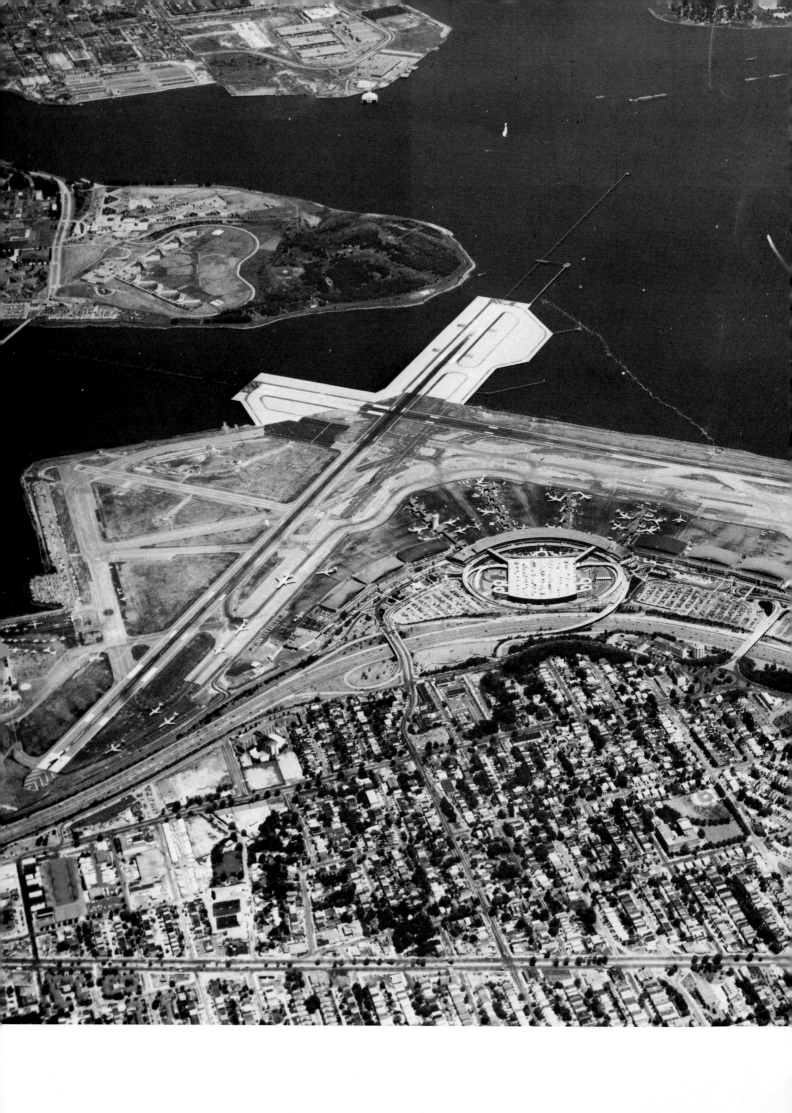

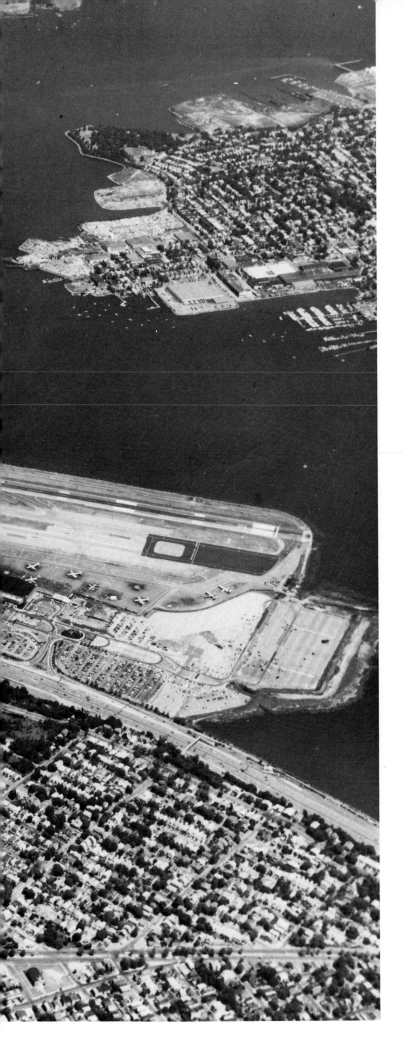

67
Northeast across La Guardia Airport, Queens,
July 15, 1977

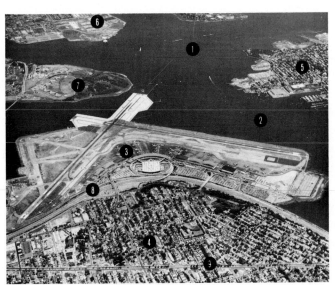

1 East River.
2 Flushing Bay.
3 La Guardia Airport.
4 Jackson Heights.
5 College Point.
6 Hunts Point, The Bronx.
7 Rikers Island.
8 Grand Central Parkway.
9 Astoria Boulevard.

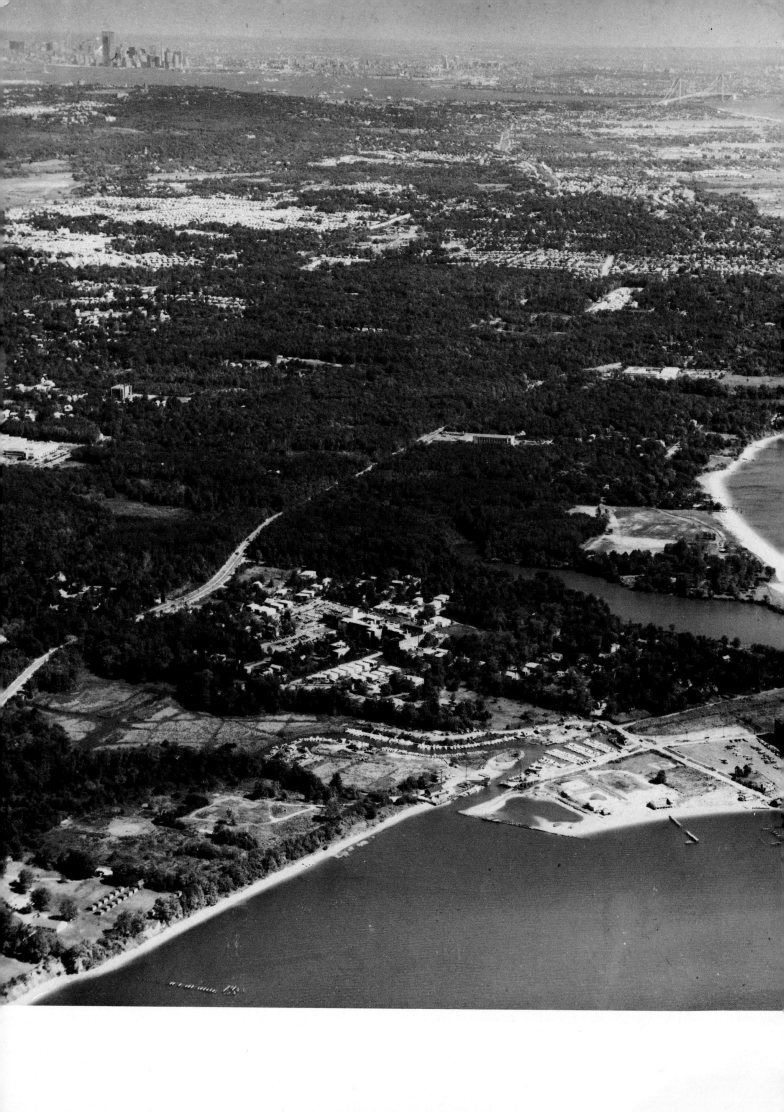

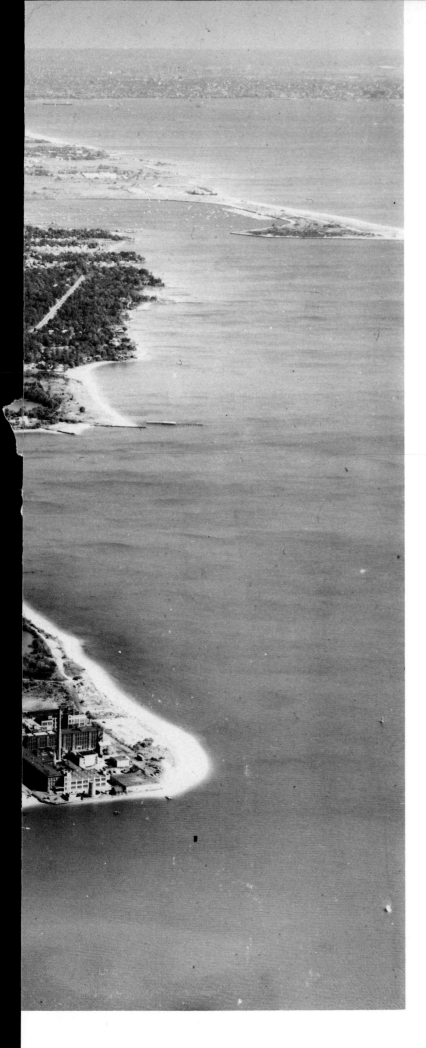

Staten Island, northeast from Prince's Bay,
September 29, 1977

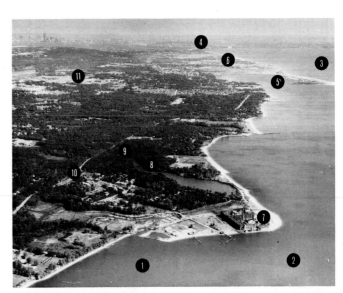

1 Prince's Bay.
2 Raritan Bay.
3 Lower New York Bay.
4 The Narrows.
5 Great Kills Harbor.
6 Great Kills Park.
7 Seguine Point.
8 Wolfe's Pond Park.
9 Prince's Bay section.
10 Hylan Boulevard.
11 Great Kills section.